DALLAS
THEN & NOW

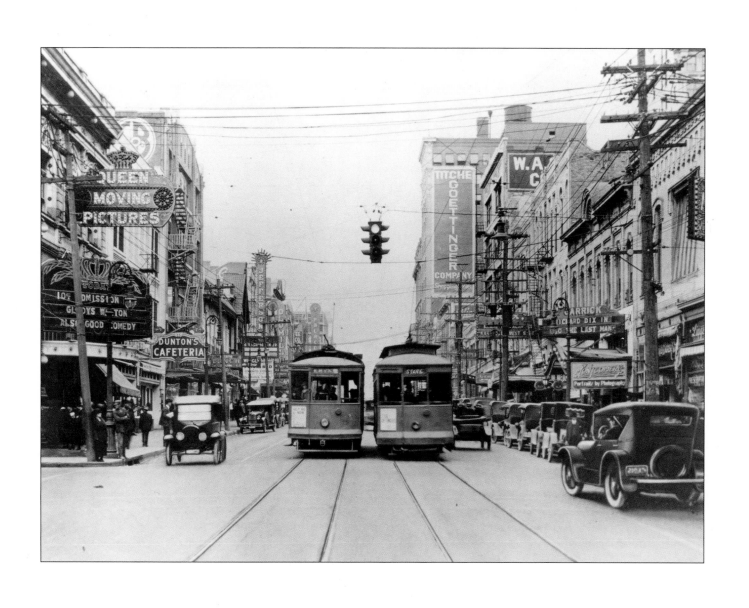

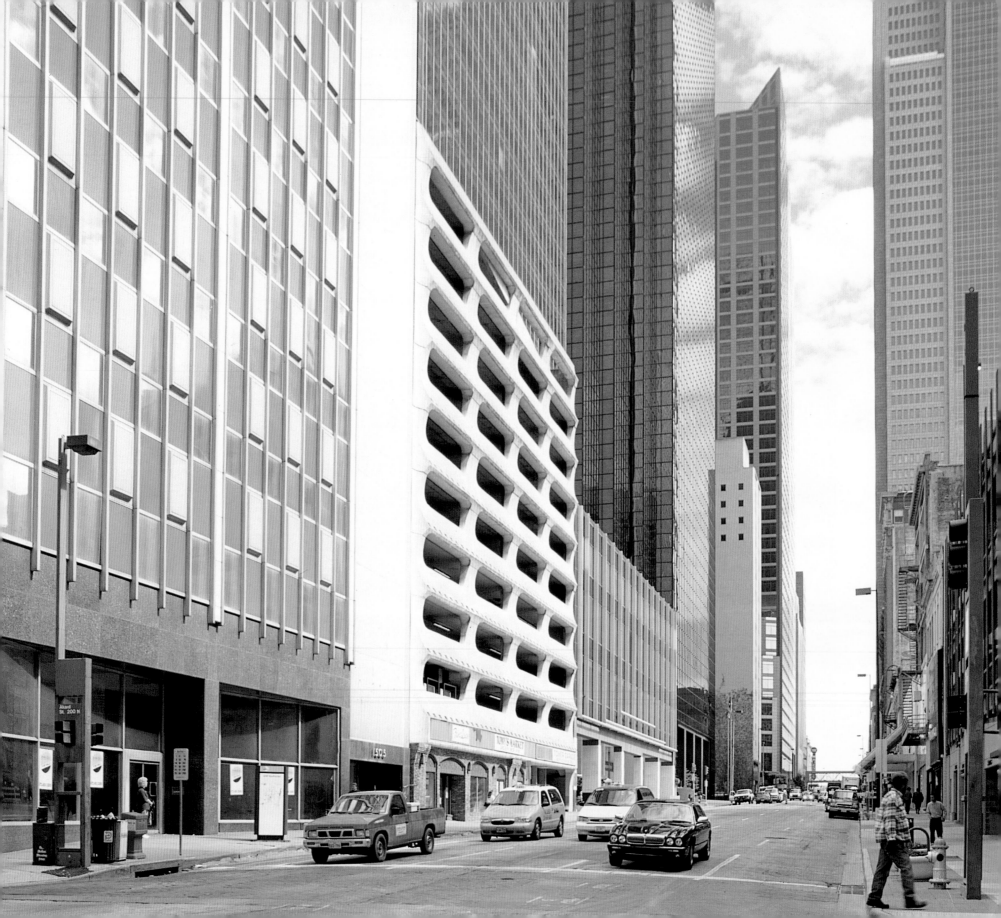

DALLAS
THEN & NOW

KEN FITZGERALD

THUNDER BAY
P·R·E·S·S

San Diego, California

Acknowledgments

The Dallas Public Library Archives Division has painstakingly cataloged the work of countless historians and photographers. Many thanks go to Jim Foster, Gretchen Boetcher, and Amy Treuer of the Dallas Public Library, and especially my wife Judy, without whose support this book would not have been completed.

Thunder Bay Press
An imprint of the Advantage Publishers Group
5880 Oberlin Drive, San Diego, CA 92121-4794
www.thunderbaybooks.com

Produced by PRC Publishing Ltd,
64 Brewery Road, London N7 9NT, England.

A member of **Chrysalis** Books plc

Library of Congress Catalog-in-Publication Data

Fitzgerald, Ken, 1955-
Dallas then & now / Ken Fitzgerald.
p.cm.
ISBN 1-57145-470-5
1. Dallas (Tex.)--Pictorial works. 2. Dallas (Tex.)--History--Pictorial works. 3. Dallas (Tex.)--Buildings, structures, etc.--Pictorial works. I. Title: Dallas then and now. II. Title
F394.D2143 F58 2001
976.4'2812--dc21 2001027465

Printed and bound in China.

2 3 4 5 02 03 04 05

Photography Credits

The publisher wishes to thank Simon Clay for taking all the "now" colour photography in this book.

The "then" photography was kindly supplied by the Texas/Dallas History and Archive Division of the Dallas Public Library, with additional credits as follows:

Dallas Public Library/City Photographer's Files for pages 1, 34, 66 and 84;
Dallas Public Library/The Hayes Collection for pages 8, 14 (unknown photographer), 16, 18, 138 and 142;
Dallas Public Library/Frank Rogers for pages 12 (copy; unknown photographer), 28, 36, 52, 72 (Neiman Marcus Archives), 86, 100, 102, 106, 120, 124, 126 and 132;
Dallas Public Library/Williams' Gold Medal Gallery for page 20;
Dallas Public Library/George E Gratz for page 26;
Dallas Public Library/Art Work of Dallas, 1895 for pages 30, 44, 56, 92 and 130;
Dallas Public Library/Henry Clogenson for page 32;
Dallas Public Library/Gershater-Rudnitzky Family Collection for page 40;
Dallas Public Library/Sanger-Harris Archives for pages 46 and 48;
Dallas Public Library/Schmucker Family Collection for pages 58 (Flash by Franklin, Dallas) and 96;
Dallas Public Library/W. Franklin for page 70;
Dallas Public Library/Carl Mangold Collection for page 80;
Dallas Public Library/Roman Catholic Diocese of Dallas Archives for page 90.

For cover photography credits, please see back flap.

Bibliography

Payne, Darwin, *Big D—Triumphs and Troubles of an American Supercity in the 20th Century*, Three Forks Press; 2000 Revised Edition.
Dallas Public Library, *The WPA Dallas Guide and History*, University of North Texas Press; 1992.
Evelyn Oppenheimer & Bill Porterfield, *The Book of Dallas*, Doubleday & Company; 1976.

INTRODUCTION

The history of Dallas is a roller coaster of pride and shame, good and bad, boom and bust. It would be a travesty if Dallas were only remembered in conjunction with a single vile moment in American history that transpired on November 22, 1963, resulting in the assassination of President John F. Kennedy. Instead, Dallas should be remembered for the determination and perseverance of those who have fought and labored to overcome the odds to build a city of over one million people on the mesquite-covered plain.

Spanish explorers in the 1500s found Native Americans of the Caddo tribe living by raising crops and hunting along the banks of the river they called "Arkikosa." Two hundred years later as the Spanish made treaties with the Native Americans, the three forks of the river inspired its modern name, "Trinity." Its course through the prairie grasses twisted and turned on itself, drawing abundant game to water, and leaving black, rich soil in its wake.

Following early Spanish rule, one of the biggest problems facing the new Republic of Texas in 1837 was no different than that of any modern Chamber of Commerce—how to attract new residents to the area. The Native American population was hostile toward the prospect of white settlers, and so the new republic sent a company of rangers to secure the area. Those rangers became the first Anglo-Americans to visit the location of present-day Dallas when they camped there after a bloody battle that saw losses on both sides.

With the Native Americans held at bay, the first hardy opportunists began to move into the area, looking for places to settle and call home. Tennessee lawyer and trader John Neely Bryan found a spot slightly downstream from where the West Fork joined with the Elm Fork of the Trinity River. Bryan thought the location marked a viable crossing of the Trinity, which he hoped would be navigable to that point from existing settlements spreading northward from the Gulf of Mexico. A military road was due to be built through the area, and as the Native Americans before him had known, the surrounding land was fertile for growing crops.

Claiming the 640 acres available to a single person, he built the first cabin on the banks of the Trinity River in 1841. There were no oceans, mountains, forests, railroads, or local industries that had predicated the establishment of other new communities. Yet by 1843 Bryan found himself building a larger cabin for his new bride, Margaret Beeman, the daughter of one of the many new settlers moving into the community he had named "Dallas." While it is widely accepted that the county of Dallas was named after President James K. Polk's Vice-President, George Miffin Dallas, the person Bryan was actually thinking of when he named the community Dallas is probably more obscure. It might have been Commander Alexander James Dallas of the United States Navy, or it may have been one of Bryan's local acquaintances, also named Dallas, whom he held in high regard.

Texas became the 28th state when President James K. Polk signed the Texas Admissions Act on December 29, 1845. John Bryan and a surveyor formally laid out the town of Dallas soon after, running east from the banks of the Trinity. Official papers were taken by horseback 140 miles to the courthouse in Franklin, the seat of Robertson County, for judicial review. On March 30, 1846, Dallas became a county in its own right, and the town of Dallas was named its governmental seat on April 18. John Neeley Bryan eventually sold his holdings in Dallas and traveled westward seeking new fortunes. After the Civil War he returned to become a farmer, but died in 1877 after being committed to the state lunatic asylum in Austin.

As America expanded, the line dividing civilization from the wilderness moved westward from the original colonies to the Mississippi River and on to towns like Dallas. A wagon factory opened in 1852, and other industries sprang up as stage routes were established and the tracks of the Houston & Texas Central railroad arrived in 1872. Mirroring the rest of the primarily agrarian South, cotton as a cash crop began to replace food crops. Buffaloes were still plentiful, and Dallas became a bustling frontier town, where settlers moved west and buffalo hides and cotton moved east.

Many who passed through saw promise and stayed to build their futures. Their perseverance allowed early Dallas to survive being destroyed by fire and flood time after time by the normally placid Trinity River. Those destined to become leaders realized physical improvements such as paved streets, plumbing, telephones, and electricity alone would not be enough for Dallas the town to grow into Dallas the city. Forethought and guidance were needed if Dallas was to achieve its potential for the future. Groups dating back to the Citizen's Association founded in 1907 were organized to elect qualified businessmen to public office; promote civic improvement; and improve the quality of life for African-American, Hispanic, and other minority citizens. The importance of good city planning was illustrated by the 1912 Kessler Plan, parts of which called for the taming of the Trinity River and the establishment of a Union Station for all the railroads.

Hard work by local businessmen won Dallas a branch of the Federal Reserve Bank in 1914, and higher education arrived in Dallas in 1915 with the establishment of Southern Methodist University. The building of Love Field and eventually Dallas–Fort Worth (DFW) airport have made Dallas a major transportation hub of worldwide significance. The local economy has kept pace by moving from agriculture to oil to high-tech industry.

The preceding 160 years have seen Dallas grow steadily from a single individual person occupying 640 acres to a true city of over one million people covering 385 square miles. Dallas has a new goal of hosting the 2012 Olympics, and if past achievements are any indication, the persevering spirit of the people of Dallas will make it a reality.

Opening with the evolving skyline of Dallas, we move from the west across the Trinity River and explore the downtown area before moving back into the immediate suburbs, winding up at Fair Park to the east.

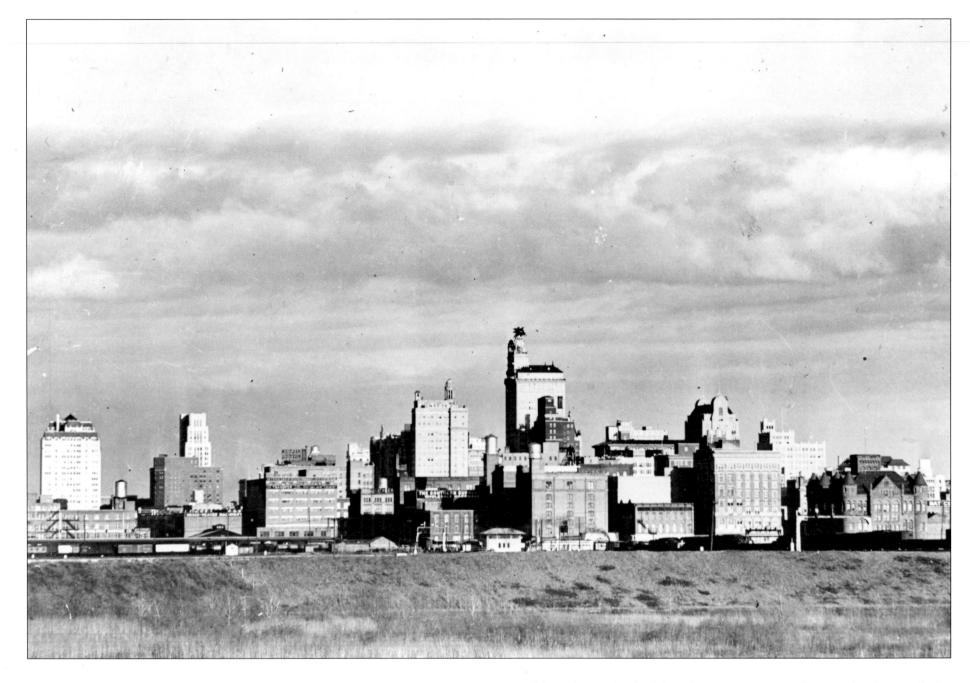

Viewed from the west bank of the Trinity River in 1934, the year after the repeal of Prohibition, the skyline of Dallas on the east side is already the talk of the Southwest. The twenty-nine story Magnolia Petroleum Building looks down on the rest of the city, displaying its giant flying red horse for all to see. In the right corner is the old red courthouse.

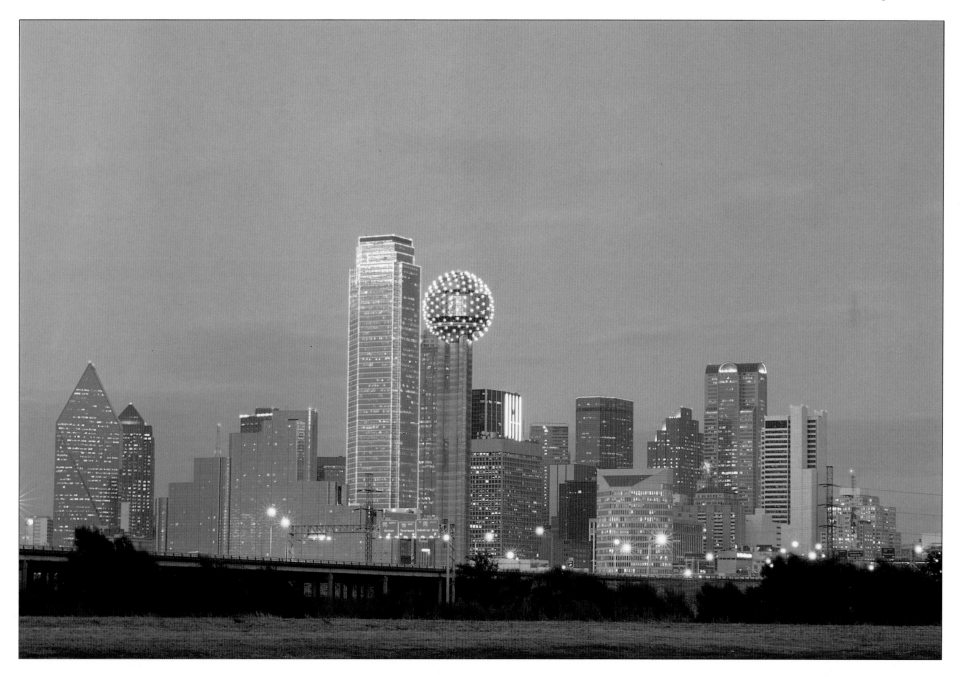

Today's view from a little further south reveals a skyline composed of more shiny steel and glass than the older brick and stone. The Magnolia Building has long since given up its crown as tallest building, the prize now going to the green-trimmed Bank of America Tower. The 260 bulbs circling the top of the fifty-story Reunion Tower present a computer-controlled light show visible for miles.

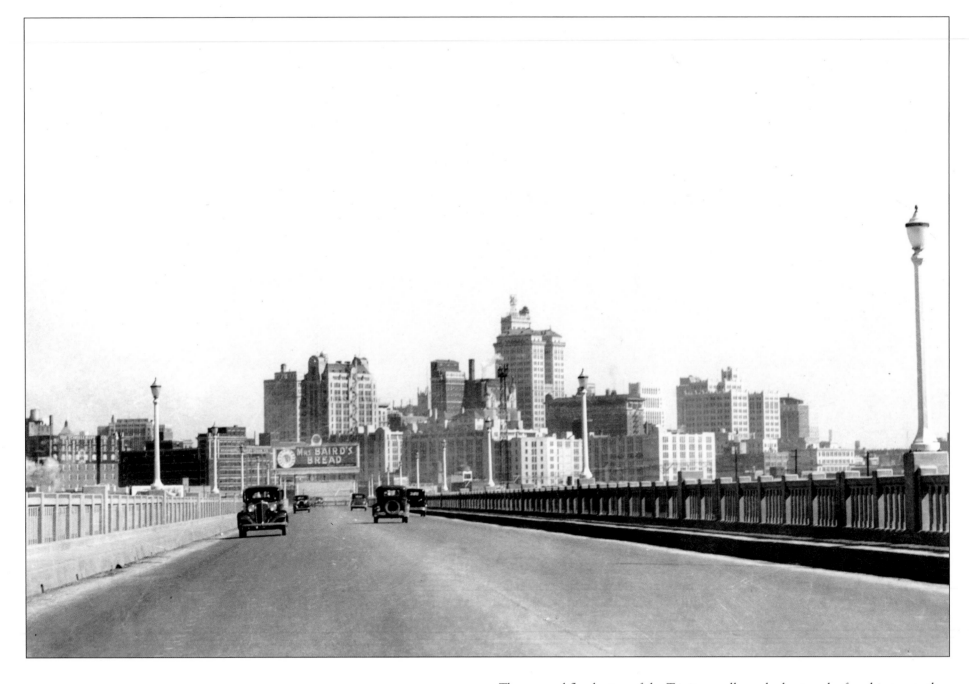

The seasonal floodwaters of the Trinity usually made short work of washing away the first wooden and even iron bridges built by early settlers to connect Dallas with Oak Cliff. This changed in 1912 with the completion of the Oak Cliff Viaduct, which, at over a mile in length, became the longest reinforced concrete structure in the world at the time of its construction.

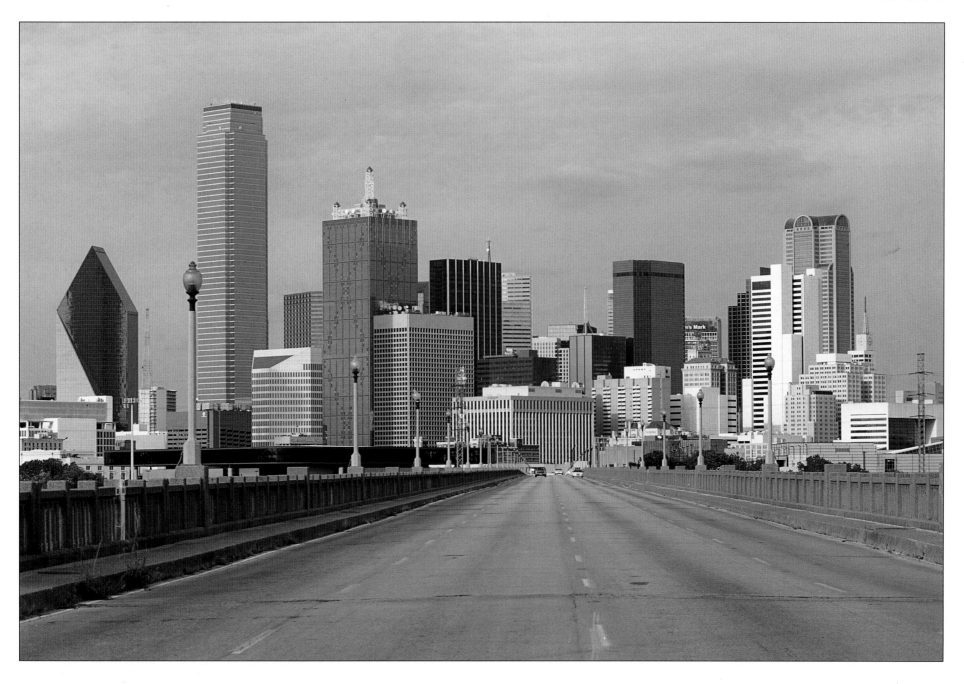

Later renamed the Houston Street Viaduct, this bridge has withstood the tests of time and water very well. Only the skyline of the city it leads to has changed over the years. Today, many modern indestructible bridges span the river, but none is as important an investment in the city's early development as this one.

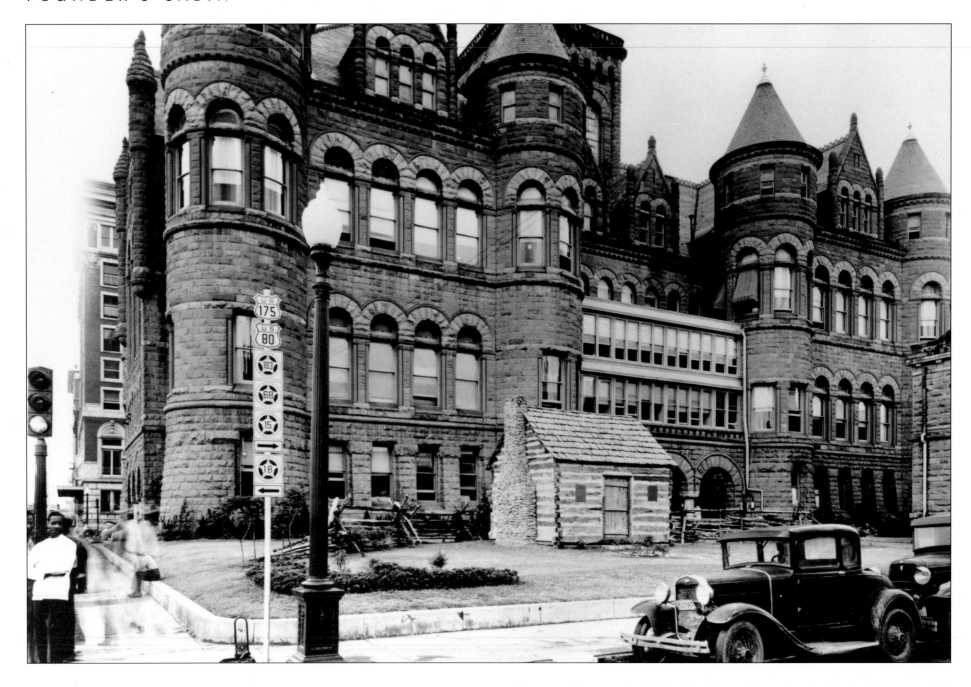

In the 1930s, the east side of the old Red Courthouse dwarfs a log dwelling intended to represent the original founder's cabin. While no doubt authentic in construction, this particular cabin is probably from a later period, as there was no glass available for windows when the first shelters were constructed in Dallas. Lacking a view of the outside was the least of the early homesteader's worries, as basic survival still depended upon what could be grown or hunted for food.

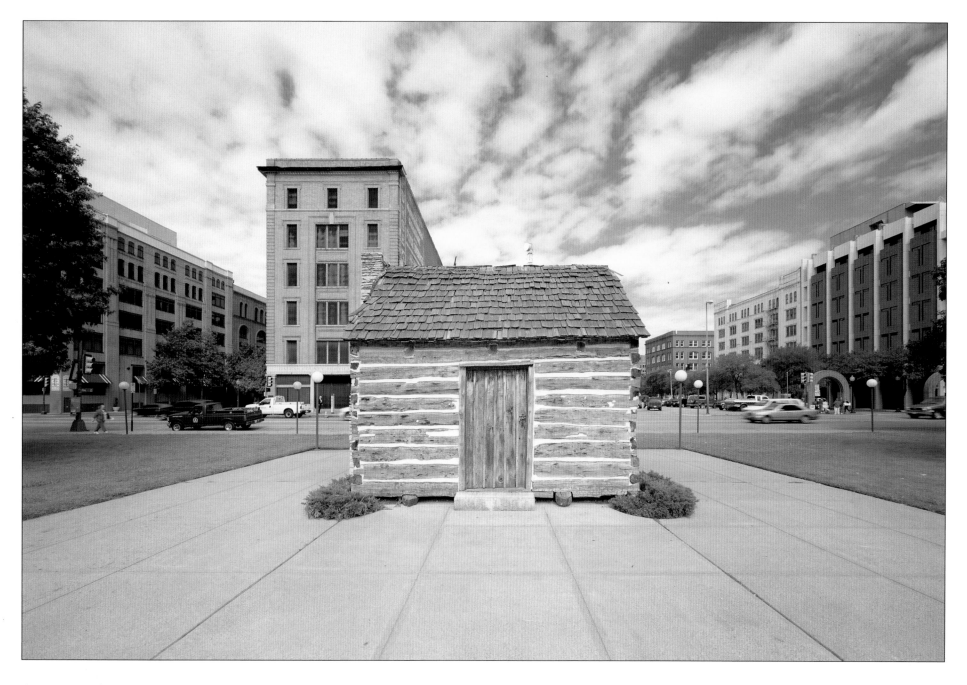

Seventy years later, a more accurate rendition of John Neely Bryan's first cabin stands in the middle of Dallas County Memorial Plaza, one block northeast of the courthouse. Few other scenes suggest the degree to which life in Dallas has changed over the years from its simple beginnings in a ten-by-ten foot single room. Where paved streets now are the norm, simple footpaths winding through the prairie grasses connected the first cabins.

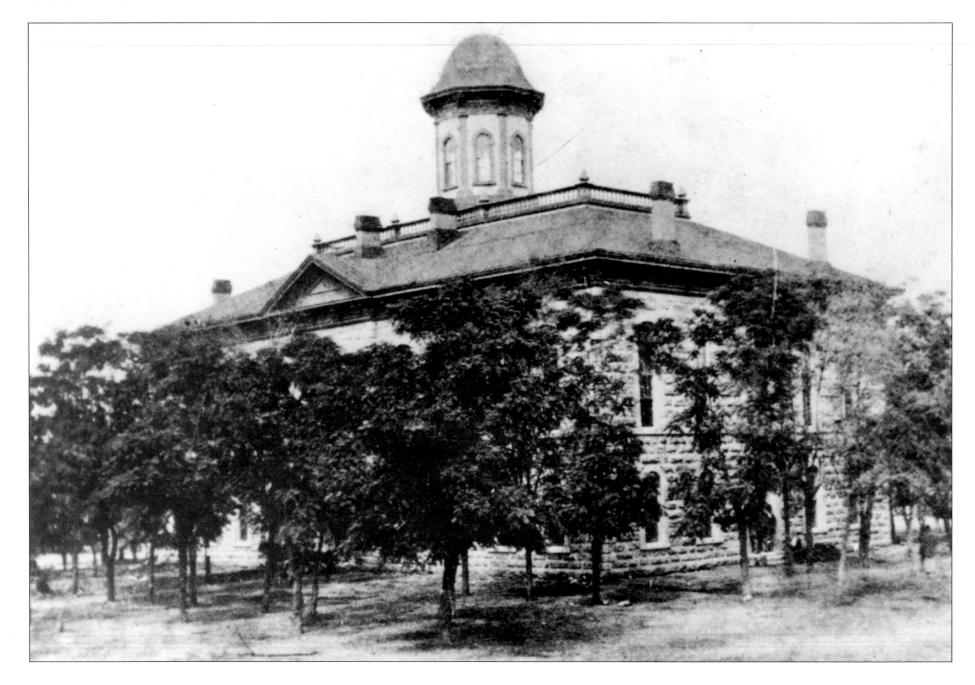

Dallas County citizens have built a total of six courthouses in the same location over the years to handle their legal matters. The limestone for the walls of this new building, shown in 1873 shortly after its completion, was quarried from what is now White Rock Lake. It suffered the same fate of many other early buildings when it was destroyed in a fire in 1880.

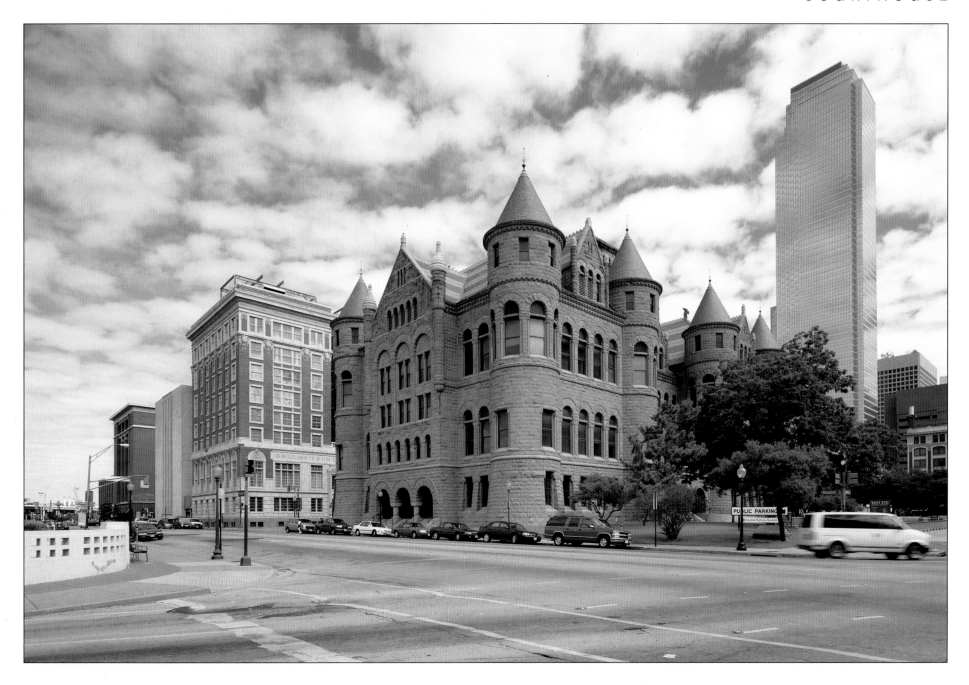

The courthouse built to replace the one destroyed by fire in 1880 was itself consumed by flames in 1890. On that same site, the focal point for the development of Dallas, rose the building popularly known today as the "Old Red Courthouse." Successfully built to be fireproof, it overlooks Dealey Plaza at the intersection of Jefferson, Main, Houston, and Commerce streets.

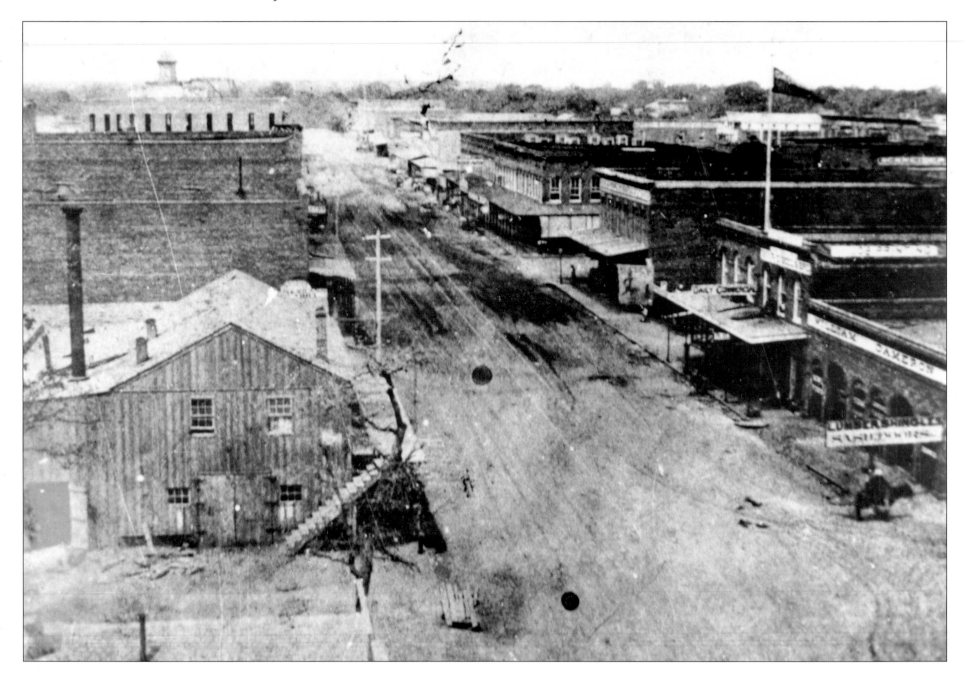

This view is from the roof of the courthouse in 1875, looking west toward the river. The top of the Windsor Hotel is visible on the left side of Main Street, and the flag is flying over the offices of the *Dallas Daily & Weekly* newspaper on the right. The first newspaper in Dallas, *The Cedar Snag*, was first published in 1849. Eventually becoming the *Dallas Herald*, it competed with the *Dallas Morning News* for many years before being purchased by the latter.

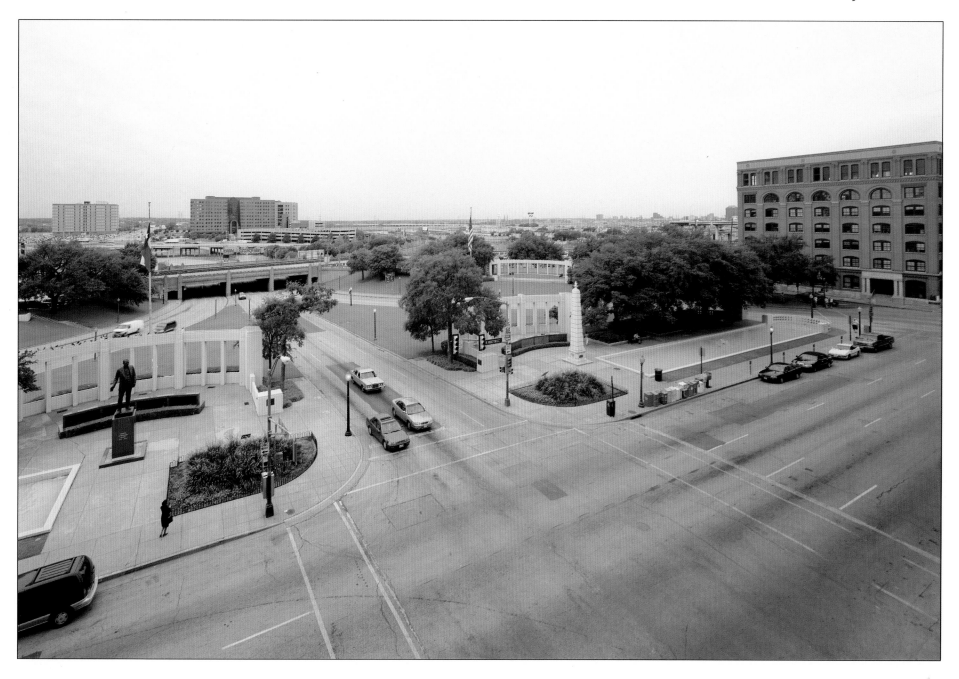

Today's view from atop the current courthouse looks out on Dealey Plaza, destination for thousands of tourists every year after the shooting of our 35th president. The infamous Texas School Book Depository is on the right, now hosting the Sixth Floor Museum dedicated to the Kennedy Assassination. Just to the left of the American flag is the so-called "grassy knoll" from which a second assassin is theorized to have fired.

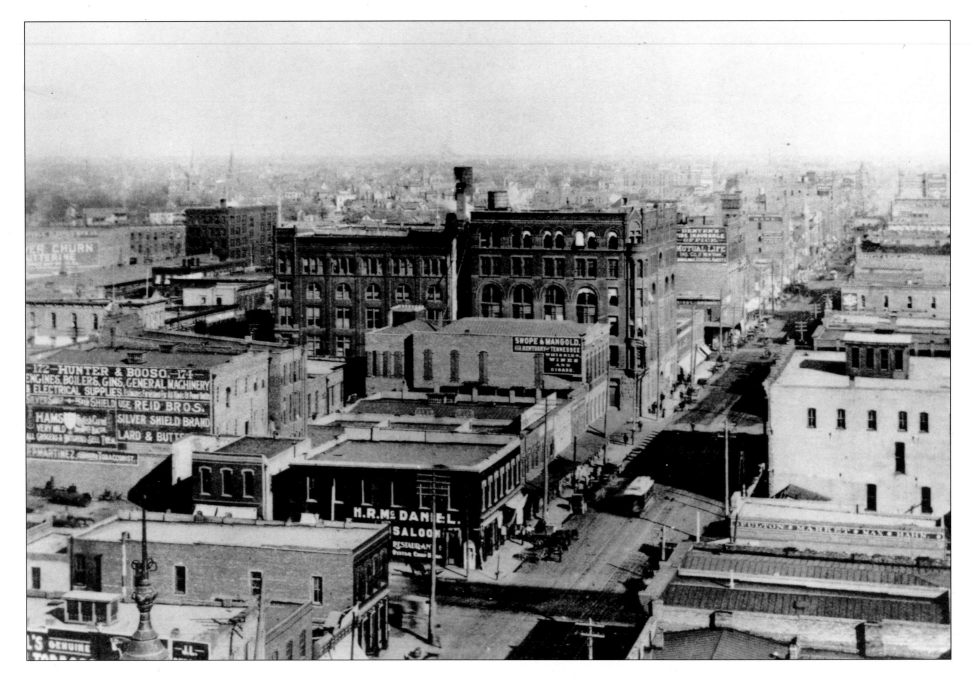

Looking northeast up Main Street from the roof of the then new, "Old Red Courthouse" in the year 1895. Dallas has, literally, grown almost out of sight in its 50-year advancement away from the Trinity River bottoms. The nationwide financial panic of 1893 slowed development, but did not dampen spirits as the city was due to host the world heavyweight championship fight between Jim Corbett and Bob Fitzsimmons; however, the fight was stopped by a special action of the state legislature after protests from local ministers.

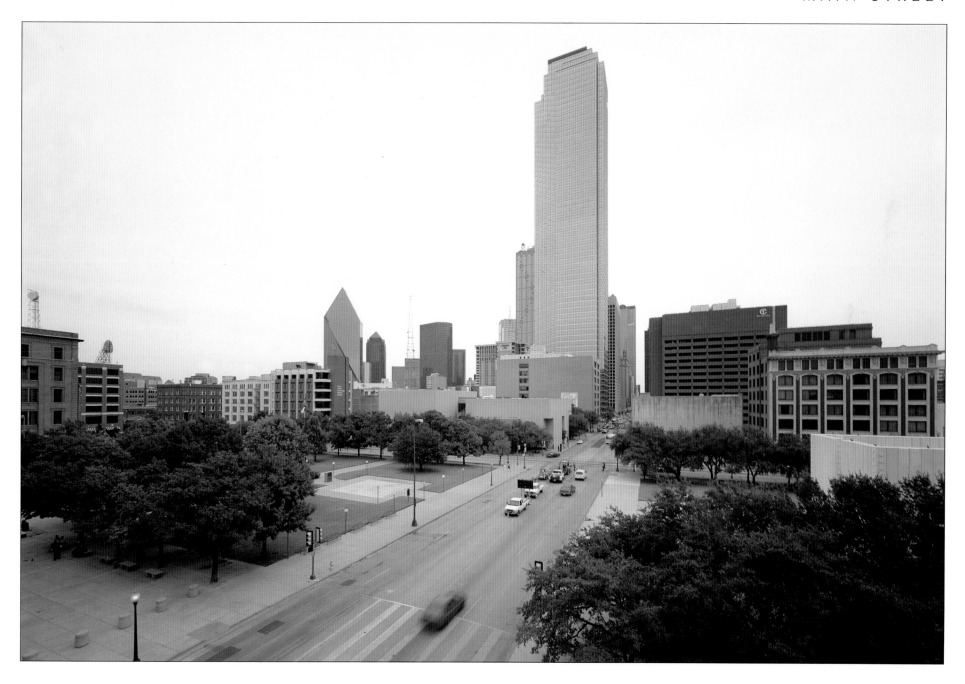

The seventy-two–story Bank of America Plaza dominates today's skyline and is the tallest building in modern Dallas. Contrasts in architecture over time are plainly illustrated by the differences between the traditionally square M-K-T (Katy) Railroad office building on the near right and the much more recent spire of the First Inter-state Bank Tower at Fountain Place on the distant left.

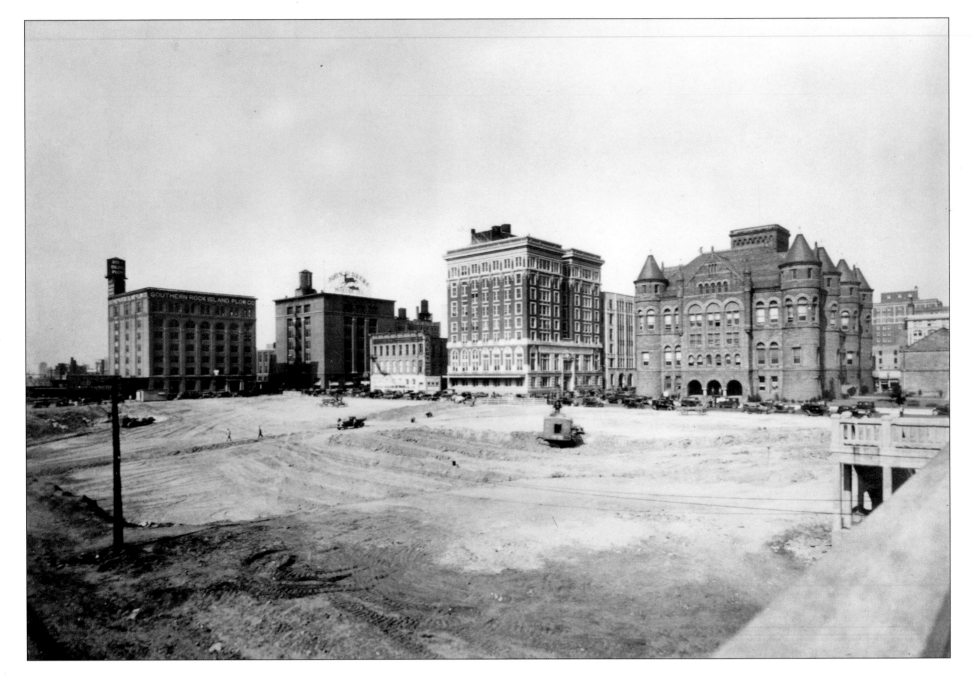

As publisher of the *Dallas Morning News*, George Bannerman Dealey used his position to influence the building of the Houston Street Viaduct and other bridges that followed. This city planning also led to the concept of the Triple Underpass and Dealey Plaza, under construction here in 1935. Where a jumble of streets and buildings existed before, a new streamlined entrance to Dallas was created, bringing Commerce, Main, and Elm streets together so traffic could flow smoothly and efficiently.

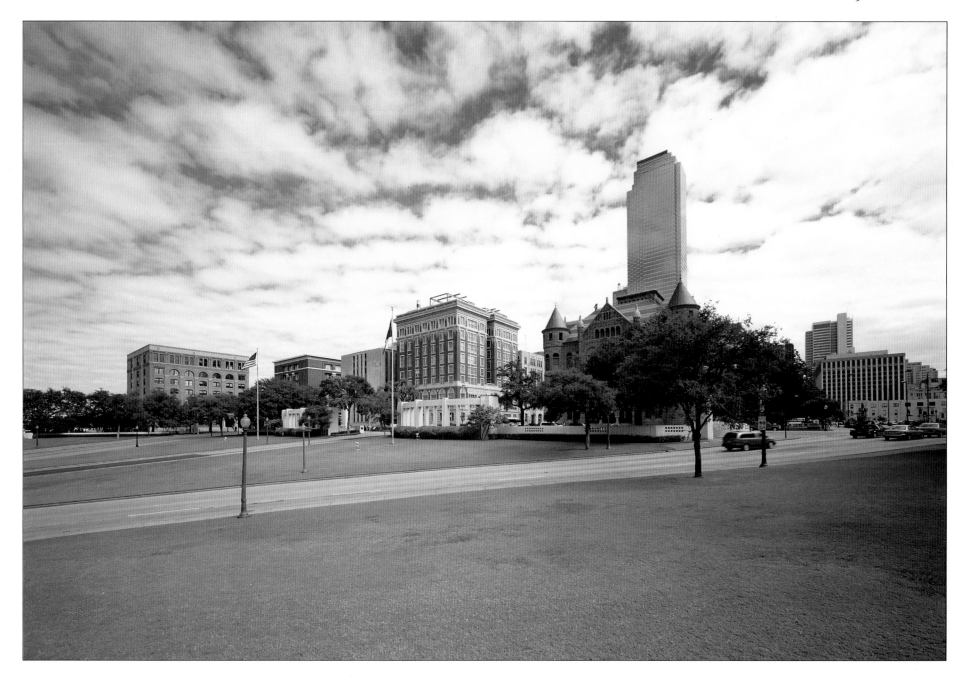

The intersection of Interstates 30 and 35, just to the left of this view, brings even
more traffic through the Triple Underpass today than early planners envisioned, but
the design handles it well. The tip of the American flag in the pristine Dealey Plaza
points to the sixth-story corner window from which Lee Harvey Oswald fired as the
president's motorcade passed downhill directly below on Elm Street.

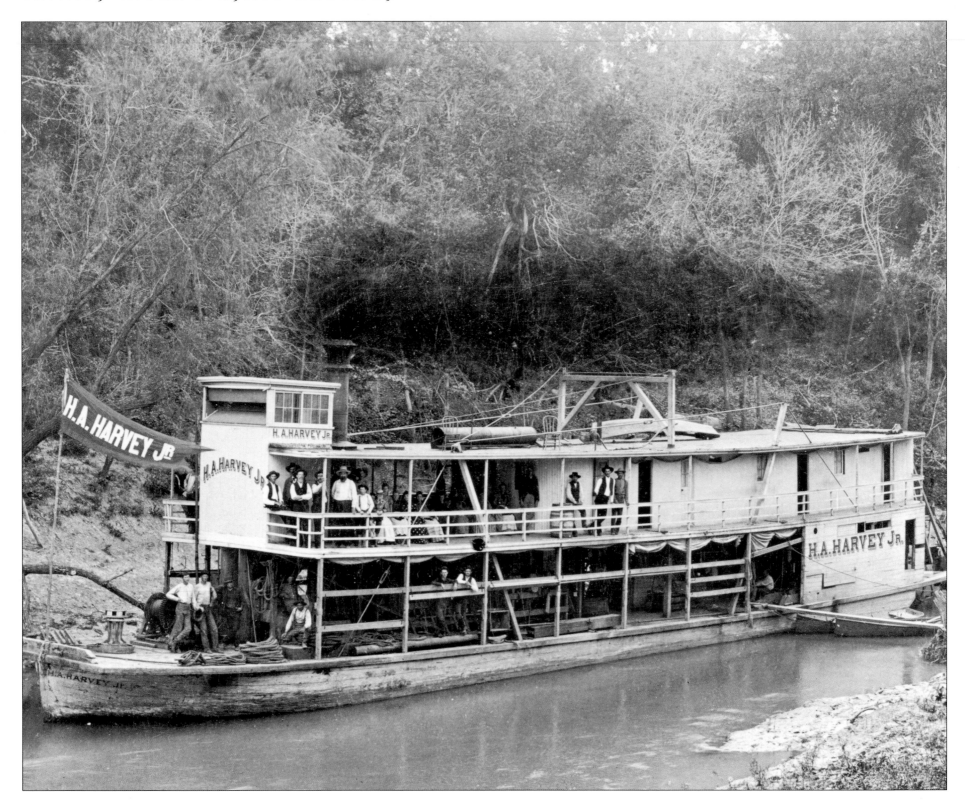

Left: When John Neeley Bryan chose the location for Dallas, one of his greatest hopes was that the Trinity River would be navigable from the Gulf of Mexico once debris was cleared from the channel. The arrival of the steamboat *H. A. Harvey* belonging to the Trinity River Navigation Company in May of 1893 proved him to be right. She was 113 feet long and could carry 600 bales of cotton or 150 passengers.

Right: In spite of money allocated by Congress for surveys and the construction of several locks and dams, over the following years transport by road and rail won out, and the Trinity was never developed as a waterway like rivers back east. The course of the river was changed by the construction of levees in 1933, and upon some of this reclaimed land the gleaming 940-room Hyatt Regency of Dallas was opened in April of 1978.

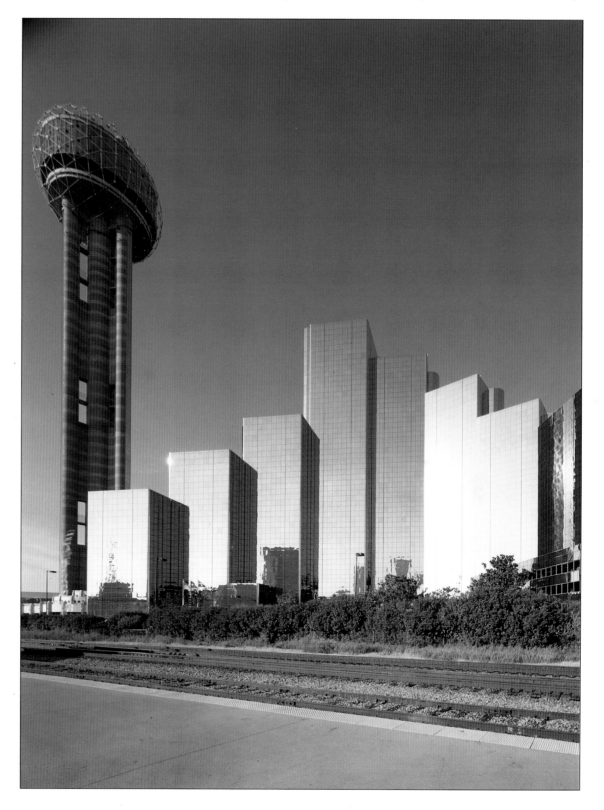

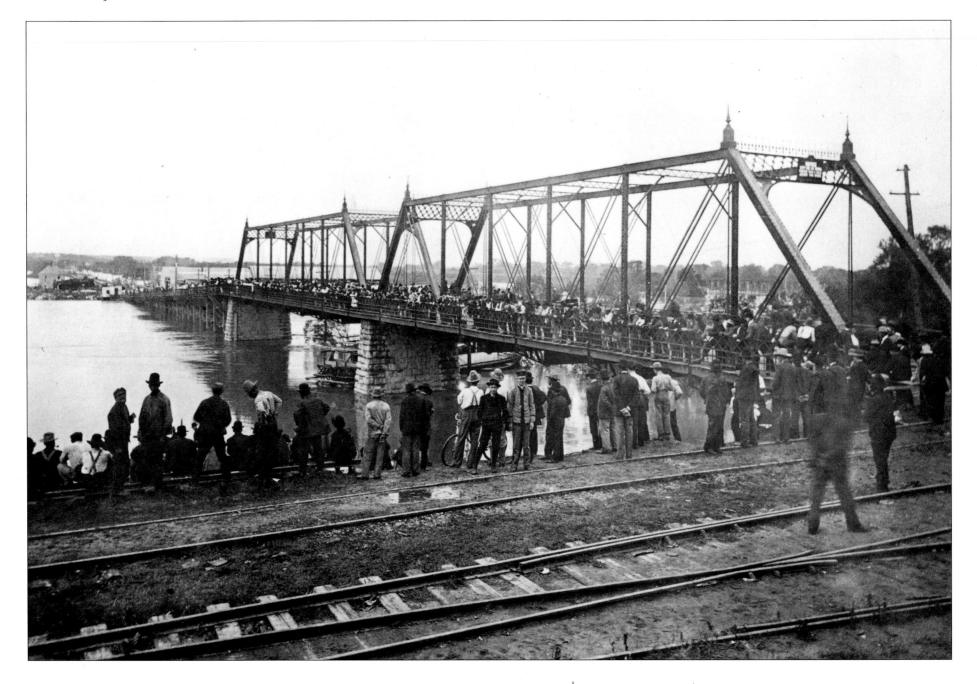

The Trinity River had risen out of its channel many times before, but no one at the time could remember it being as severe as in 1908. These people look west toward isolated Oak Cliff across the flooded bottoms. The flood began in April and reached a record crest of 51.3 feet in May. The Commerce Street Bridge shown here was the third at this location, and had to be removed and rebuilt after the waters receded.

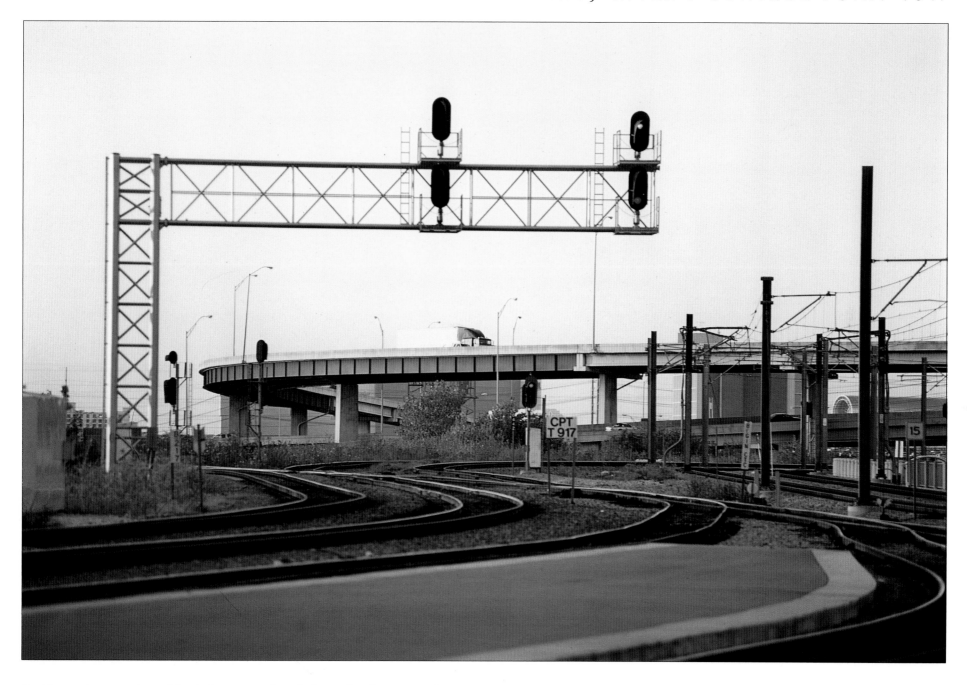

Residing today on reclaimed land, this spot is identified in railroad terms simply as
"Control Point T917." The tracks curving off to the left are those of the Union
Pacific but were originally built by the Texas & Pacific in 1876 to reach Fort Worth.
The Texas & Pacific Bridge over the Trinity collapsed in the 1908 flood taking five
people to their deaths in the muddy water.

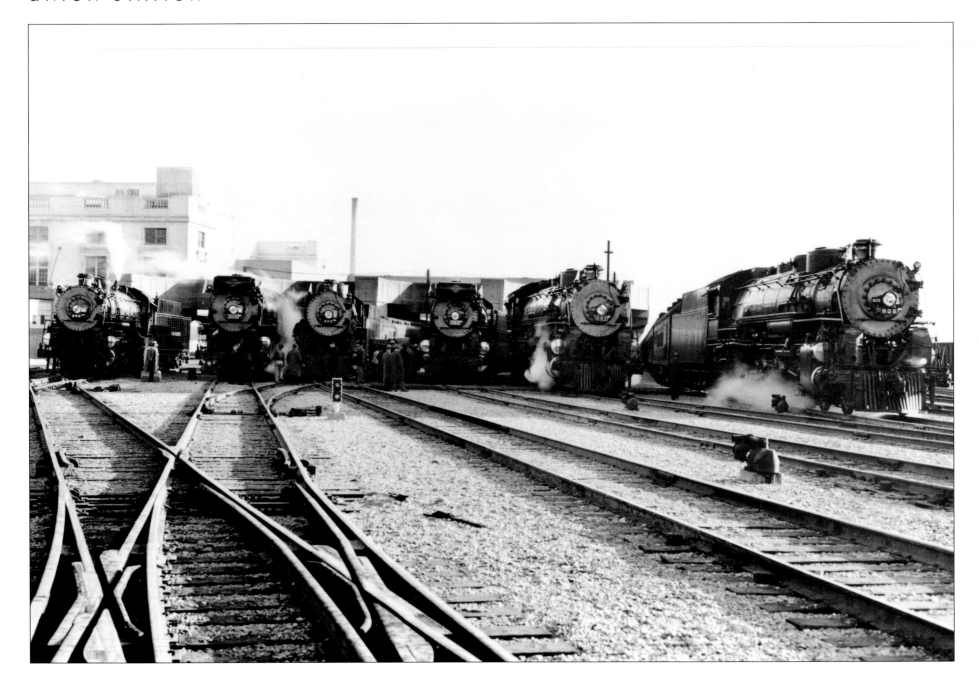

By the early 1900s, Dallas had grown into a transportation hub served by eight different railroads, each with its own terminal, and the resulting difficulties in transferring people and freight. City planner George Kessler presented a plan for a Union Station, and despite initial resistance from the railroads, construction began in 1914. Six Texas & Pacific football specials are shown here in 1936, waiting to take dedicated football fans to the Rose Bowl game between SMU and Stanford.

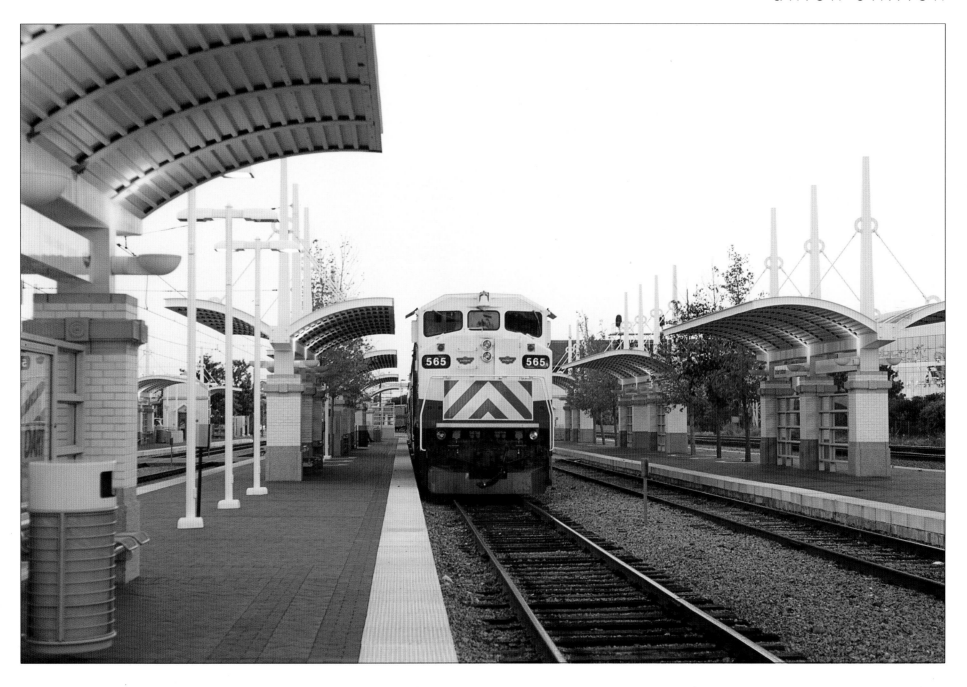

Union Station today serves only Amtrak's Texas Eagle, running between Chicago and San Antonio; the Dallas Area Rapid Transit (DART) light rail, serving Dallas and its immediate suburbs; and Trinity Railway Express (TRE), offering commuter service to Irving and continuing on to Hurst and Richland Hills in Tarrant County. Locomotive 565 of the TRE idles patiently before heading west.

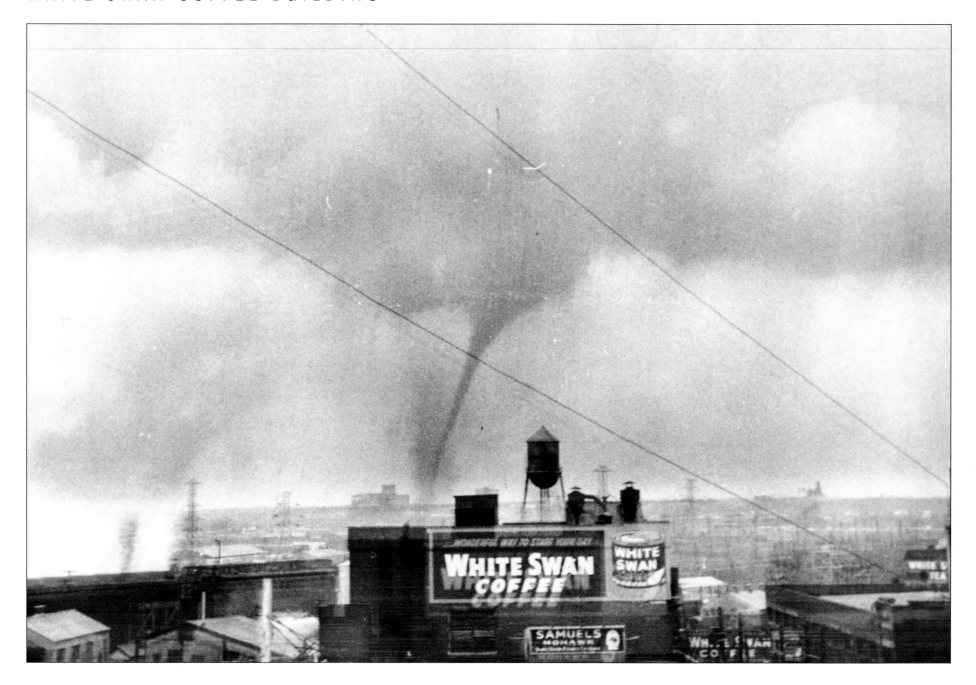

On April 2, 1957 at 4:30 p.m., a tornado touched down and wrought a narrow 16-mile-long path of destruction from west to northwest of downtown Dallas. Winds were estimated to have reached 212 miles per hour as a black funnel of dirt and debris spared nothing in its path over a 46-minute period. Ten people lost their lives that day while 170 were injured.

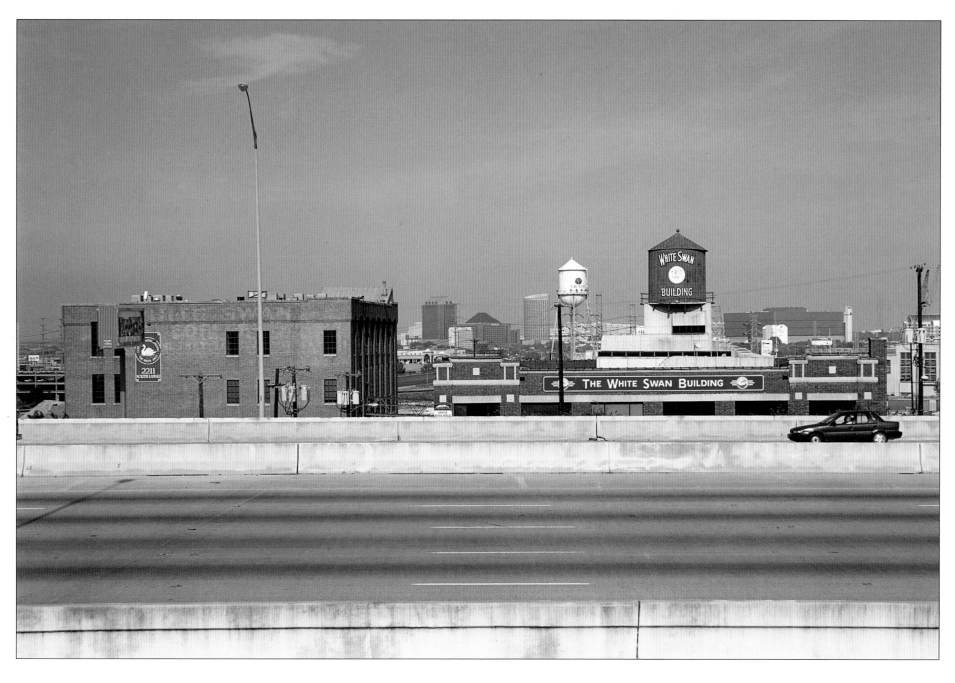

Back in 1957, the tornado caused over four million dollars in damages, devastating 800 homes and businesses. The White Swan Coffee Building still stands today, its shell and those of other old warehouses now house shops, restaurants, and nightclubs in the tourist area known as the "West End." The elevated lanes of traffic in the foreground belong to the Woodall Rogers Freeway, named after one of Dallas's most accomplished past mayors.

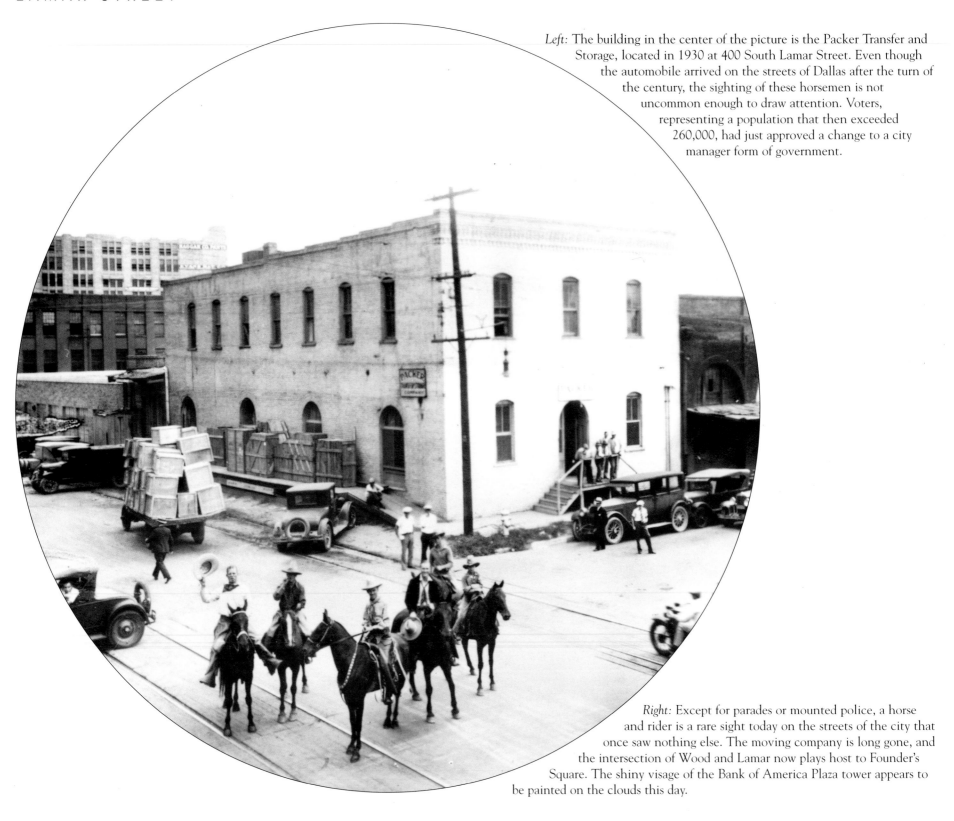

Left: The building in the center of the picture is the Packer Transfer and Storage, located in 1930 at 400 South Lamar Street. Even though the automobile arrived on the streets of Dallas after the turn of the century, the sighting of these horsemen is not uncommon enough to draw attention. Voters, representing a population that then exceeded 260,000, had just approved a change to a city manager form of government.

Right: Except for parades or mounted police, a horse and rider is a rare sight today on the streets of the city that once saw nothing else. The moving company is long gone, and the intersection of Wood and Lamar now plays host to Founder's Square. The shiny visage of the Bank of America Plaza tower appears to be painted on the clouds this day.

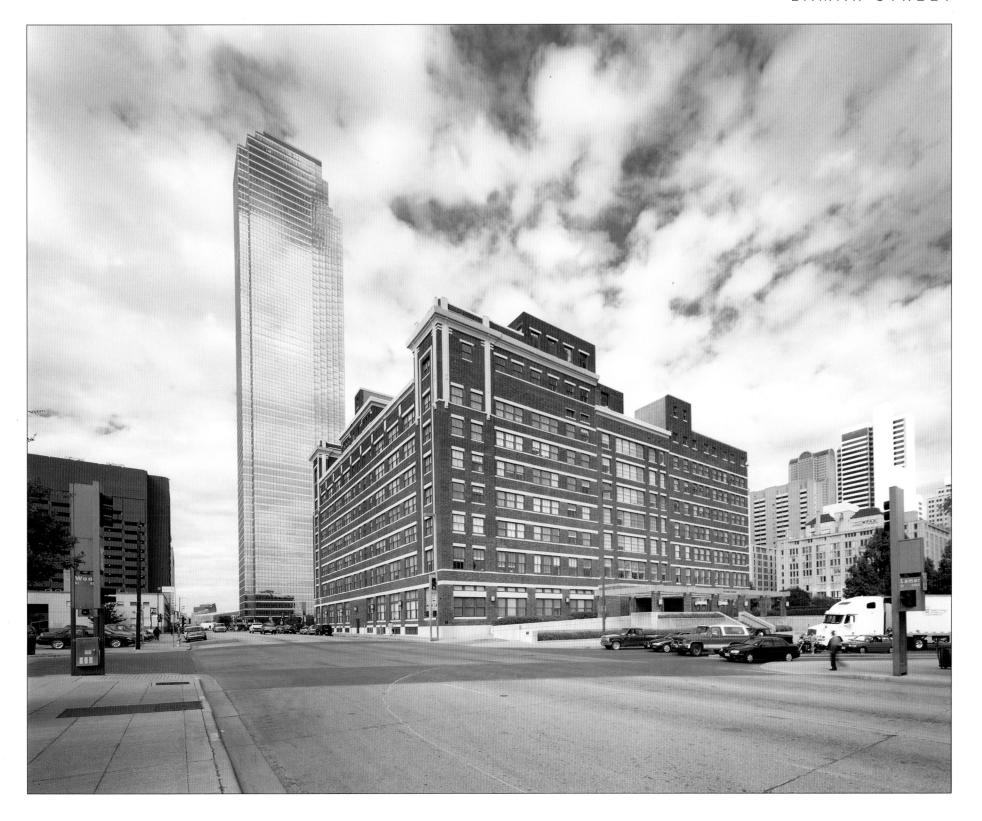

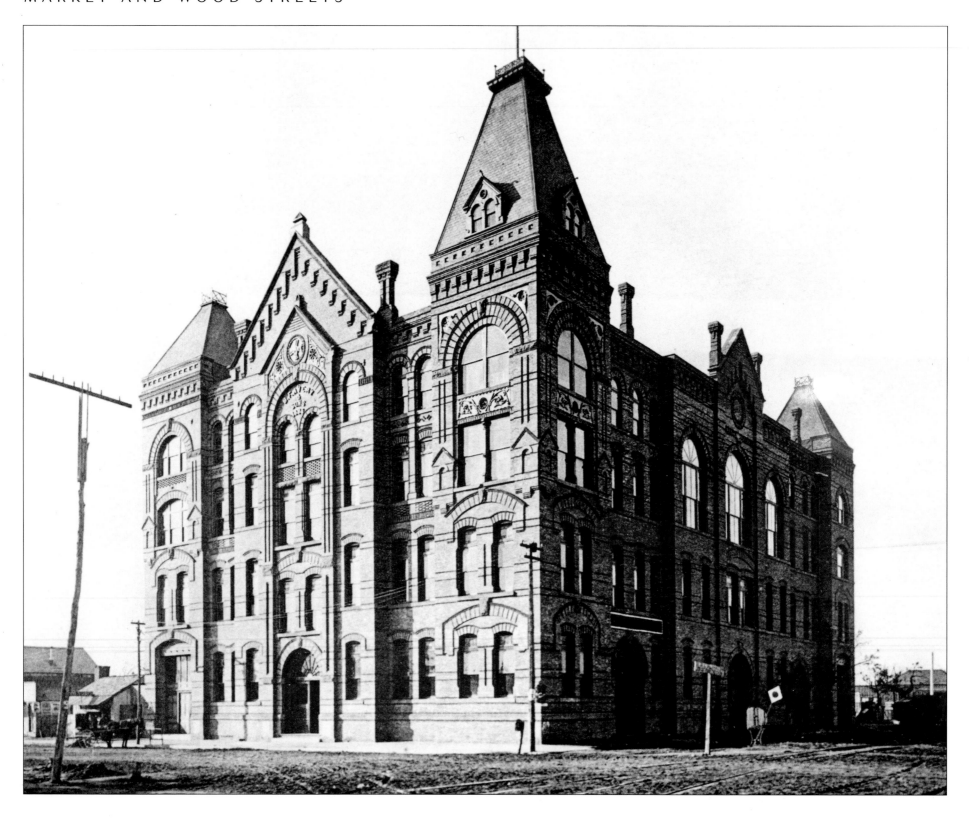

Left: The Farmer's Alliance Building was constructed in 1887 on the corner of Market and Wood. Two years before this photograph was taken in 1895, B. F. Avery and Son, dealers in farm equipment, buggies, wagons, and carriages, purchased it for their offices. Such businesses in their day were equivalent to today's automobile manufacturers.

Right: This spot is now occupied by the ultramodern headquarters of the A. H. Belo Corporation, which describes itself as the oldest continuously operating business in Texas. Pioneered by the *Galveston News* in 1842, the company's flagship publication today is the *Dallas Morning News*. Belo has also diversified to become the third largest independent broadcaster in the country, reaching fifteen percent of the market with more than a dozen television stations.

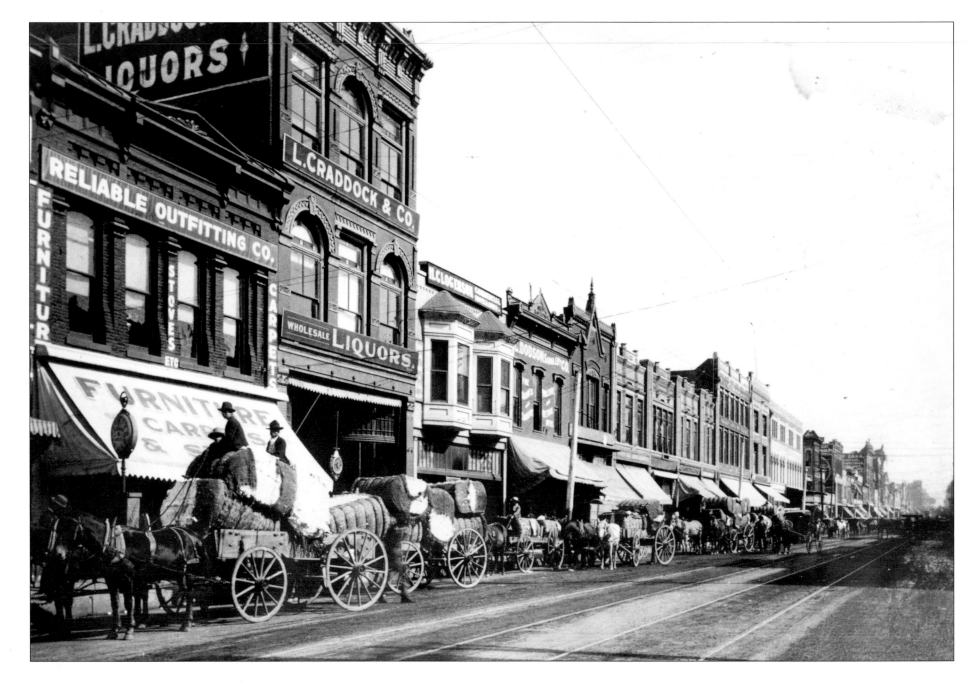

Henry Clogenson, whose photography studio is one door east of the L. Craddock & Company liquor distributors here on Elm Street near Poydras, took this shot in 1900. The line of wagons contain the fall's cotton harvest. In this period, one-sixth of the world's cotton grew within a 150-mile radius of Dallas, and the city was also a leader in the manufacture of cotton gin machinery.

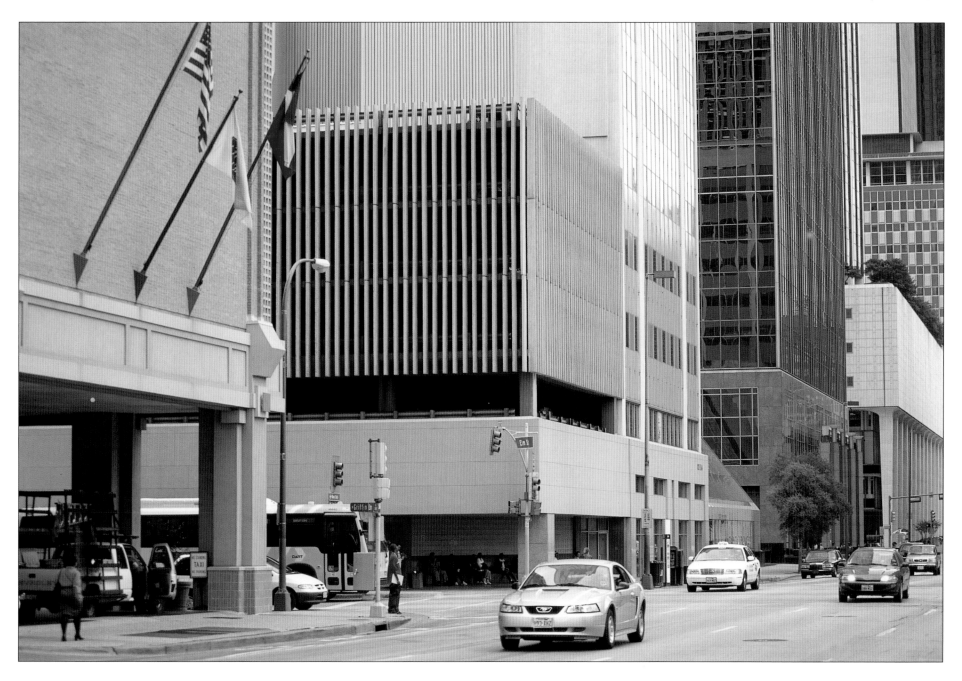

Poydras no longer intersects with Elm at this location, having been replaced by Griffin Street. Looking north up Elm today, we see that the Elm Place and Renaissance Tower buildings have replaced Henry Clogenson's business. Cotton has also been replaced as a major contributor to the local economy, superseded by electronics and other high-tech industries.

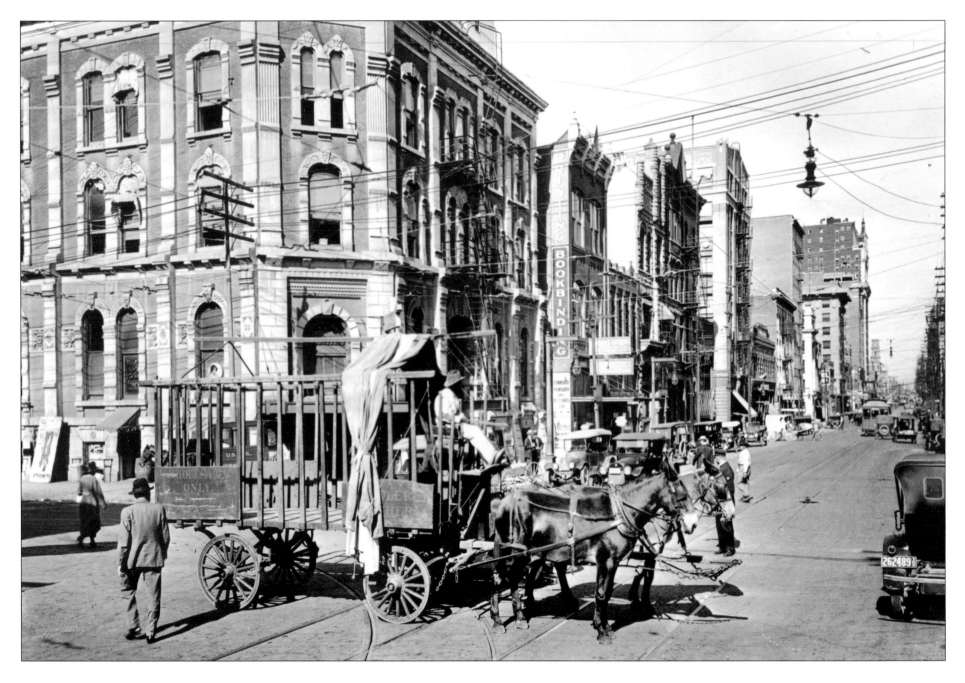

Looking east along Commerce, the officer directing traffic at the Lamar Street intersection appears to have his hands full negotiating the right of way between mule and car. The year is 1920, and city planner George Kessler was in the process of revising his plans to meet the changing needs of an expanding Dallas, which had then reached a population of 158,976.

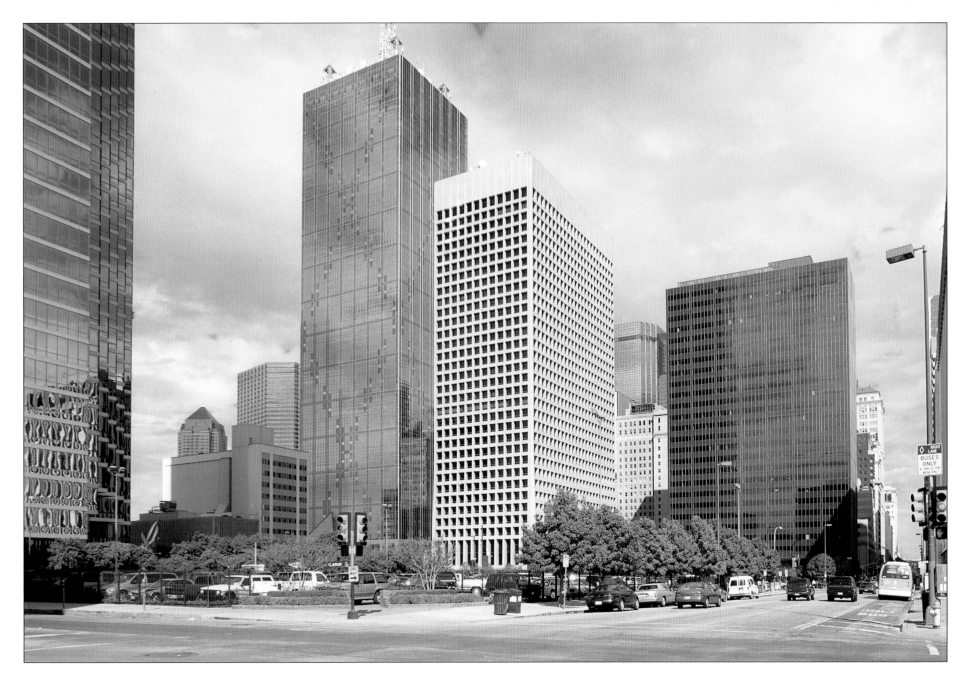

Modern traffic lights mean the officer's continual presence in this intersection is no longer needed. Brick and stone have given away to steel and concrete, allowing buildings to grow to previously impossible heights. From left to right, we see the reflective corner of the Bank of America Plaza, the helix-windowed Renaissance Tower, the white grids of One Main Tower, and the darker visage of One Main Place.

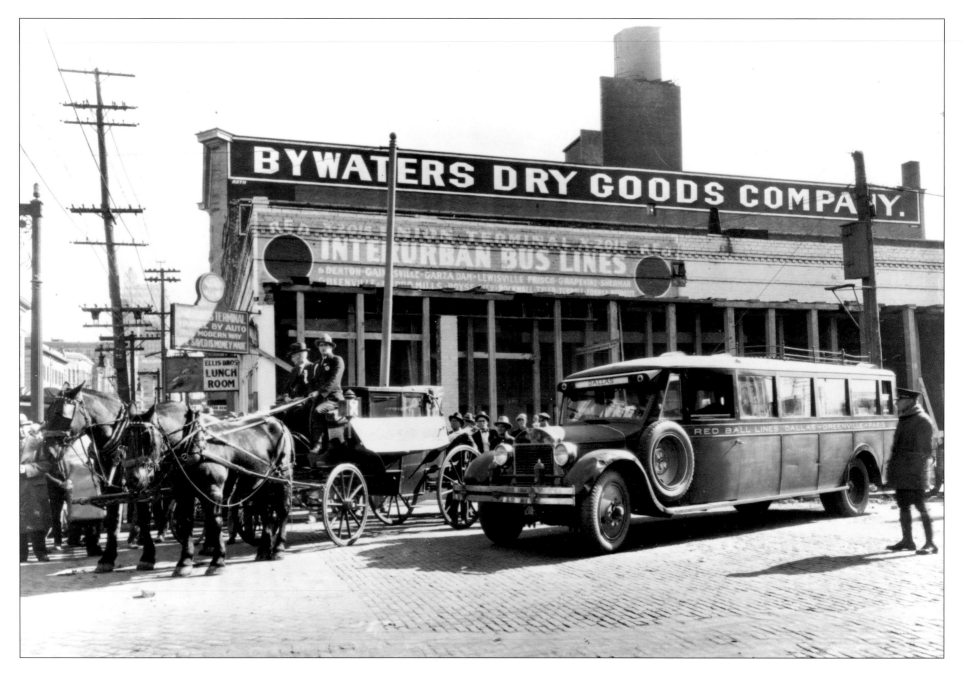

In 1925, Bywaters Dry Goods store spanned from 710 to 714 Commerce Street and also served as the Dallas terminal for Red Ball Bus Lines. Small by today's standards, a bus had just arrived in town from a laborious journey over primitive roads and was in the process of transferring passengers and freight to the time-tested wagon. Rules and regulations for the operation of bus companies in Texas were set by their owners and would not be taken over by the Railroad Commission of Texas until 1928.

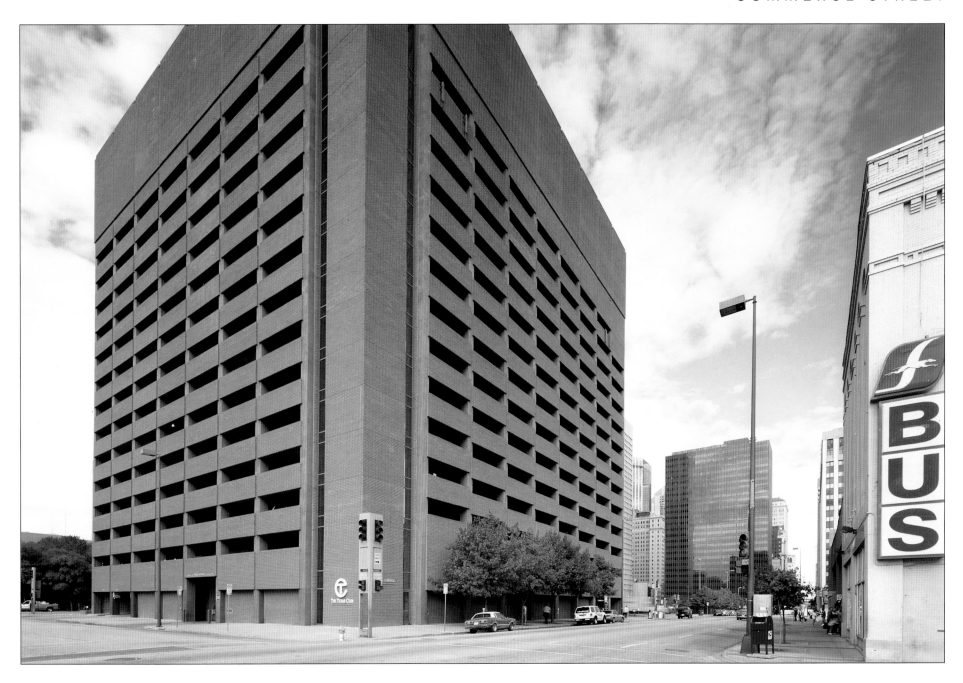

The Greyhound Bus Terminal was previously used as the passenger station for the St. Louis-Southwestern and the Trinity & Brazos Valley railways. The St. Louis Southwestern, or "Cotton Belt," was eventually merged into the Union Pacific, while the Trinity & Brazos Valley, nicknamed the "Boll Weevil," became part of the Burlington Northern. While early settlers got their exercise hunting and farming, today's citizens join health clubs like The Texas Club to work out.

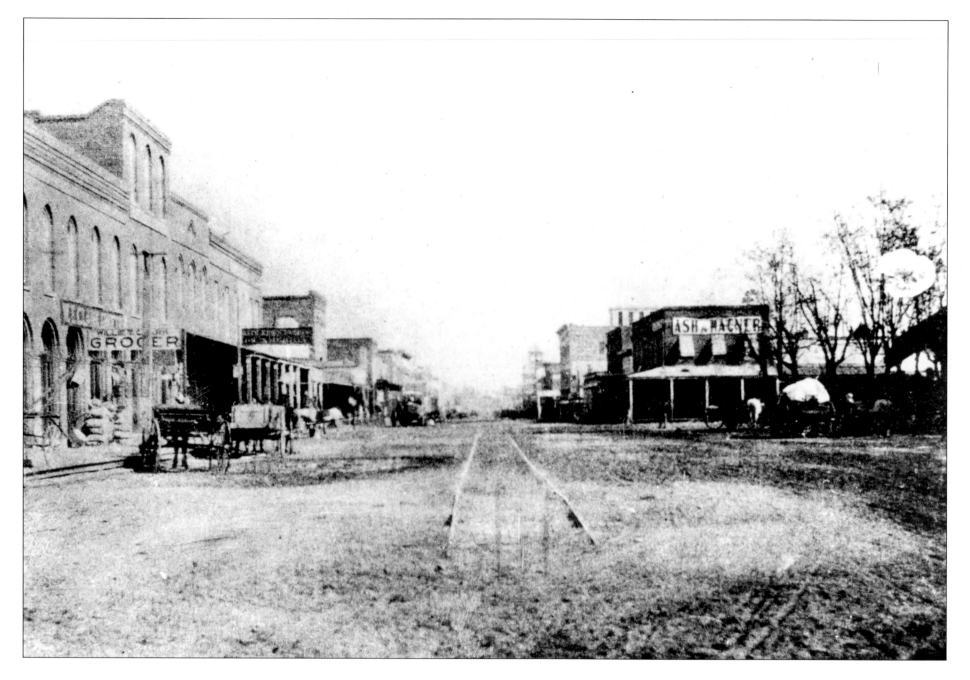

Dallas as a city is thirty-five years old in this view of Main Street at Houston in 1885, and the dirt street is serenely empty compared to today's traffic-clogged artery. Cedar Springs Road had the honor the previous year of being the first street in Dallas county to be macadamized, an early paving process where broken stones are mixed with tar or asphalt and rolled hard in multiple layers.

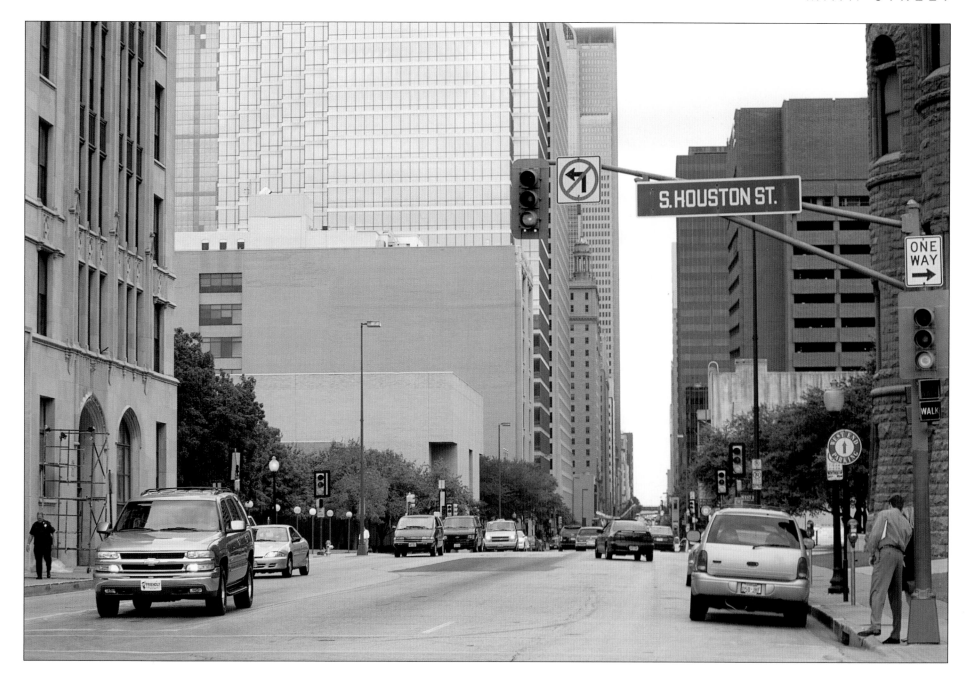

Cement has replaced macadam in the paving of the streets today, providing a smooth and quiet ride for these drivers. The spire of the old Republic Bank Building several blocks away on the left, once proudly reigning over the landscape, now stands dwarfed in a man-made canyon of skyscrapers where direct sunlight rarely shines.

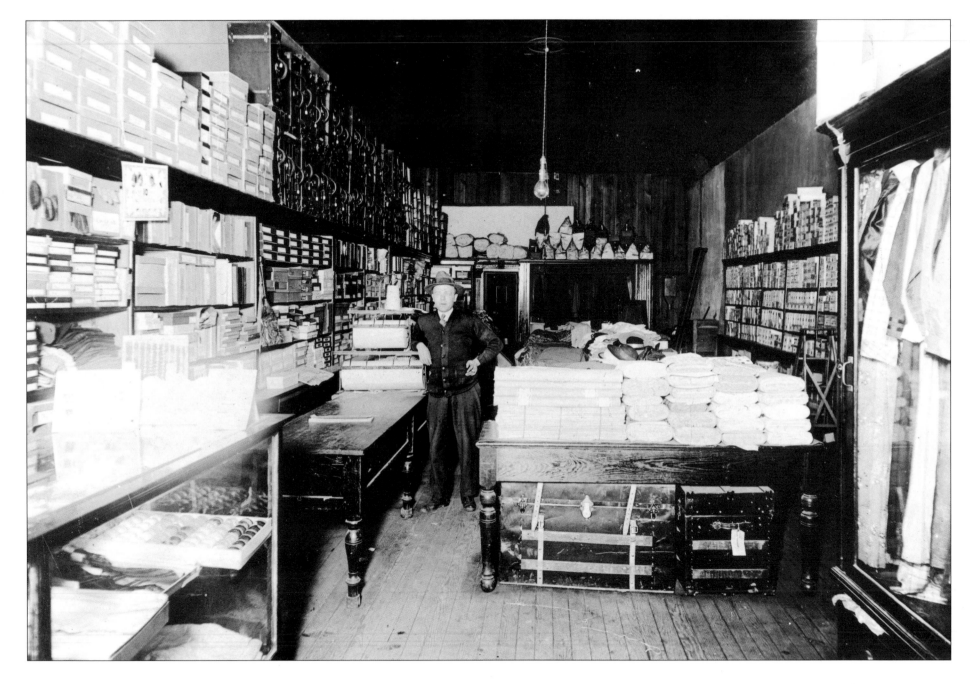

Many of the first structures built in the undeveloped west were trading posts set up to deal with local Native Americans and trappers. Animal pelts were traded for items that could not be obtained from the wilderness, such as coffee, sugar, or nails. Local merchants such as Joseph Rudnitsky, shown here in his dry goods store at 605 Commerce Street in 1913, soon followed to offer more specialized goods.

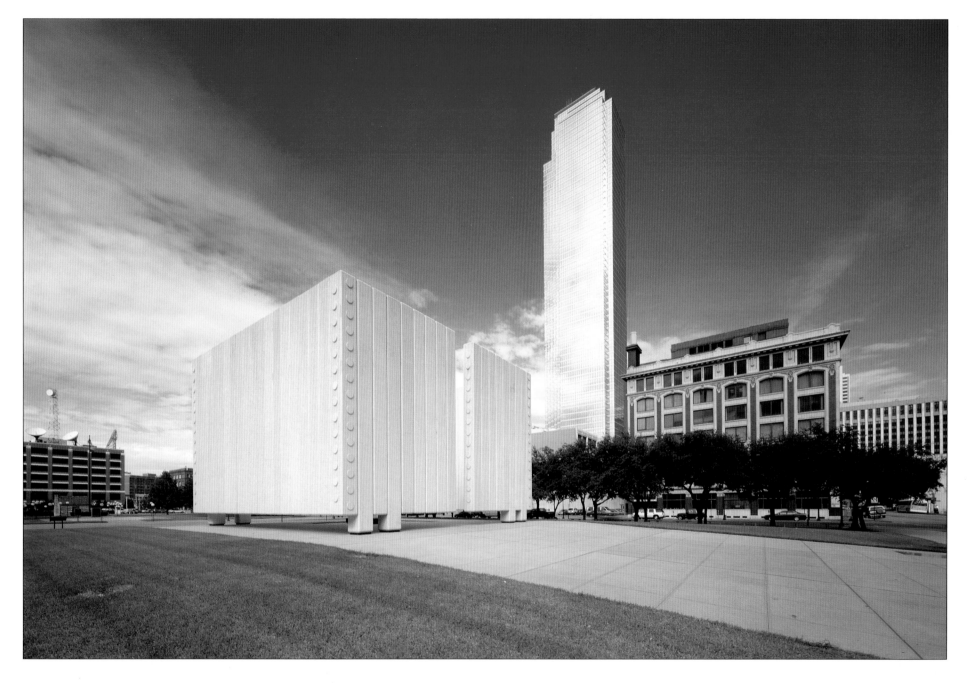

The Kennedy Memorial Plaza, a tribute to the slain President, today occupies the site of Joseph's store. John Neeley Bryan's cabin is visible to the left. Bryan had wanted to establish a trading post of his own to deal with the local Native American tribes, but most of his desired customers had moved on, further west, by the time he established his homestead.

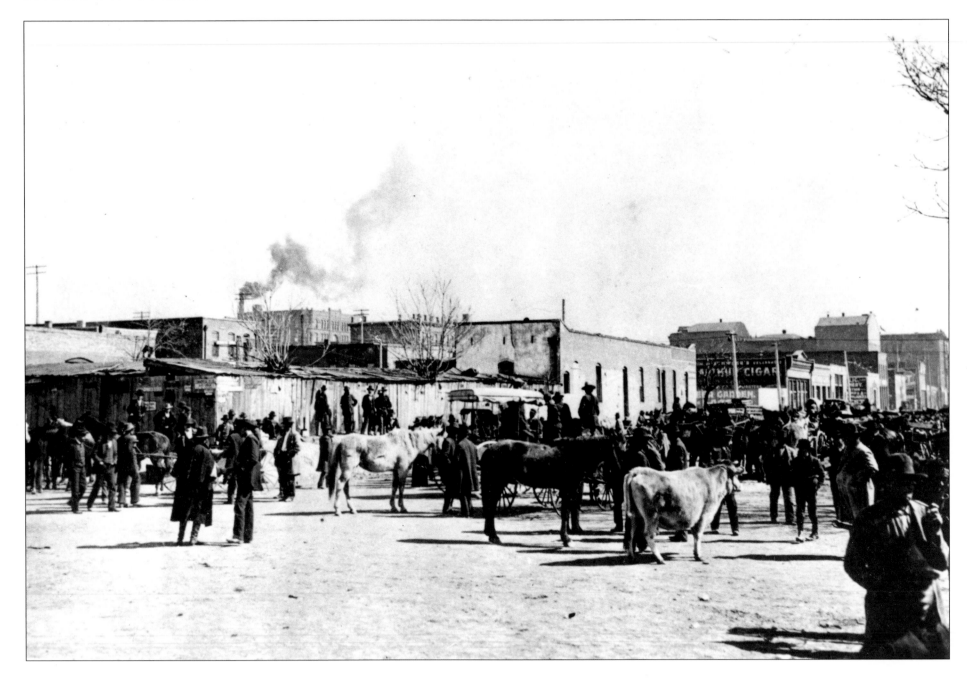

Every Saturday in 1893 witnessed the sale of stray livestock east along Jackson Street from the corner of Houston Street. Much of the territory was still unfenced, and if a stray cow or horse was not readily identifiable by its brand, it ended up here for disposition. Many local banks failed in 1893 due to a nationwide panic, but optimism was high that the Trinity would be navigable after the first steamer from the Gulf arrived.

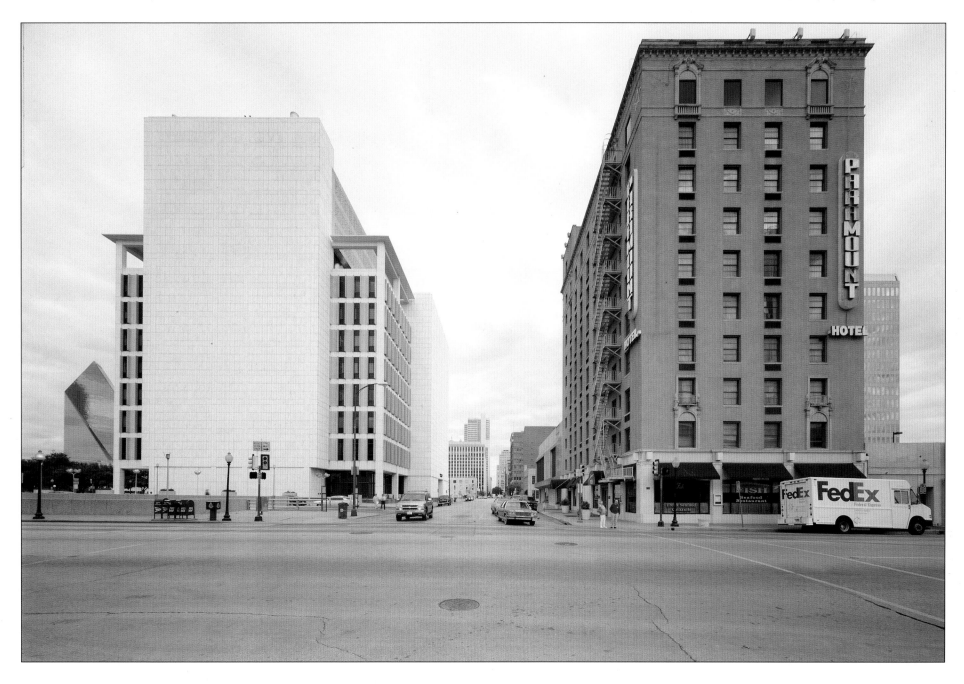

The old Bradford Plaza Hotel has reopened as the Paramount, serving downtown and Union Station to the right of the photographer. Looking east up the now one-way westbound Jackson Street, the clean white edifice of the George L. Allen Sr. Courthouse can be seen on the left. The courthouse primarily houses the civil and family district courts for the over two million citizens of Dallas County.

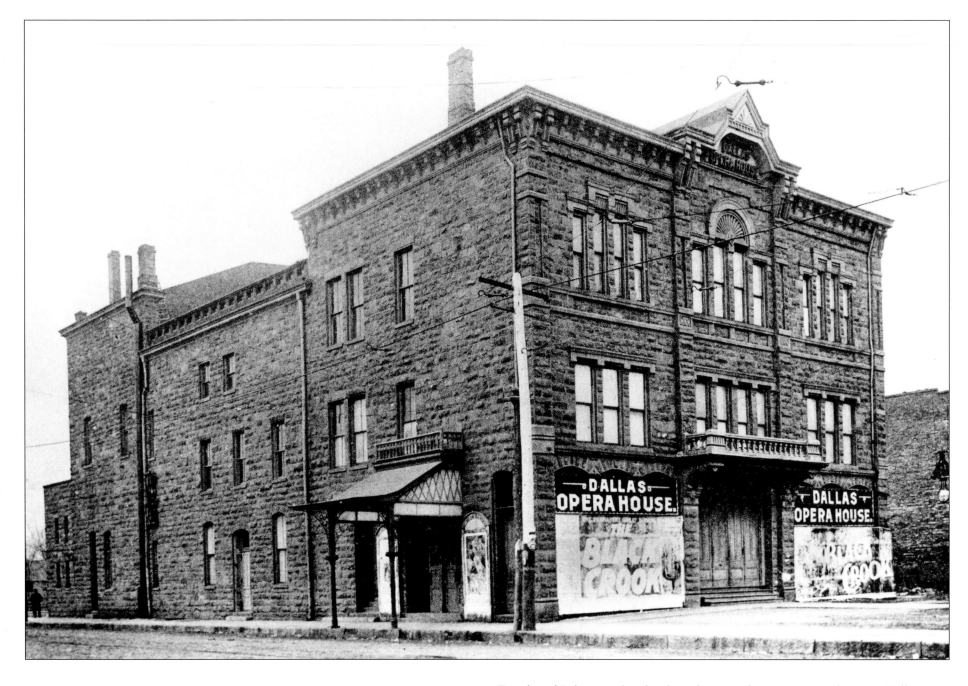

French and Belgian settlers first brought musical instruments and song to Dallas in 1854. Culture took root, and Dallas hosted its first opera in 1875. The first opera house, shown here in 1895, had already been in operation for two years at the southeast corner of Commerce and Austin Streets. It had a seating capacity of 1,200 people, but succumbed to fire in 1901.

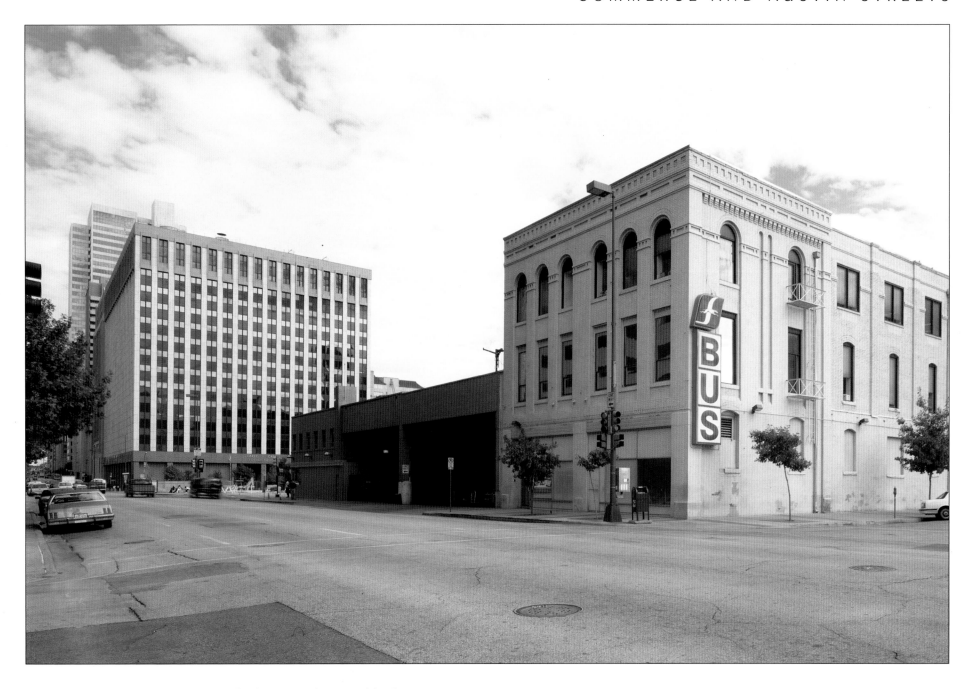

Culture and the opera still thrive in Dallas but at new locations like the Mort Myerson concert hall, rather than at the Greyhound Bus Station, which stands here today. Headquartered in Dallas, Greyhound makes music of its own, orchestrating 21,000 daily departures from all forty-eight continental states on 3,000 buses covered by 5,250 drivers, hauling over nineteen million passengers in 1999.

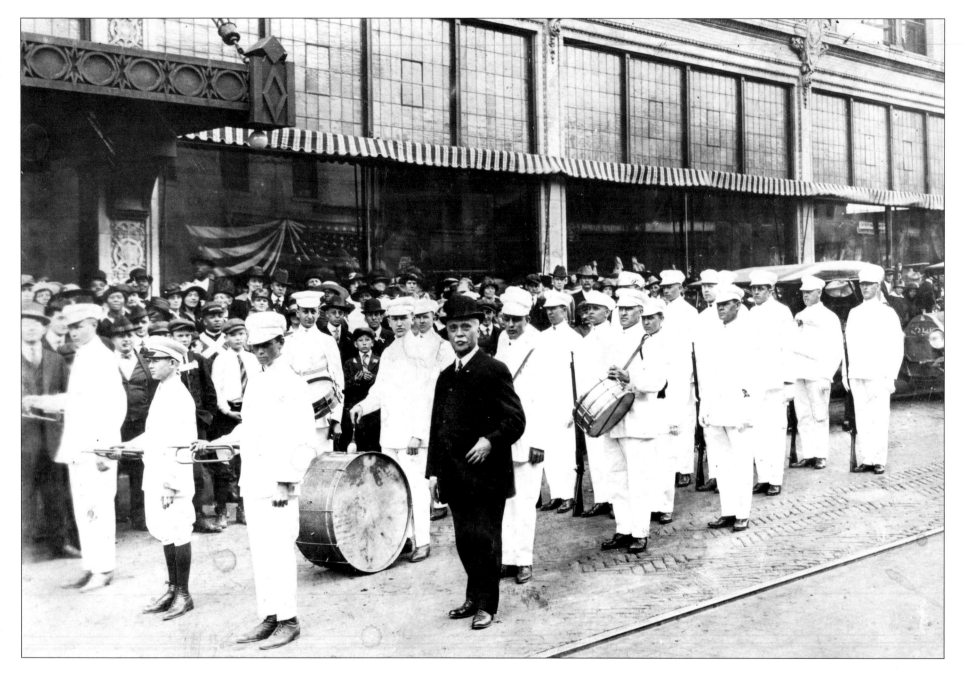

Sam Sanger, neatly dressed in a dark suit, stands outside his family's Dallas department store in 1918 as a band forms behind him. Sanger Brothers was the leading retailer in the Southwest at this time. The lot on Lamar between Main and Elm for this store was purchased for $100,000 dollars in 1907; the selling price is a testimonial to the rapid growth of the city—the original owners paid only $50 for it some forty years earlier.

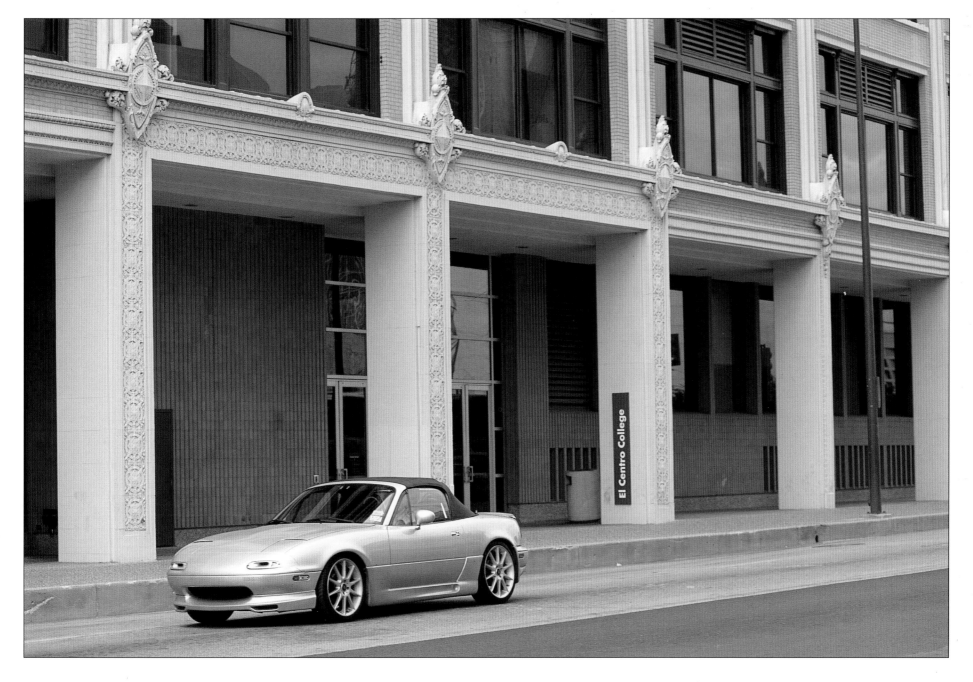

Today Sanger Brothers is just a memory, soon to be followed by another early merchandising giant, Montgomery Ward, which closed its doors in 2001. The El Centro College now occupies the building, still recognizable by its decorative buttresses. The urban community college offers freshman and sophomore classes in the arts and sciences, as well as vocational training courses.

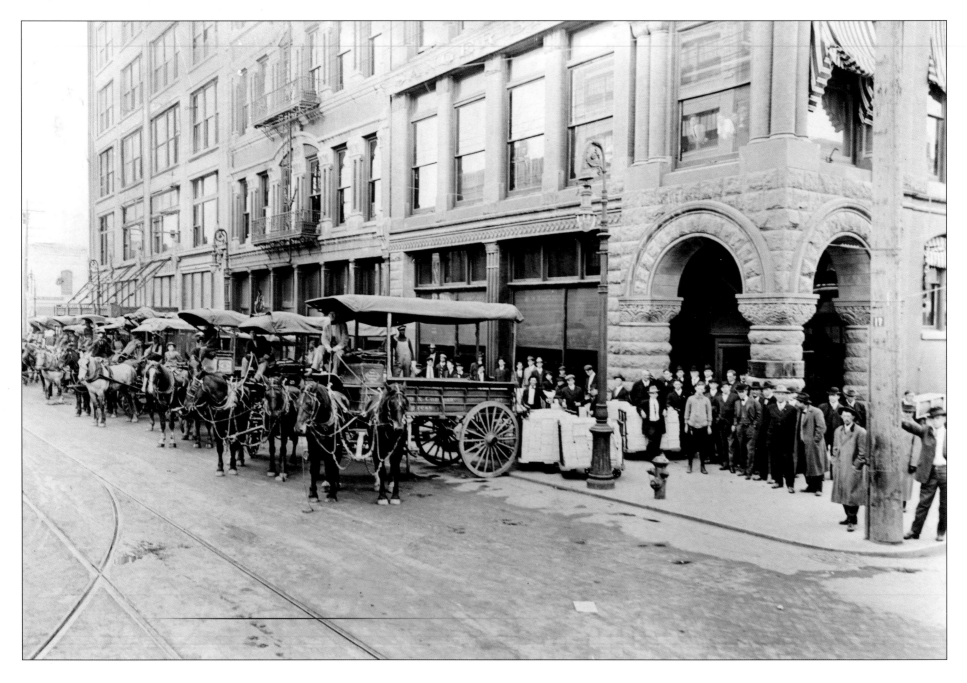

A large shipment of merchandise being delivered in 1915 for the Sanger Brothers Department Store's wholesale department at the corner of Elm and Austin. The wagon drivers held their teams at rest while everyone paused in their labor to give the photographer this moment in their workday. Five Sanger brothers emigrated from Germany and learned the retail trade back in Europe before opening their own store in Dallas in 1872, selling everything from dresses to plows.

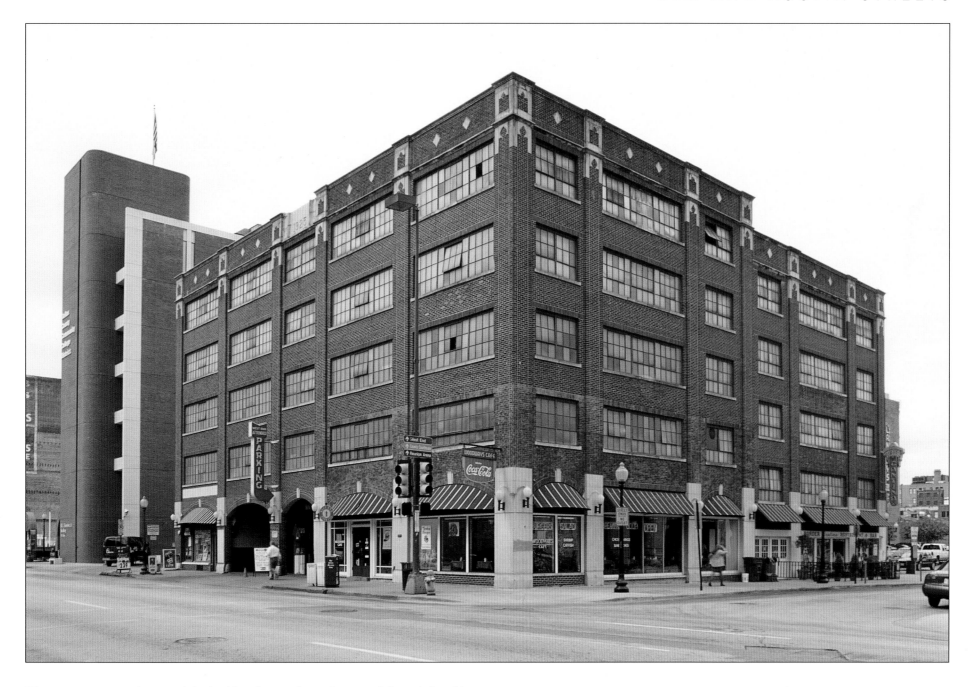

The center stone at the top of the building here today indicates it followed the old
Sanger Brothers building by only a few years and may well contain parts of it. As the
appearance of many buildings in this area suggest, the upper stories (now housing a
parking garage) seem to have been once occupied by a factory or storage facility,
while the ground level has been converted for use by restaurants and shops.

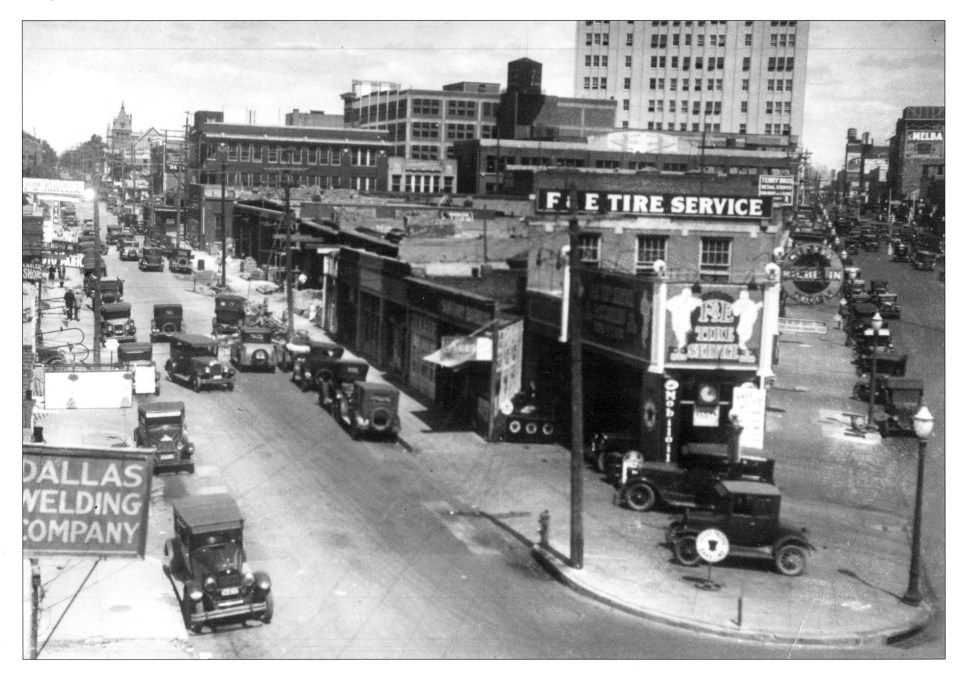

By 1928, the smithing of iron shoes for horses had evolved a parallel industry—rubber tires for the ever-increasing number of automobiles on the streets of Dallas. Looking east, the business of shoeing "steeds" at the tire dealer on the corner of Bryan, on the left, and Pacific, on the right, is as brisk as that of an old blacksmith. A new mode of transport was also at hand this year: Texas Air Transport, a predecessor of American Airlines, began passenger service to San Antonio and Houston.

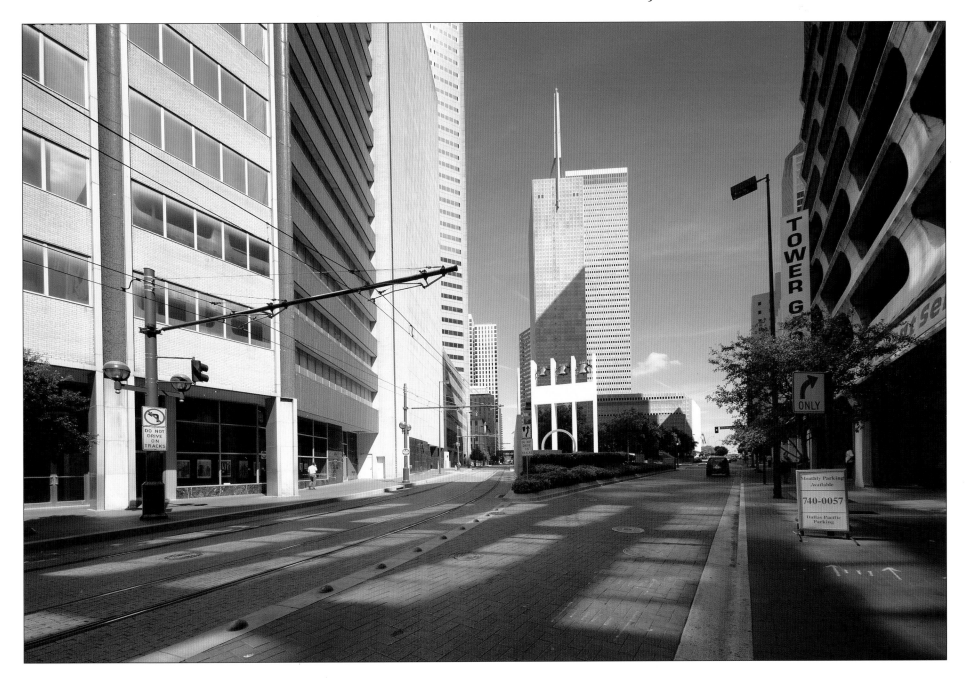

The triangular intersection today hosts Thanks-Giving Square, home of the Center for World Thanksgiving, established in 1981. The Center is devoted to the sharing and promotion of the American and world tradition of Thanksgiving, and to conducting research into the concept of gratitude in all religions and cultures. Shaped in the form of the American Liberty Bell, the three bells out front are inscribed with the meaning of the three truths of gratitude: "God loves us, we love God, we serve God singing."

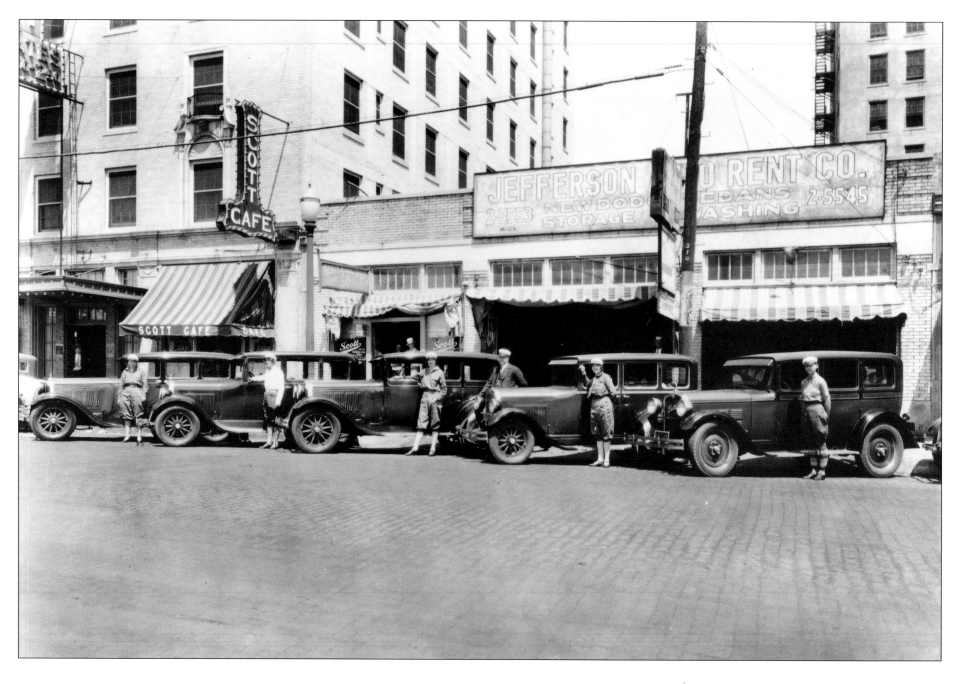

Jefferson Auto Rent offers the latest in chauffeured transportation in 1925 from their location on Houston Street between the Jefferson and Scott Hotels. Even thirteen years earlier, Dallas was recognized as first in the nation for a city of its size with over 3,000 vehicles on the road. Drivers were neatly dressed and stood at attention by their cars, waiting for patrons from the nearby hotels, forerunners to the modern taxi.

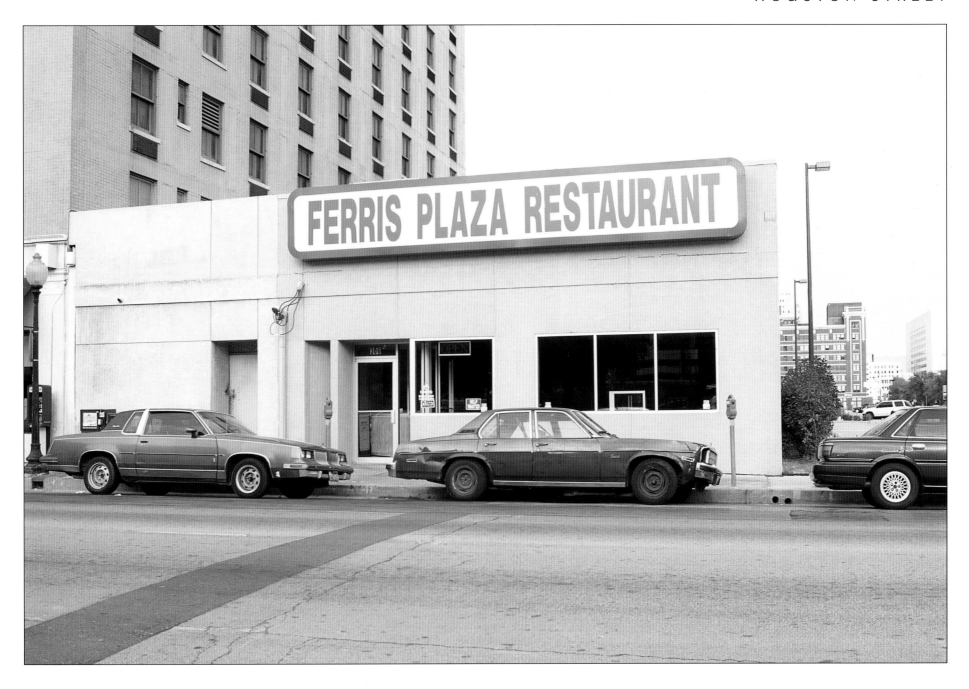

Today at this location is a restaurant named after a landscaped square named after Royal A. Ferris, President of the American Exchange National Bank in the early 1900s, who moved to Dallas in 1884 from Waxahachie. Ferris was active in many of the early political and social organizations that shaped the future of Dallas, for example, heading up the financial relief committee after the 1908 flood.

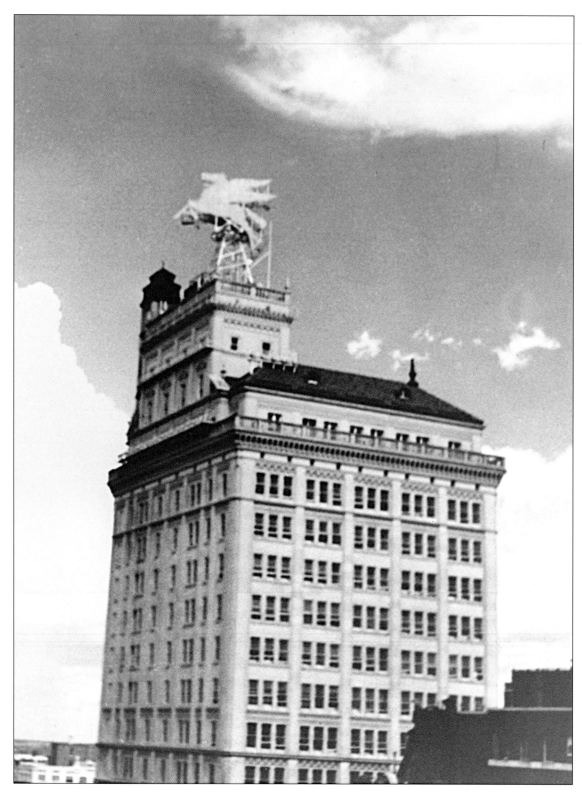

When it topped out at twenty-nine stories in 1921, the Magnolia Petroleum Building became the tallest building in the city. As part of the American Petroleum Institute's Dallas convention, a forty by thirty-two foot, thirteen-ton rendition of the mythological winged horse, Pegasus, the adopted symbol of the Mobil Oil Company, was added in 1934. Rotating slowly on its perch 450-feet above street level, it gained instant worldwide attention.

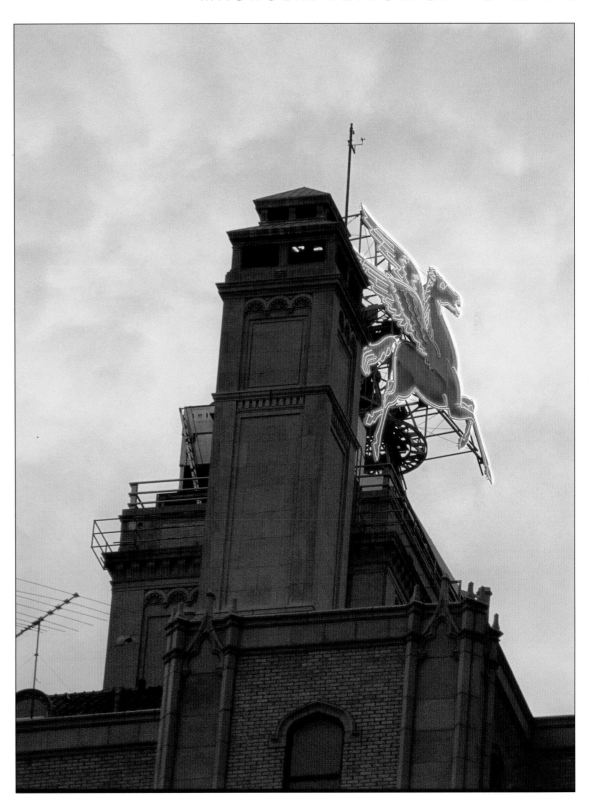

Originally lighted by over 1,000 feet of neon tubing, the bright red image of Pegasus eventually went dark as the building below it became empty and was dwarfed by a cadre of new and taller buildings. Dallas did not forget the horse however, and as the clock struck midnight on New Years Eve 1999, Pegasus once again lit up the night sky. The Magnolia Building below is now a luxury hotel by the same name.

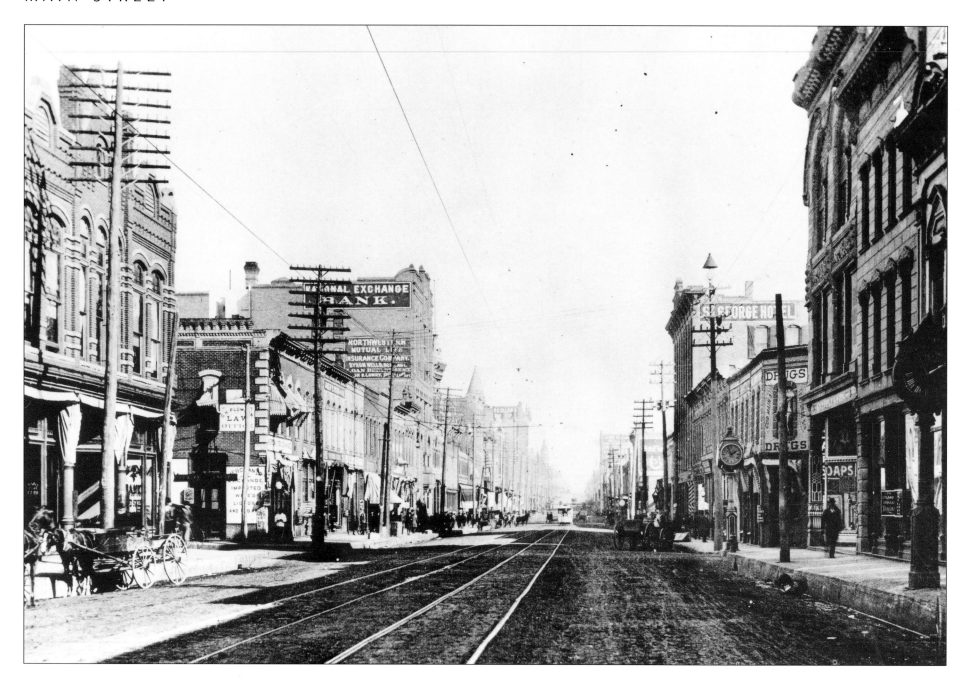

The National Exchange Bank on the left dominates this Main Street scene in 1895, looking east toward Field Street. The Democratic State Convention in Dallas the year before backed "Cleveland and sound money," a wise choice in light of numerous bank failures at this time.

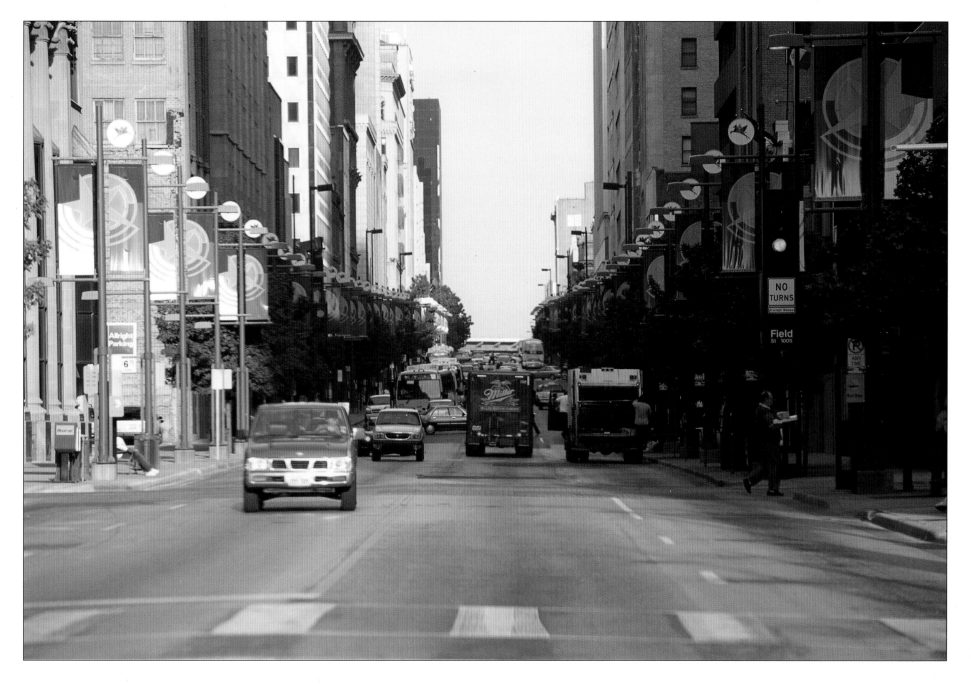

Back in 1895, crossing the street was a simple proposition with no crosswalks or lights to obey, and only a few slow-moving wagons and streetcars to look out for. Looking east down Main today is like watching a sea of traffic with the elevated Julius Schepps Expressway on the horizon.

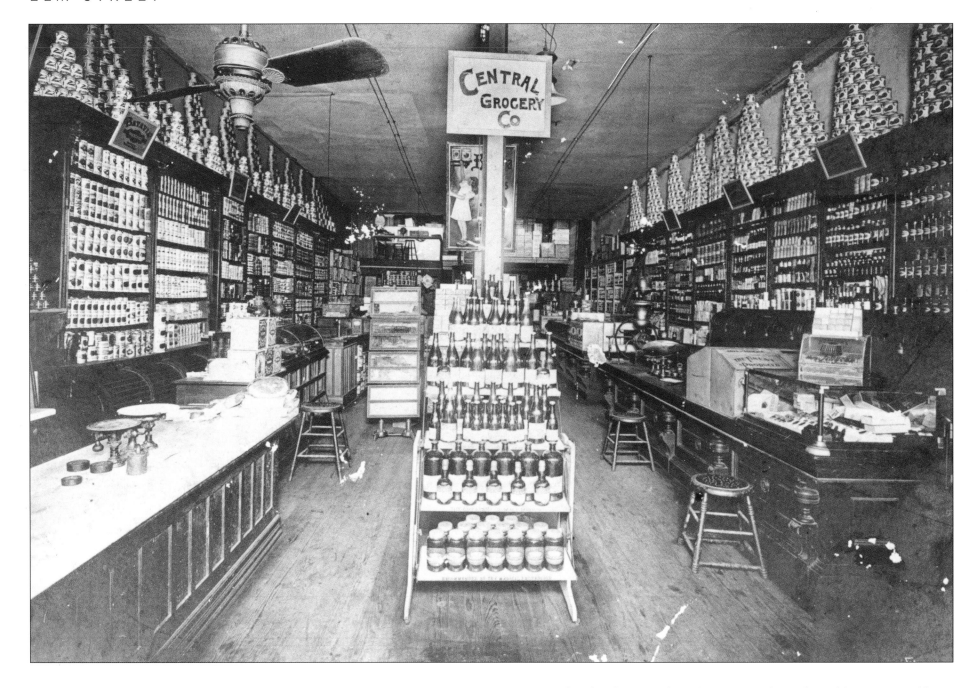

By 1905, rather than having to hunt for every meal, people could go to a store like the Central Grocery Company at 1512 Elm Street. Owned and operated by George L. Franklin and Henry Schmucker, the store stocked many canned and bottled goods under slow moving fans and electric lights. Modern methods of preservation were still years away, and fresh items were limited to what could be kept on ice.

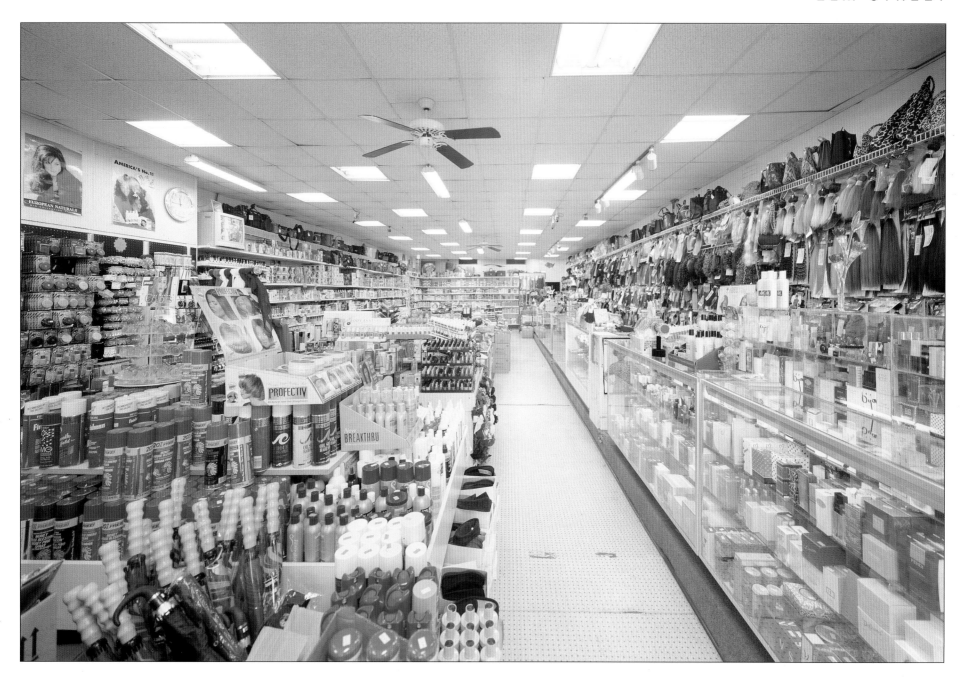

A retail store still exists here, and lights and ceiling fans still look down from above but little else is the same. Many small businesses have migrated to the suburbs following the residential population's move away from downtown. The Main Beauty Supply has not followed that trend and survives in the concrete canyons today by selling beauty products instead of food staples.

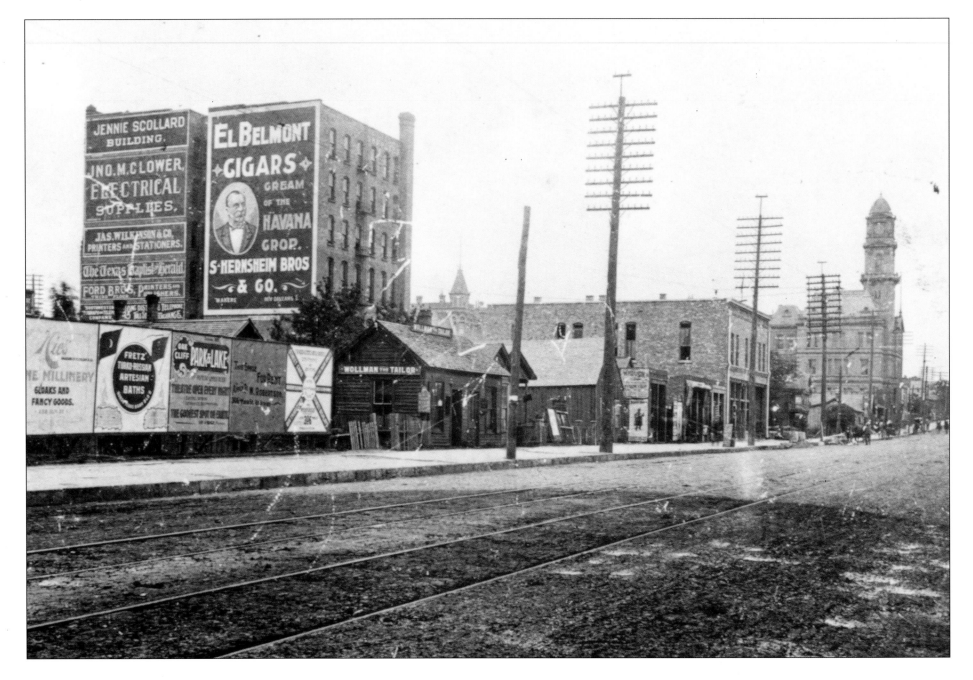

The clock tower of the old Post Office is the most prominent feature in this 1896 view looking east along Commerce Street from the intersection of Browder Street. Period advertisements take up every inch of space on the sides of the Jennie Scollard Building, hawking everything from cigars to ladies' dresses. A year from the date of this photograph citizens will be looking at a new kind of image: the first motion picture show will be shown in Dallas.

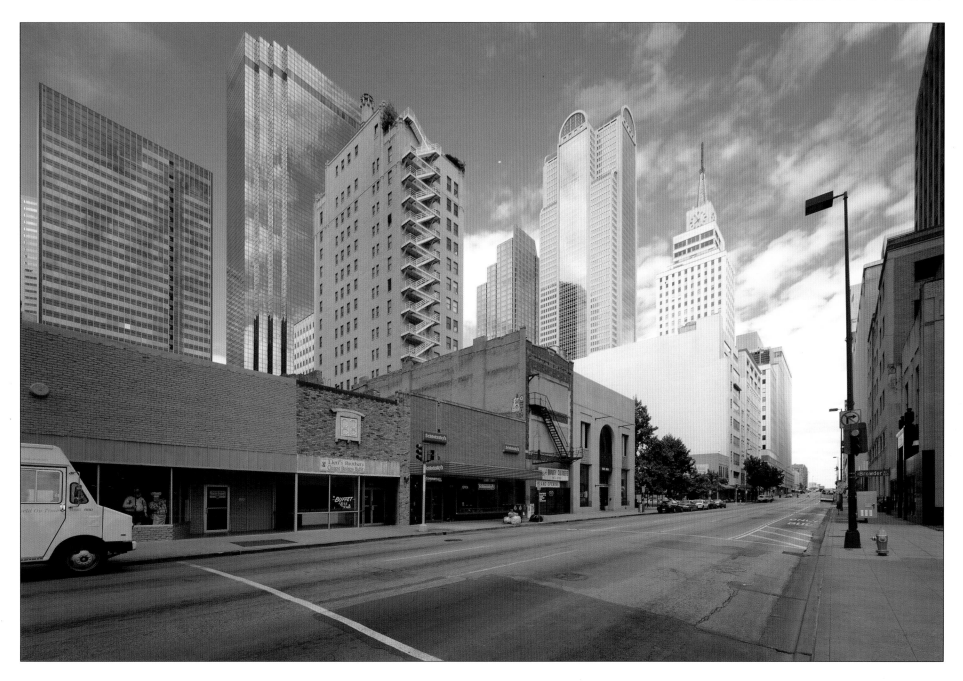

A pedestrian looking up to lofty heights of the new skyline would strain their neck today. From left to right are 1600 Pacific, the reflective Thanksgiving Tower, 1530 Main with its old-fashioned outside fire escape, First City Center, the Bank One Center with its round top, and the Mbank Building with the clock and spire.

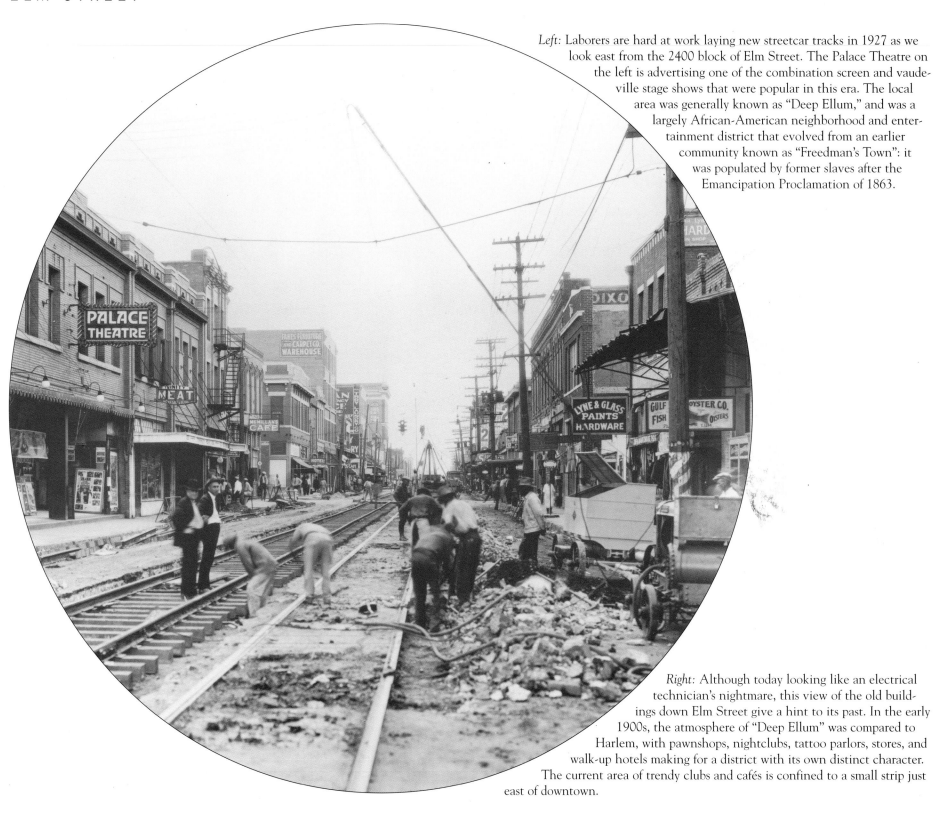

Left: Laborers are hard at work laying new streetcar tracks in 1927 as we look east from the 2400 block of Elm Street. The Palace Theatre on the left is advertising one of the combination screen and vaudeville stage shows that were popular in this era. The local area was generally known as "Deep Ellum," and was a largely African-American neighborhood and entertainment district that evolved from an earlier community known as "Freedman's Town": it was populated by former slaves after the Emancipation Proclamation of 1863.

Right: Although today looking like an electrical technician's nightmare, this view of the old buildings down Elm Street give a hint to its past. In the early 1900s, the atmosphere of "Deep Ellum" was compared to Harlem, with pawnshops, nightclubs, tattoo parlors, stores, and walk-up hotels making for a district with its own distinct character. The current area of trendy clubs and cafés is confined to a small strip just east of downtown.

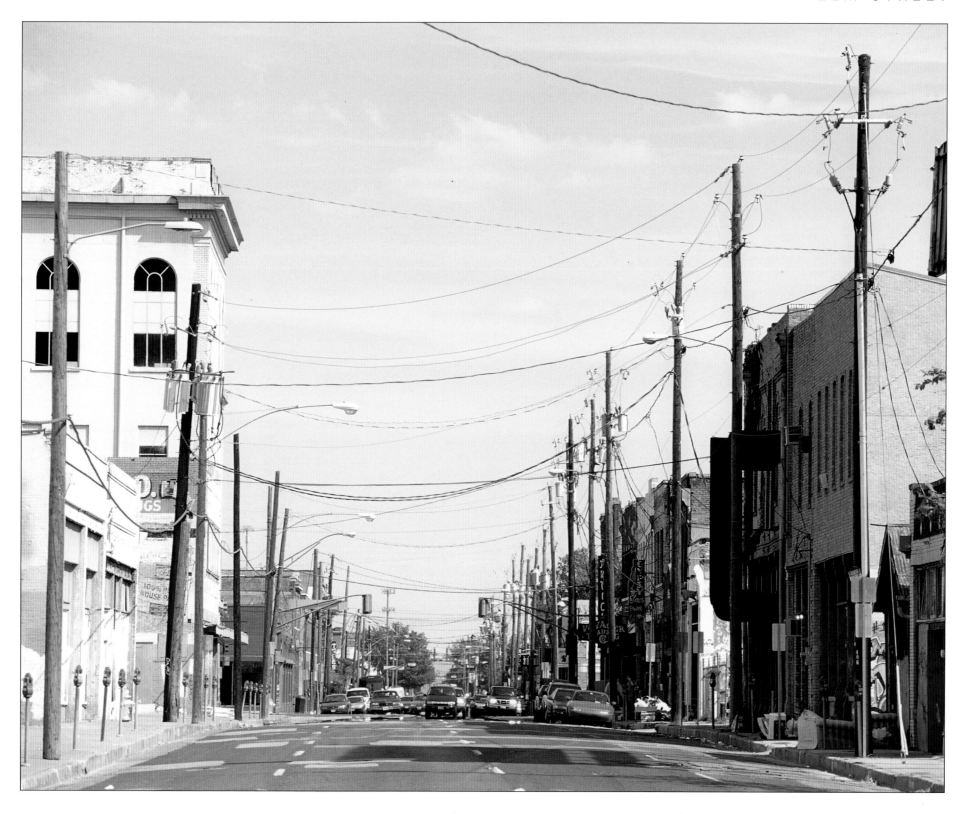

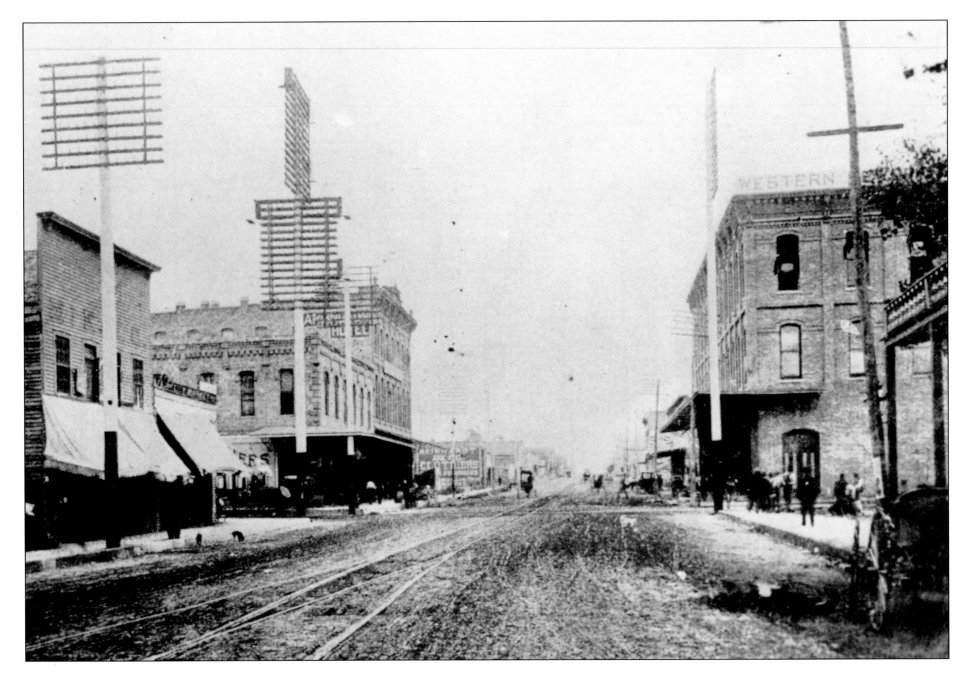

Main Street in 1887, looking east from the intersection with Akard. The three-story structure on the right is the Western Newspaper Union Building, while the Arlington Hotel stands on the left. As the streets intersect below, note the crossing of a myriad electric lines above on the left. Electric light came to Dallas in 1882, and the first customers were local saloon owners, who hoped to draw more patrons with their bright lights.

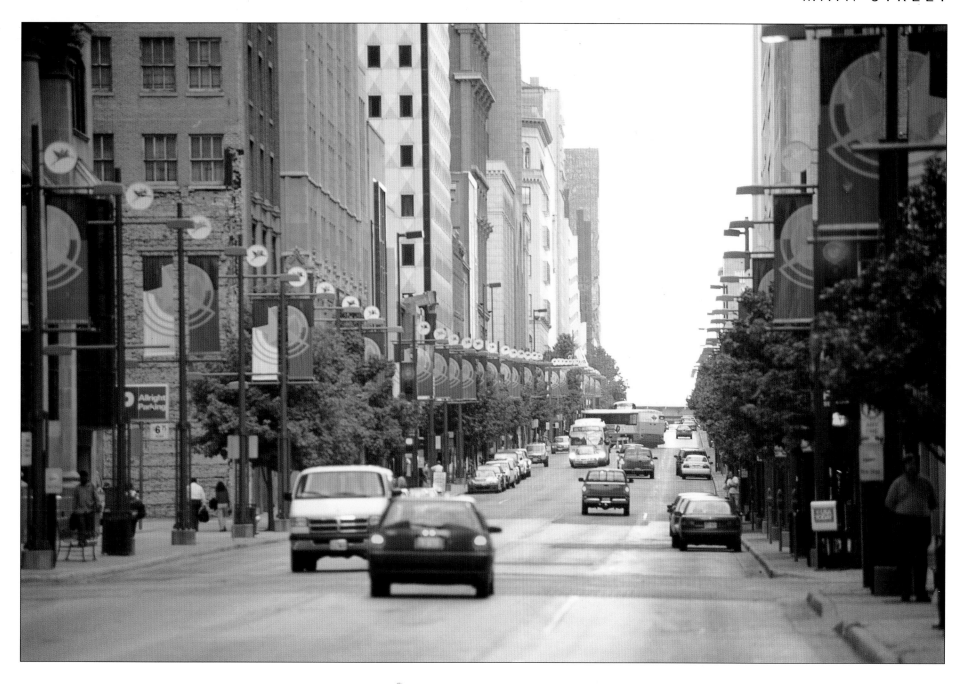

Main is one of Dallas's oldest streets, having been named by John Neely Bryan in 1844 in the original plot of the settlement. Today, however, it bears little resemblance to its historical counterpart. It has become an American tradition in towns and cities to give the name "Main" to the one street that most symbolizes the best that municipality has to offer in economic development.

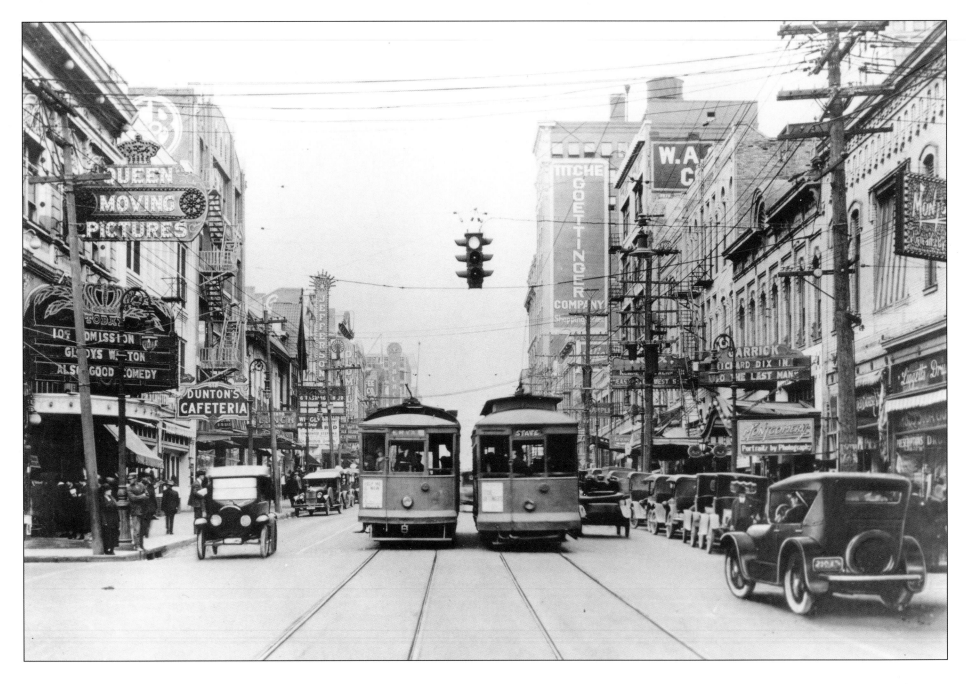

One block north and thirty-eight years after the previous shot, this photograph, taken on Akard, looks east up Elm Street in 1925 at a considerably busier scene. A new traffic light hangs over the intersection, holding up a streetcar and motorcar. A vast array of services are now available: a person can pick up a prescription at the pharmacy on the right, cross the street for a meal at the cafeteria, and then take in a show for a dime at Queen Moving Pictures.

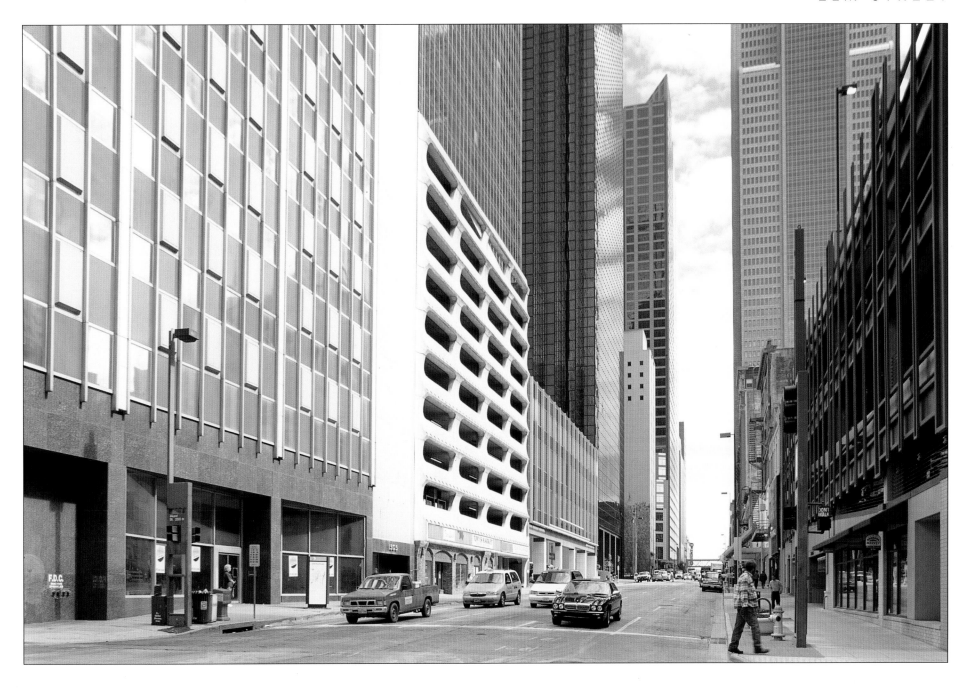

In this contemporary view, the streetcar tracks are gone, and Elm has become a one-way street. One can no longer find the great selection of shops and services as most of the small businesses having been replaced by office buildings. Down the street on the left are the Nations Bank Elm Place, Thanksgiving Tower, and First City Center, while on the right, hundreds of windows mark the Bank One Tower as it rises out of sight.

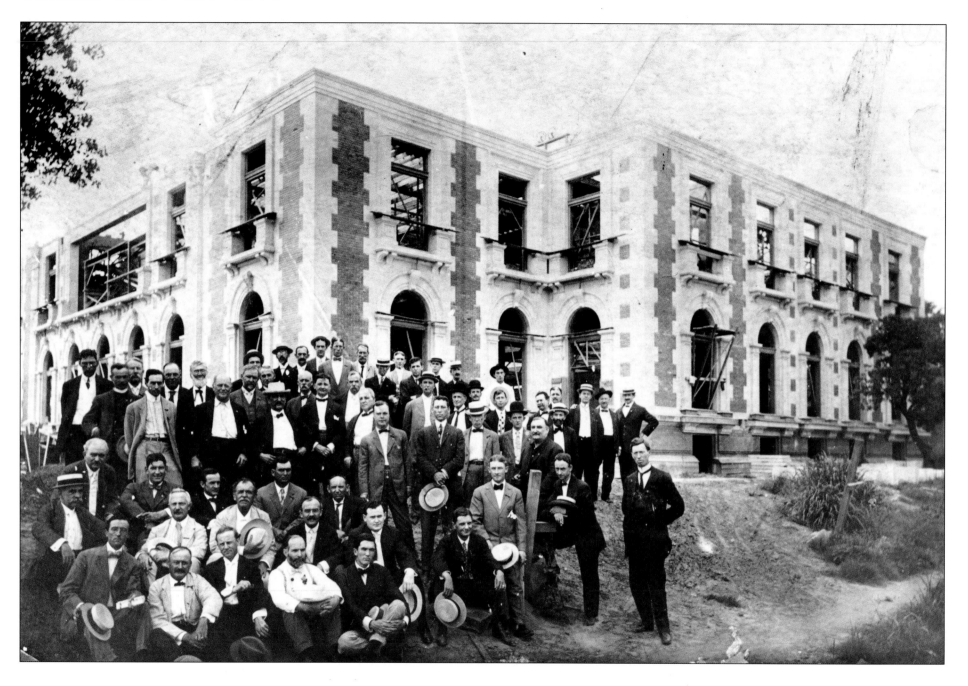

The Dallas Scottish Rite was first organized in 1898, and in a few years achieved a membership of over 6,000. A permanent meeting place was needed, and construction began on the Scottish Rite Temple in 1907. The chosen location is shown here behind this group at the corner of Harwood and Young Streets. Across the street from the Masonic Temple, the edifice was designed in the neoclassic Greek revival style, as were other period Dallas buildings, and was completed in 1913 at a cost of $300,000.

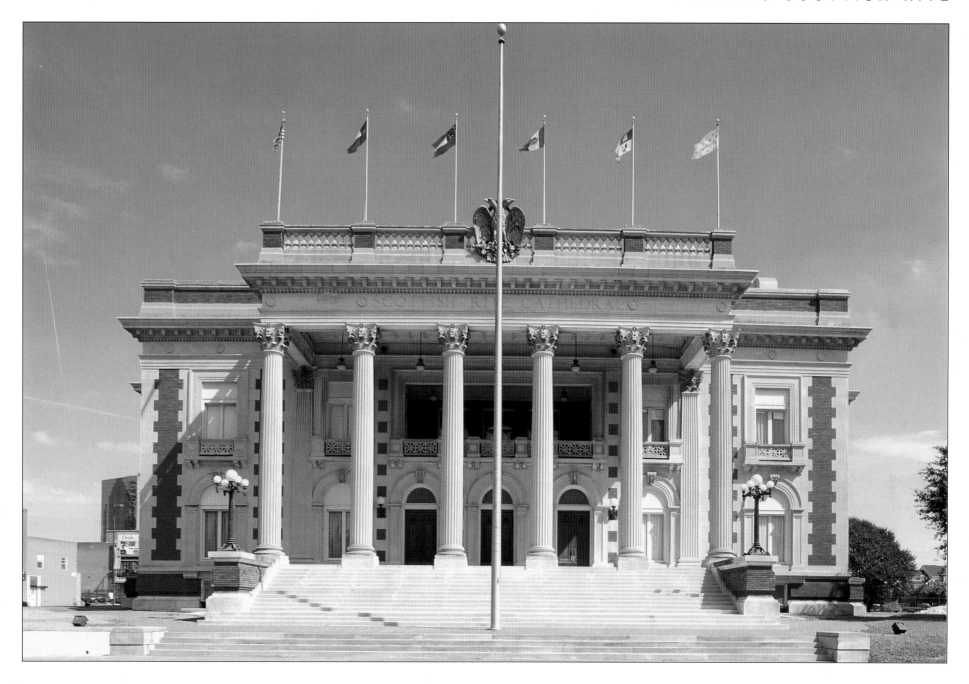

Today the Texas Historical Commission has designated the Dallas Scottish Rite Temple as an official historical landmark. The Scottish Rite is a fraternal organization of Freemasons who are members of a recognized Grand Lodge. With the membership now up to 11,000, the Valley of Dallas in the Orient of Texas is the largest of 221 Valleys of the Supreme Council, Southern Jurisdiction, United States, Mother Council of the World.

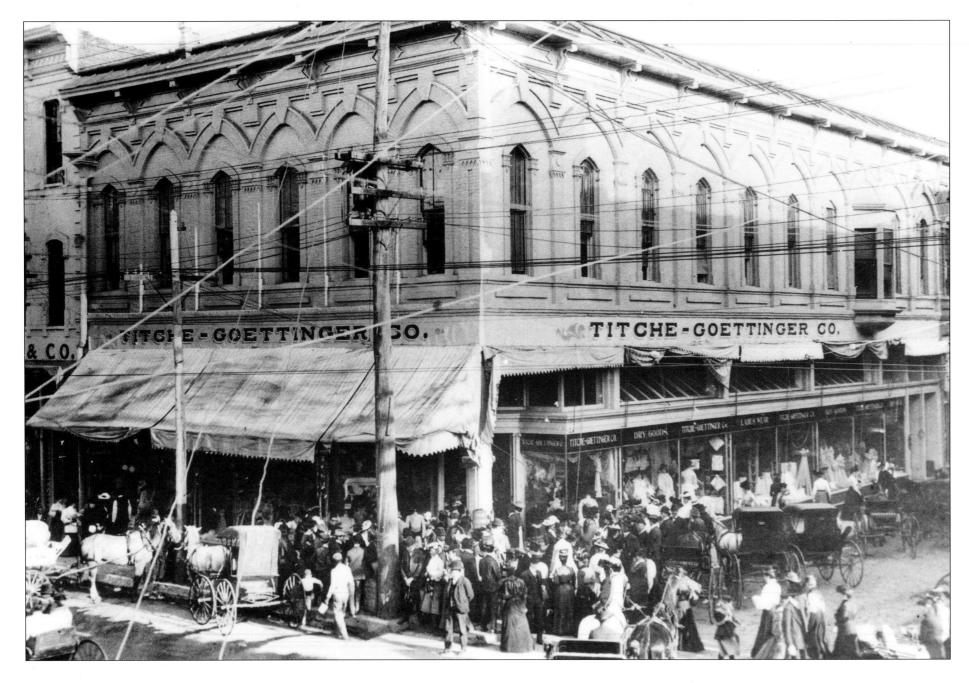

Edward Titche worked in his parents' store in Louisiana as a boy, and after further retail experience, moved to Dallas in 1894 to put his own name on a store left by his deceased uncle. He later formed a partnership with Max Goettinger, which led to the establishment of the new Titche-Goettinger Company department store at the corner of Elm and Murphy. The large crowd gathered in this photo was present to sample the latest in consumer goods and celebrate the opening day on March 4, 1902.

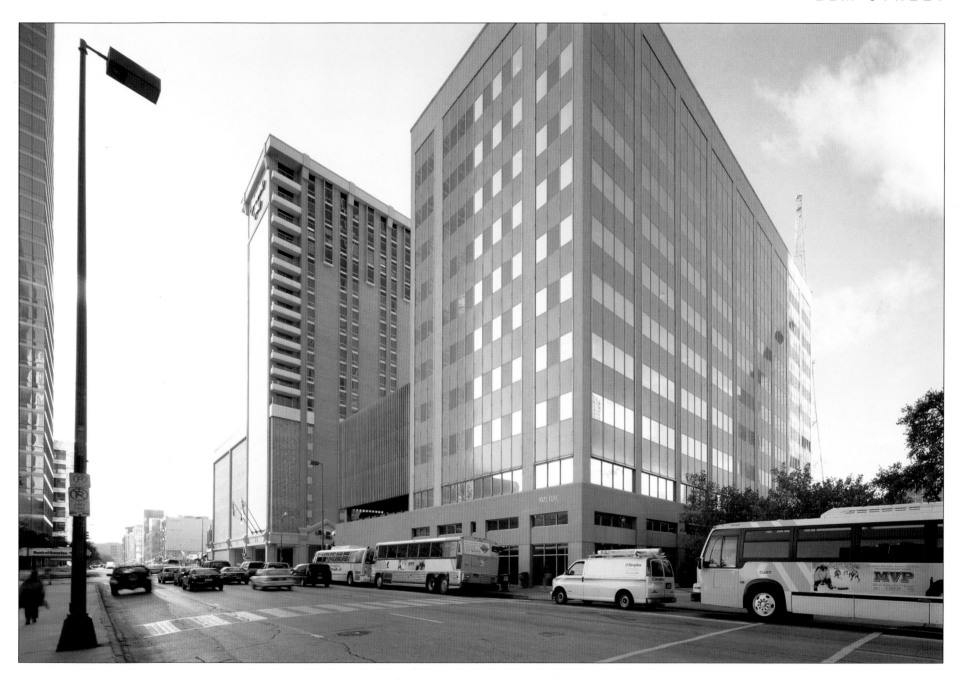

Murphy no longer intersects with Elm, its old path blocked by new high-rise office buildings. The Titche-Goettinger store at this location lasted only two years before moving to the new Wilson Building on Elm and then again to larger quarters on St. Paul in 1929. The name was shortened to Titche's before the chain was eventually purchased and became Joske's, and finally became part of the Dillard's chain in 1987.

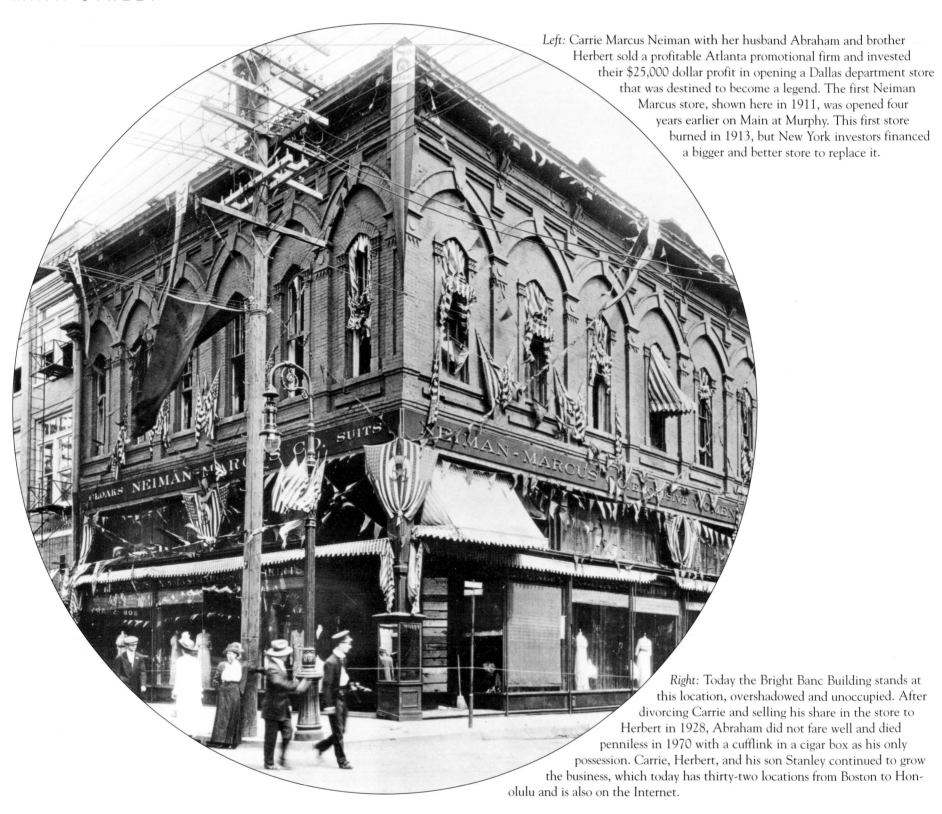

Left: Carrie Marcus Neiman with her husband Abraham and brother Herbert sold a profitable Atlanta promotional firm and invested their $25,000 dollar profit in opening a Dallas department store that was destined to become a legend. The first Neiman Marcus store, shown here in 1911, was opened four years earlier on Main at Murphy. This first store burned in 1913, but New York investors financed a bigger and better store to replace it.

Right: Today the Bright Banc Building stands at this location, overshadowed and unoccupied. After divorcing Carrie and selling his share in the store to Herbert in 1928, Abraham did not fare well and died penniless in 1970 with a cufflink in a cigar box as his only possession. Carrie, Herbert, and his son Stanley continued to grow the business, which today has thirty-two locations from Boston to Honolulu and is also on the Internet.

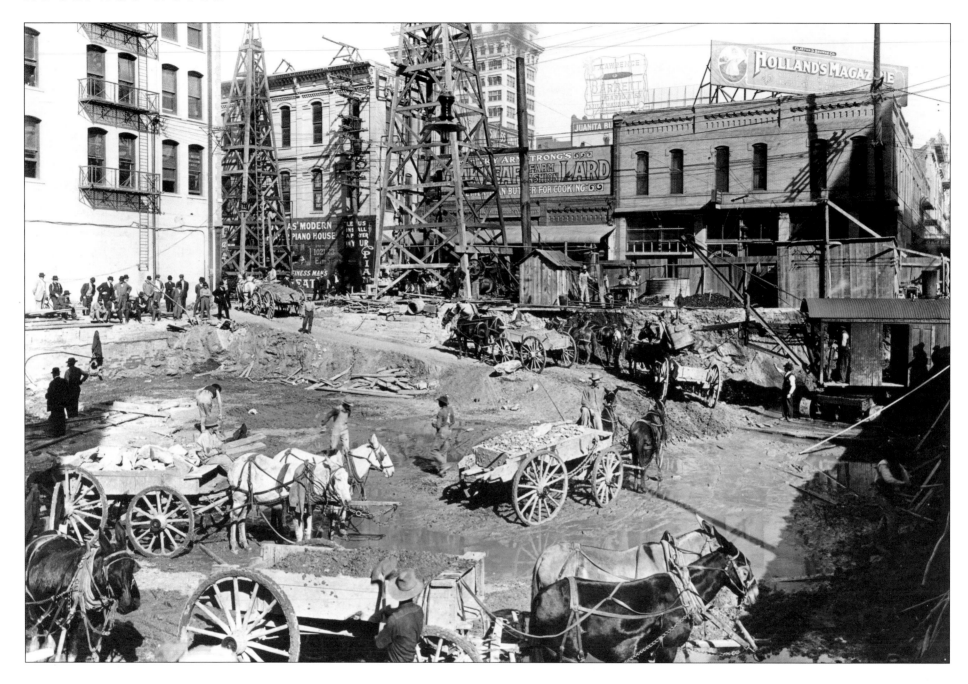

These laborers were hard at work in 1912 at the corner of Commerce and Akard, building the foundation of the twenty-one story Adolphus Hotel. Two million dollars were spent to make the Adolphus the most luxurious hotel in the Southwest when it opened the same year—a princely sum at the time. The derricks along the street in the background are evidence that drilling for oil for profit or for water for survival were a large part of the local economy.

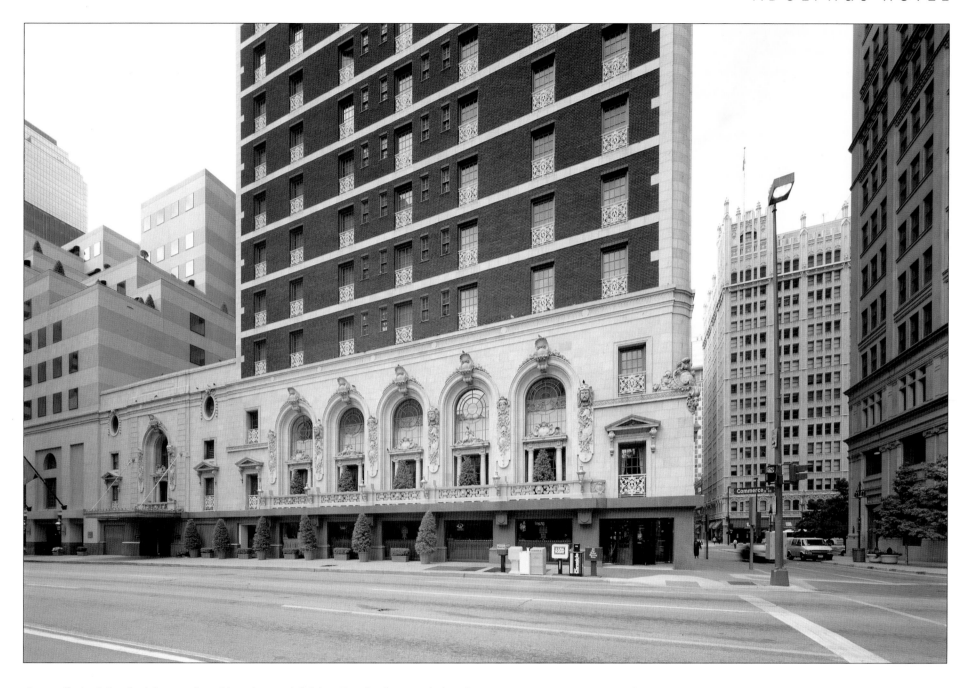

Originally built by the Missouri-based beer baron Adolphus Busch, the upscale hotel boasted over 825 rooms, 275 of which were air-conditioned. Customers paid two dollars a day and up. Reopened in 1981 with the rooms remodeled to make 439 larger ones, the Adolphus still wins awards for its opulent accommodations, restaurants, and service. The Texas landmark was described in 1912 as being the "most beautiful building west of Venice" and its magnificence is still evident today.

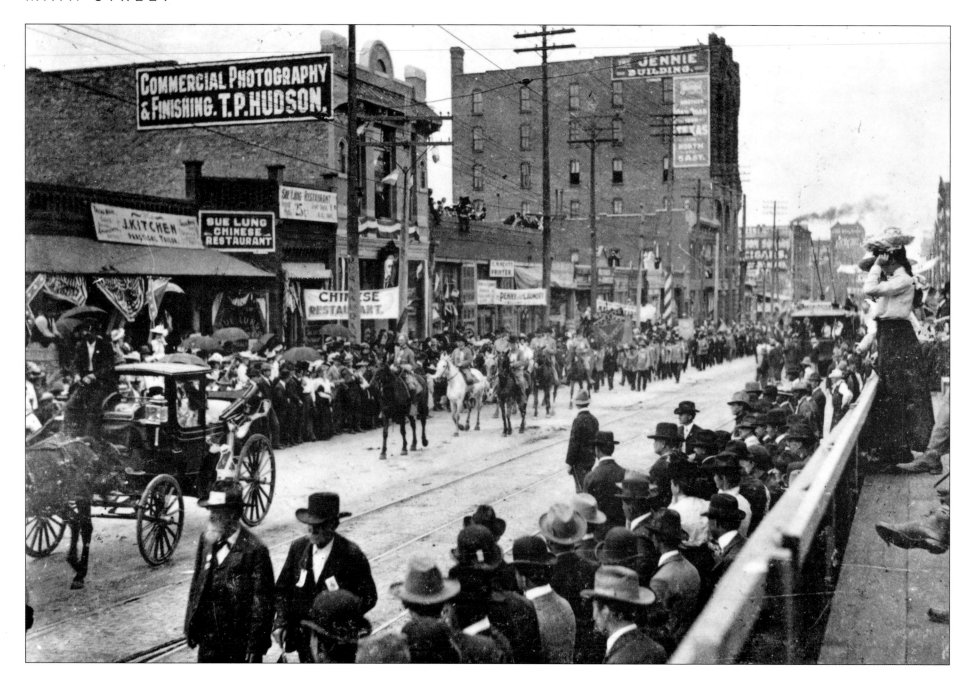

Looking west in the 1600 block of Main, T. P. Hudson's studio is prominently advertised, but the actual photographer who captured this view of the Confederate veterans reunion parade on April 23, 1902, is unknown. Thirty-seven years had passed since the end of the "war between the states," and most of these ex-soldiers were in their sixties. Texas favored the southern cause and seceded from the Union on January 28, 1861.

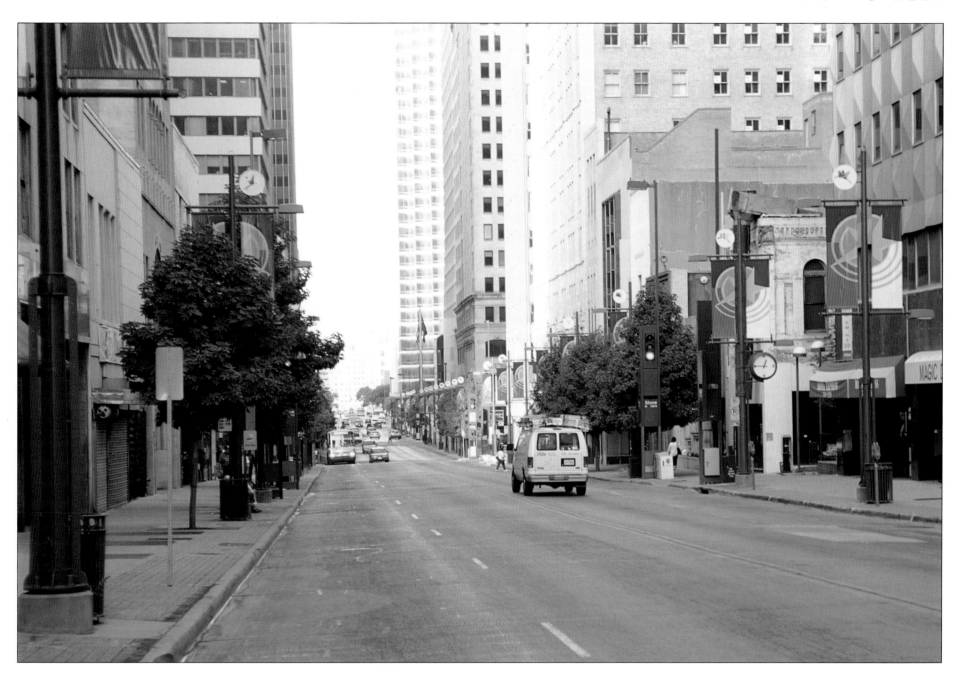

Parades still grace Main Street today, but the Civil War has been over for 135 years and its veterans are just a memory. Agriculturally rich, Texas was far separated from the actual fighting, so it became the major source of food for the rest of the Confederacy, and Dallas contributed $5,000 in gold from the city treasury. After hostilities ceased, over 1,000 Dallas citizens had to take an amnesty oath to rejoin the Union.

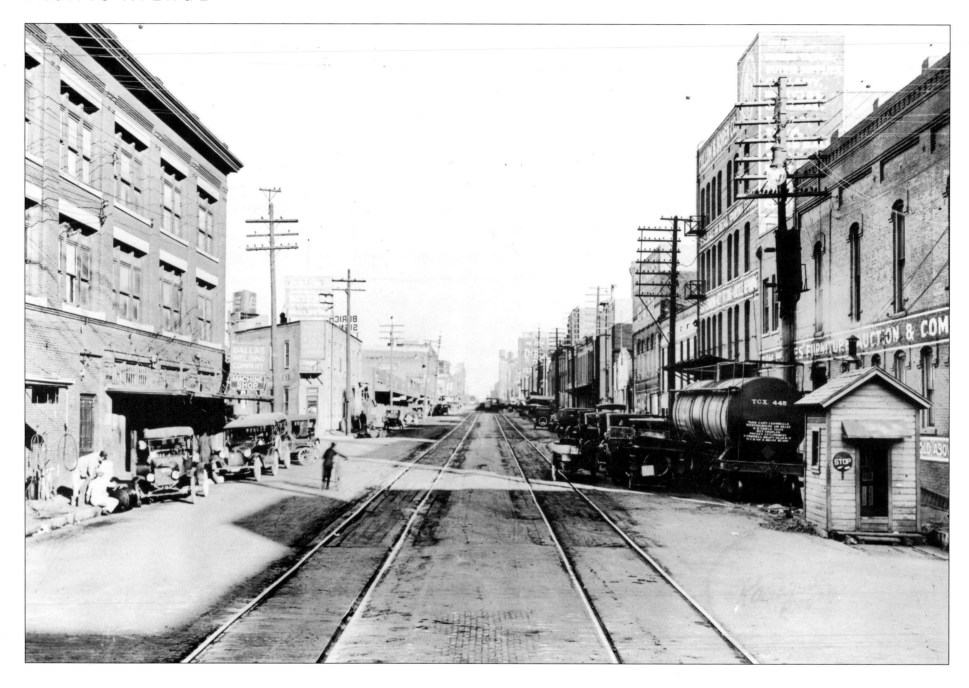

When the tracks of the Texas & Pacific railroad arrived in 1873, they were laid right down the middle of the entire length of Burleson Avenue, which was renamed Pacific Avenue to honor the occasion. In time, the constant interruption of trains passing was found to be detrimental to the development of Pacific Avenue as a modern business thoroughfare. However, it was not until 1921, the year after this picture was taken, that a new route around the eastern edge of Dallas was adopted.

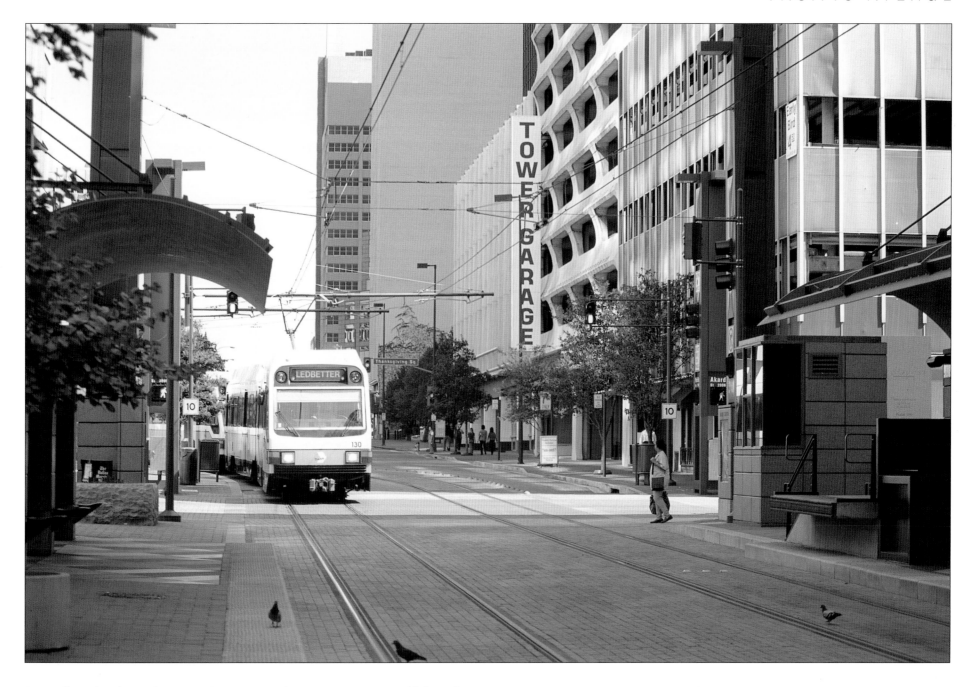

Ironically, vehicular traffic on Pacific Avenue today must once again yield the right-of-way to steel rails, this time to the light-rail passenger trains of the Dallas Area Rapid Transit, first conceived in 1983 when it took over operation of the city's buses. Light rail followed in 1997, and now these sleek, quiet electric trains transport 37,000 riders each day from Oak Cliff to Dallas and on to Plano in 2003.

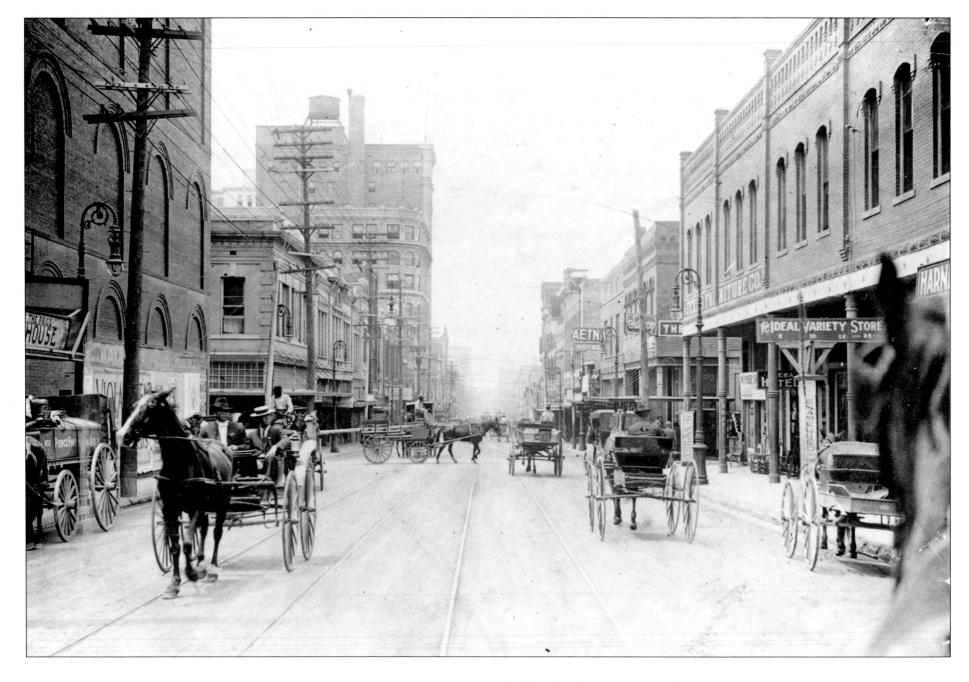

The first "horseless carriage" rolled into Dallas in 1902, but three years later, looking west on Elm from near St. Paul in 1905, no evidence of the motorcar's arrival is to be seen. The early economy needed horse- and mule-powered vehicles to transport goods, so it is no surprise the first real industry in Dallas was a wagon factory that opened in 1852.

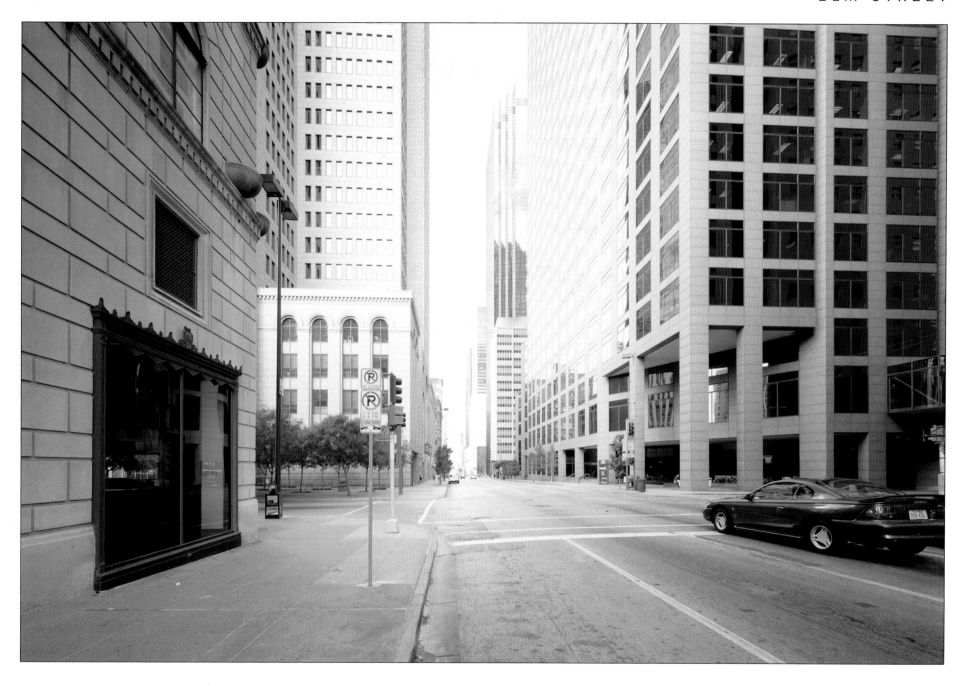

Surrounded today by buildings of a height beyond the imagination of John Neely Bryan, this sports car waits for a green light. Wagons for hauling cotton and manufactured goods evolved into pickup trucks and "eighteen wheelers," while the buggies used to carry the family to church or to the general store were the forbearers of this passenger car.

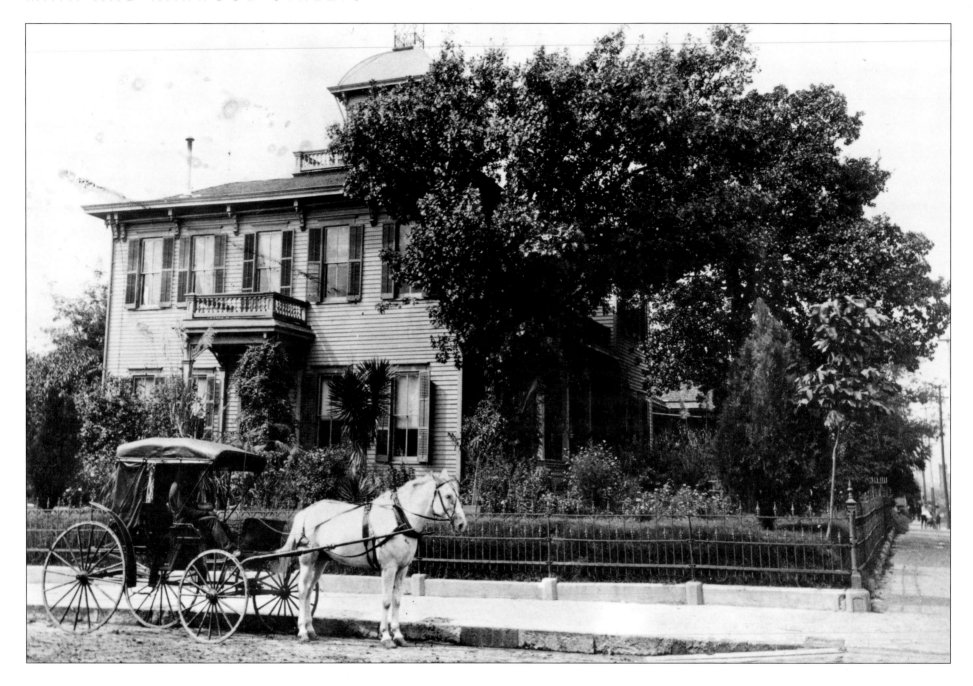

This buggy is parked in front of a fine residence standing at the southwest corner of Main and Harwood in 1892. It belonged to Colonel John C. McCoy, who purchased this impressive two-story house from James P. Simpson around 1885. This residential area was located roughly halfway between the business district and "Deep Ellum."

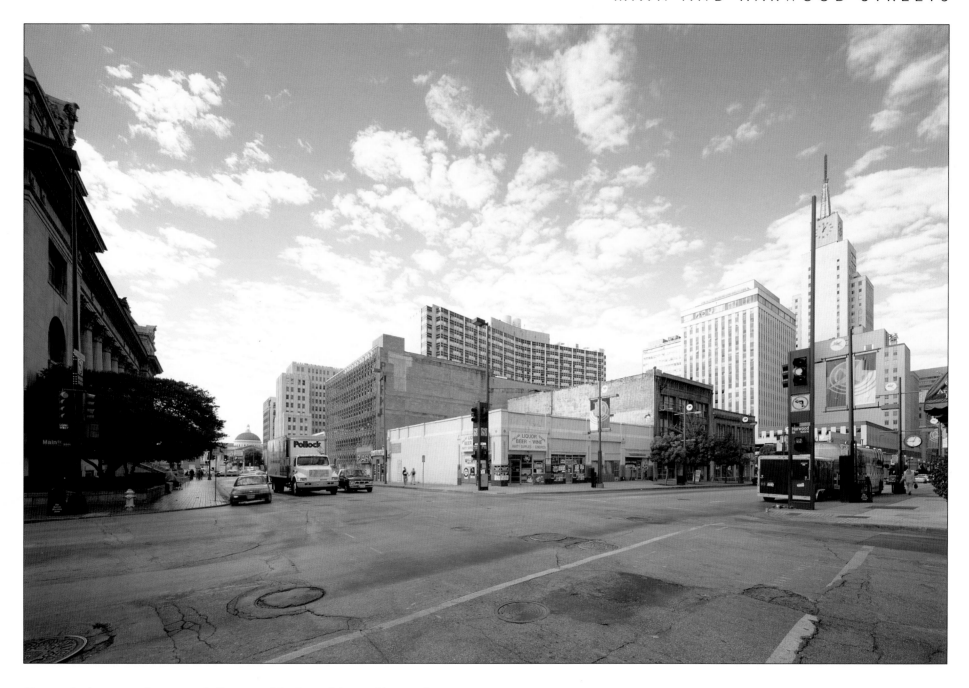

Time and urbanization have erased all traces of the beautiful period homes that once occupied this area. Looking south down Harwood, on the left is the imposing edifice of Dallas's fourth city hall, completed in 1914 at a cost of $700,000. It now functions as the police and city courts building. In the distance, the dome of the First Presbyterian Church can be seen.

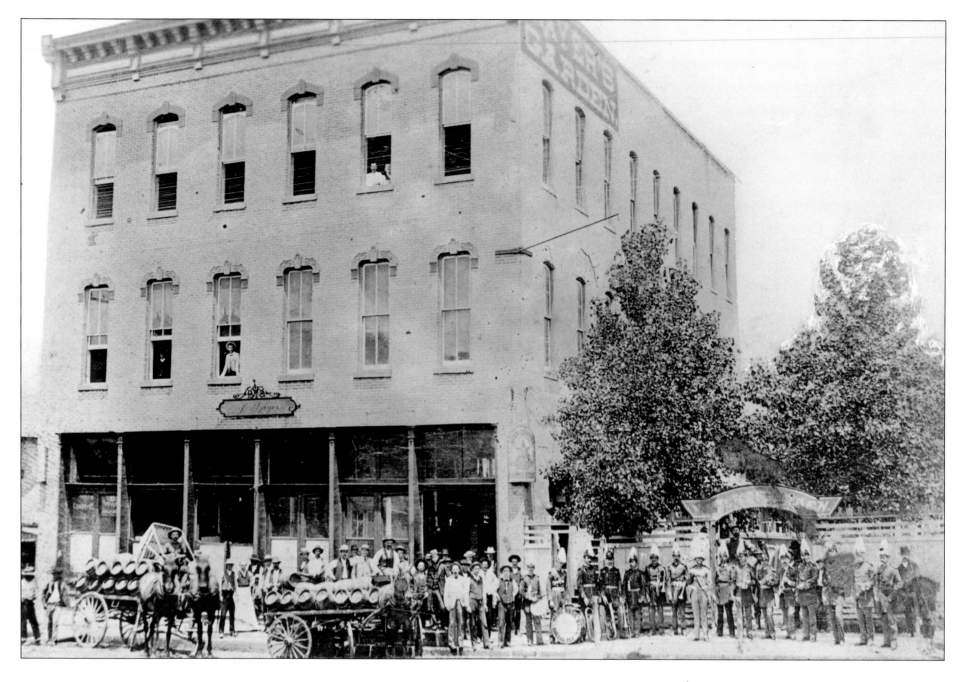

With wagonloads of beer and a brass band on hand, it looks like everyone at Mayer's Garden had a good time on this day in 1885. Located on the north side of Elm at Stone, it was one of Dallas's most popular entertainment spots. Beers cost five cents a glass and were primarily lagers—the handiwork of immigrant German brewmasters who brought their secrets with them.

Today at this location, Stone Street is just an alley between the 1600 Pacific
Building, on the left, and Thanksgiving Tower, on the right. Mayer's Garden has long
gone. The overall number of breweries in the Lone Star state and the whole of the
U.S. has declined since 1876, but Texans still consumed an estimated twenty-seven
gallons of beer each in 1997.

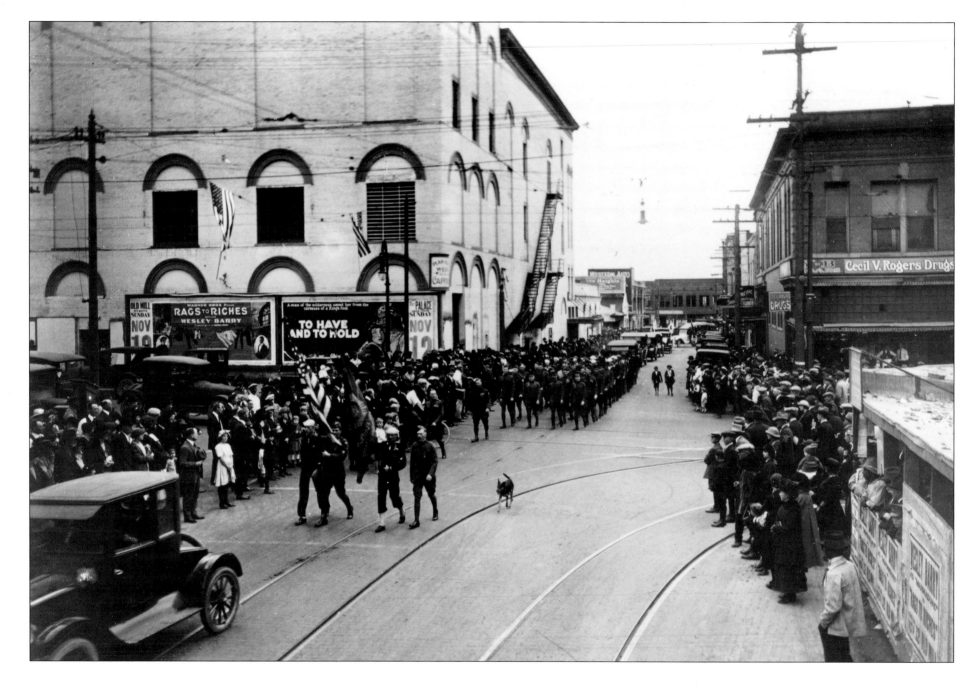

Approximately 8,000 citizens of Dallas served in World War I from April 6, 1917, until the cessation of hostilities on November 11, 1918. Love Field was established to train Army fliers, while Fair Park was converted into Camp Dick. Electricity was cut to all business establishments two nights a week to save coal for the war effort. This photograph shows the Armistice Day Parade heading north on St. Paul at Elm Street in 1922.

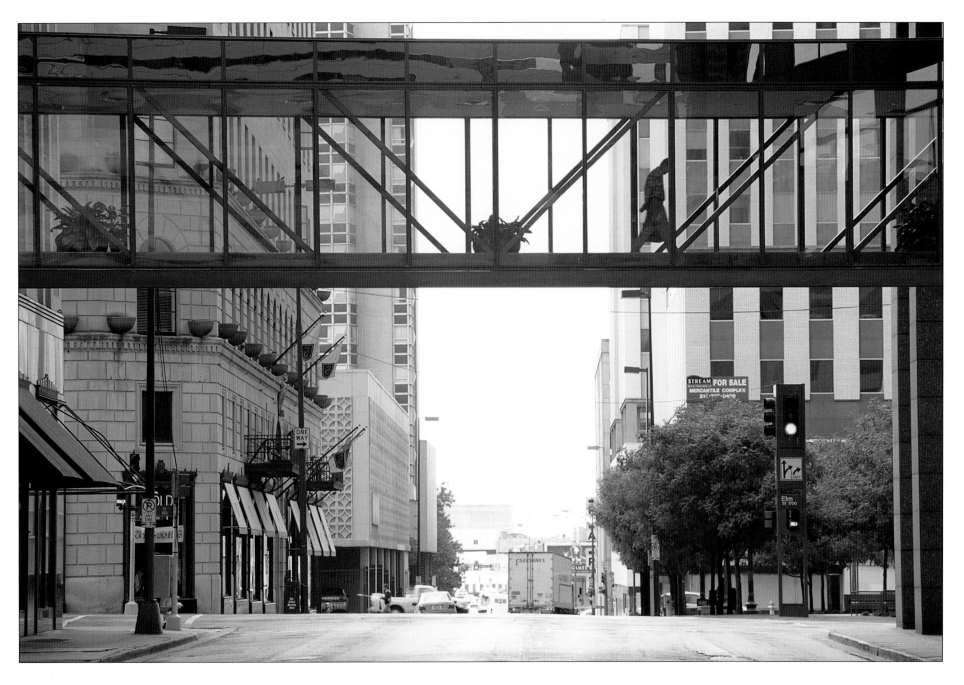

Enclosed in a glass tube, this sky-walking pedestrian crosses St. Paul in air-conditioned comfort, while soldiers once marched below. The Ninetieth Division formed from Texas and Oklahoma came to be known as the "Tough Ombres," or "Texas' Own." The battlefields of WWI France claimed the lives of over 9,700 Texans.

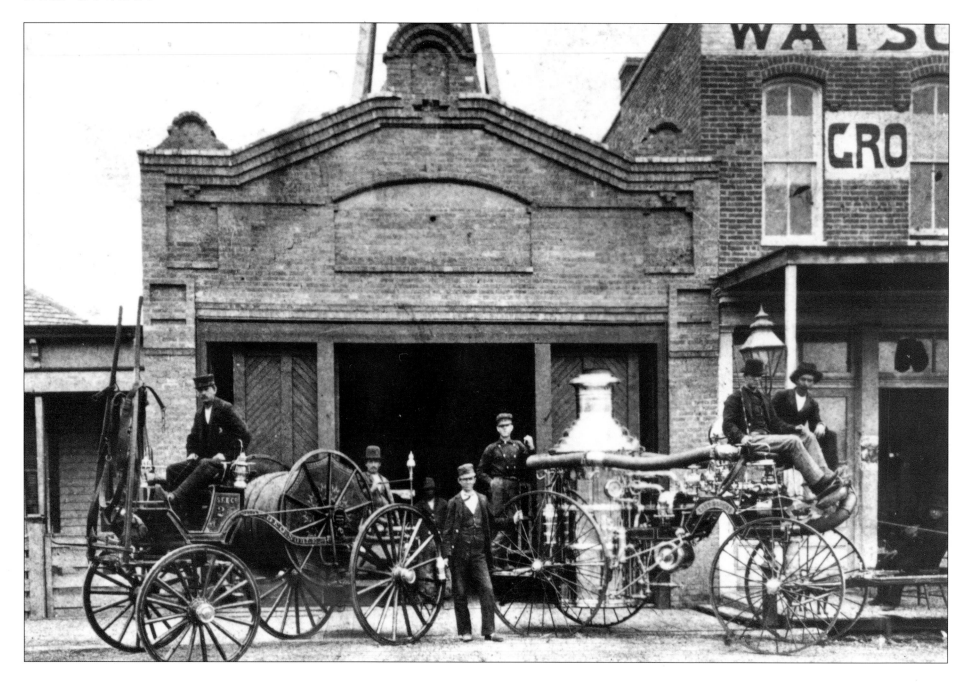

These firemen pose outside their station at 1444 Elm Street in 1882, their wagons highly polished and ready for action. Although the need for a fire brigade became evident after most of the business district burned in 1860, it was not until after the Civil War in 1871 that the first department was formed. Water to fight fires was initially pumped from the Trinity River into cisterns under the sidewalks.

The Fire Department has grown to 55 stations, but the old Mayfair Department Store Building stands here today, vacant since the 1970's. Always on the cutting edge, the first telephone in Dallas in 1880 connected the Fire and Water Departments. Now computer terminals and GPS units installed in fire trucks and ambulances locate the nearest unit to any call.

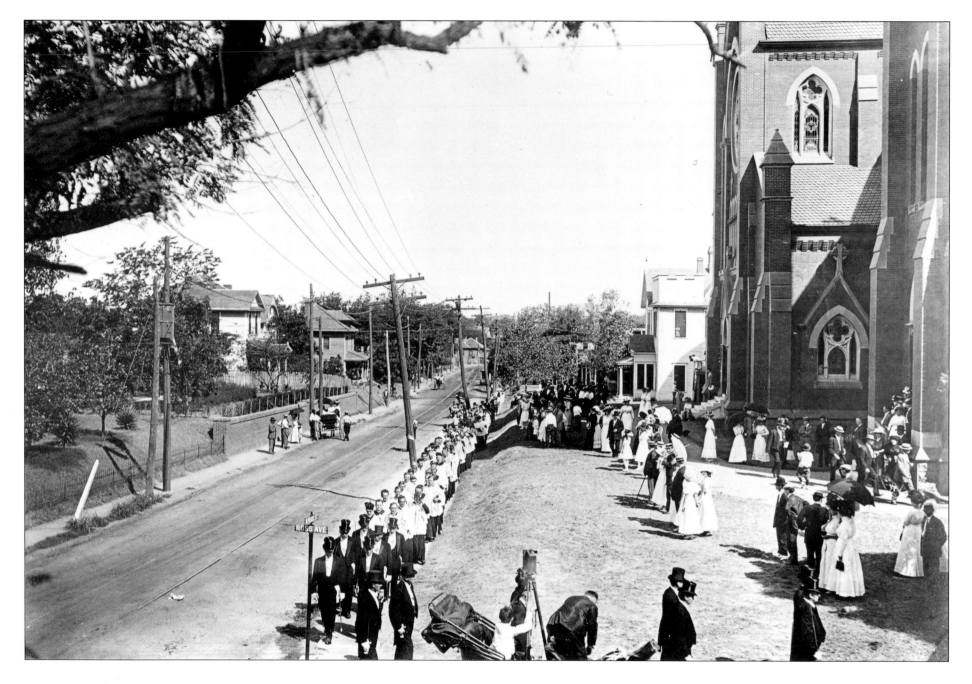

This photograph, taken on July 12, 1911, looks north at the corner of Ross and Pearl streets, at the procession for the consecration of Bishop Joseph Patrick Lynch arriving at the Cathedral of the Sacred Heart of Jesus. Abandoning an early law career, Lynch was ordained as a priest in 1900. When Bishop Edward Joseph Dunne passed away in 1910, Lynch became the youngest Bishop in the United States at the age of thirty-eight.

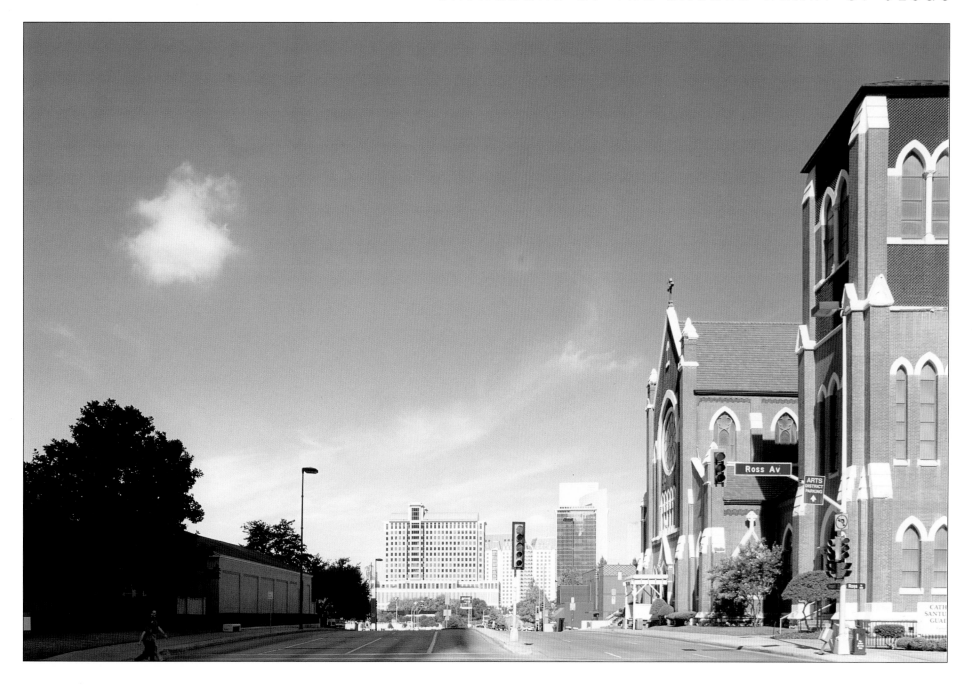

Except for the buildings rising majestically in the distance across the Woodall Rogers Freeway, the passage of time has changed little in this scene. The experience and determination Bishop Lynch brought to the position served him well as he guided the growth of the diocese for forty-three years. He died in office in 1954 and is buried in the Calvary Hill Cemetery.

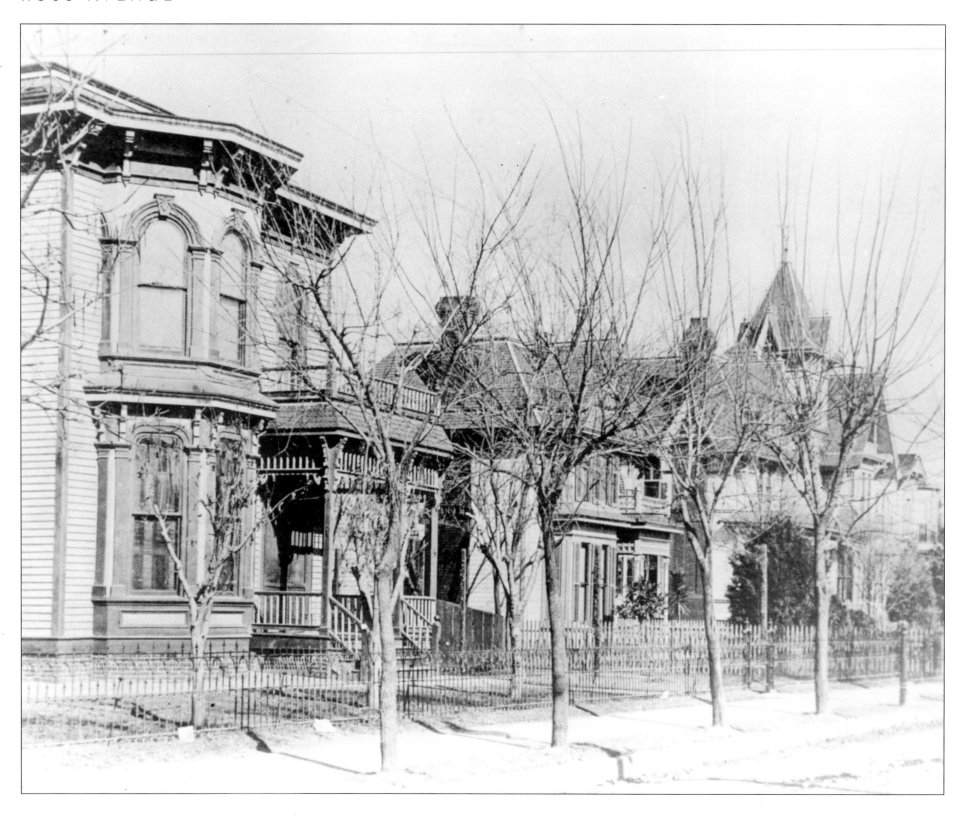

Left: This pristine neighborhood of wooden, upper-class houses is located at the northeast corner of Ross Avenue and Harwood. Probably taken during the winter of 1895, the photograph shows the perfectly arranged Victorian homes behind the sidewalk and decorative fences of iron. Ross Avenue was named for William and Andrew Ross, original owners of the land through which it passes.

Right: The real estate once occupied by families is now utilized by commercial real-estate services giant Trammel Crow Company. Dallas is host to the firm's home office, as it is for many corporations these days. Founded in 1948, the company is at the heart of 170 field offices offering property management and brokerage services across the U.S. and Canada. The building rises high above the surrounding streets.

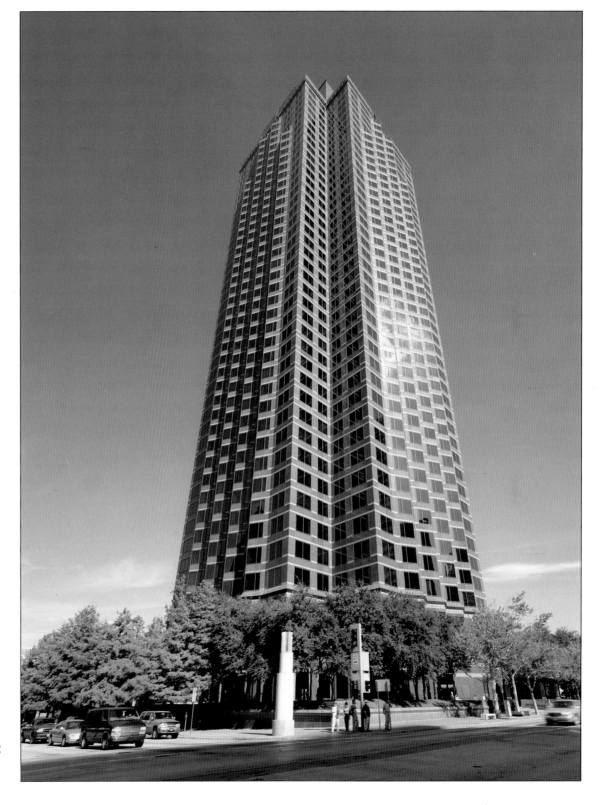

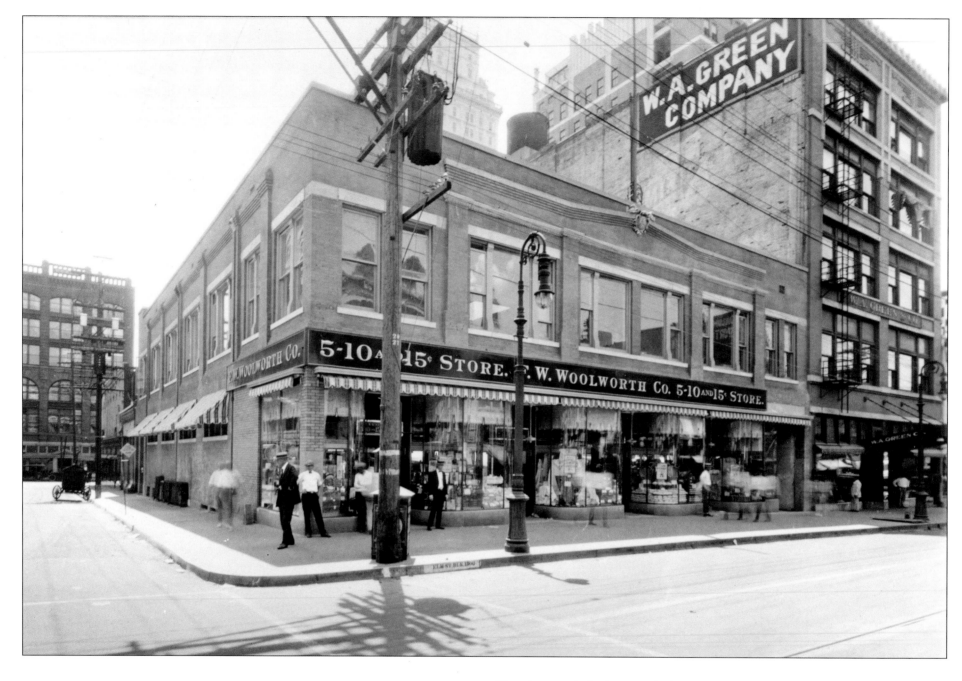

This photograph, looking south along Stone Street from Elm, shows an institution that was born in 1879 when Frank Winfield Woolworth opened his first successful five-and-ten cent store in Lancaster, Pennsylvania. Woolworth expanded to over one thousand stores bearing his name, including the one shown here in 1922.

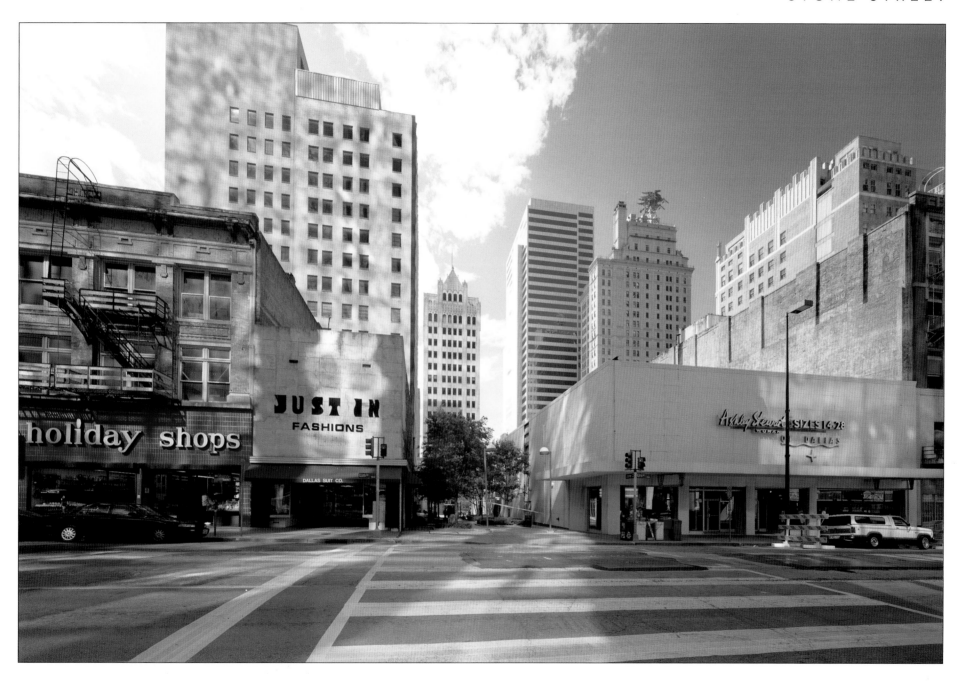

Pegasus looks down on a contemporary scene where Stone Street is now a pedestrian walkway, and the merchandise in these stores costs much more than a five-and-dime ever would have allowed. The remaining 400 Woolworth's stores were closed in 1997 as losses mounted—it was feared they would drag down new diversified businesses such as Foot Locker. The parent corporation even changed its name to the Venator Group to distance itself from the old image.

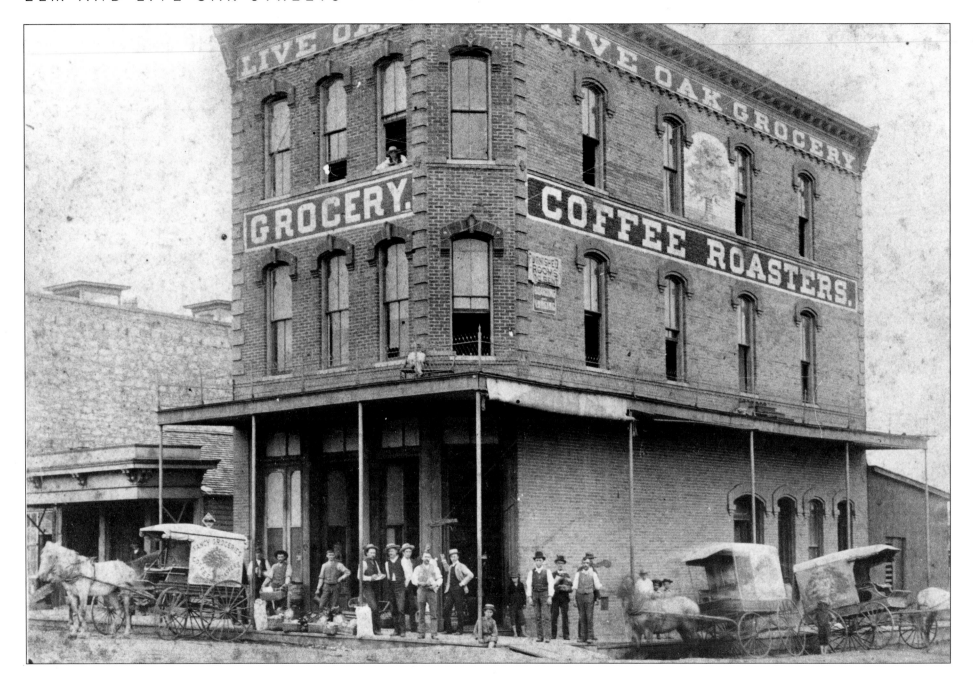

At the northwest corner of Elm and Live Oak, the owners of the Live Oak Grocery advertise "free and prompt delivery" of staple and fancy groceries. The prominent advertising of coffee roasters shows that the caffeinated joy of a morning cup of coffee was as important to people in 1895 as it is today.

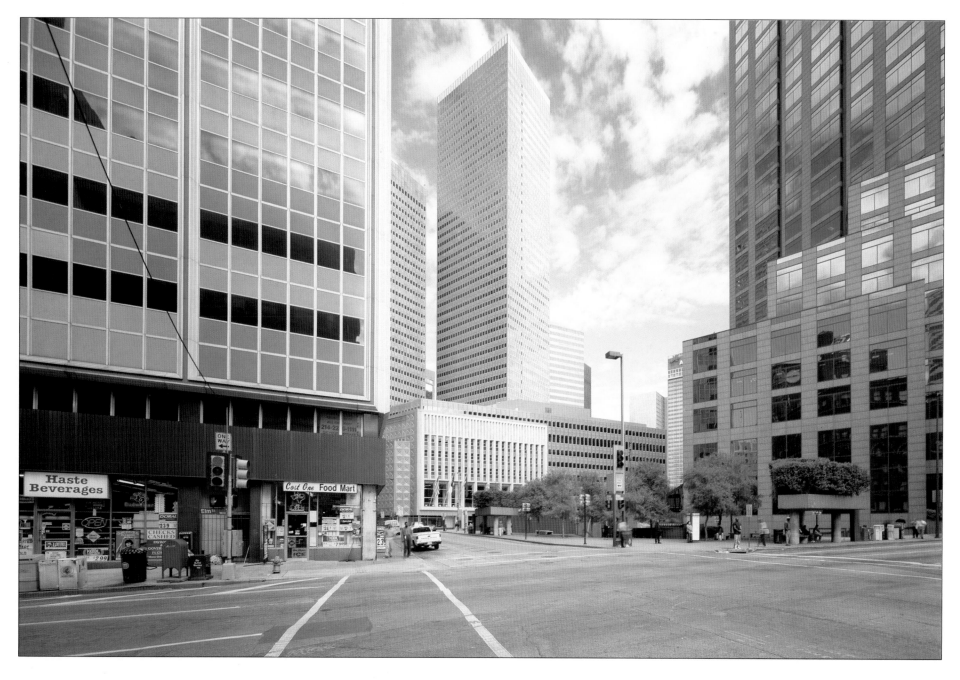

Against all the odds there is still a grocery at this site today. However, the scene is a striking contrast. No delivery wagons stand ready at the curb—the nearest residential areas are now miles away. Workers must come down from their offices in the cluster of towers to buy food, liquor, tobacco products, or lottery tickets.

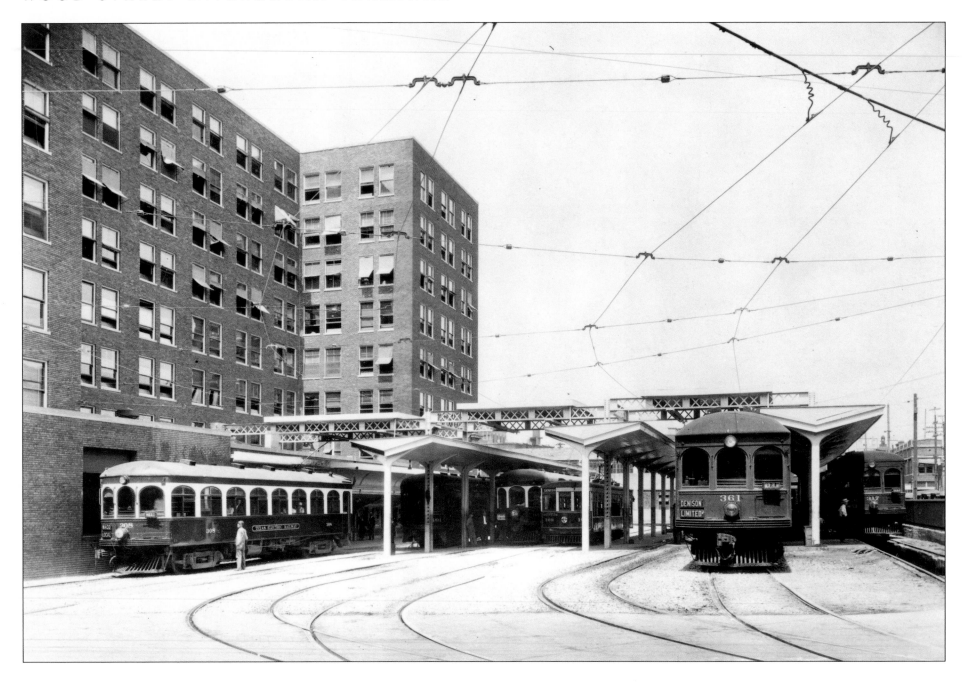

The first streetcars in 1873 in Dallas were powered by mules, but by 1889 electricity had taken over. Larger than the streetcars were the "Interurbans," named so because they connected towns and cities. Here we see the Wood Street Interurban Terminal for the Texas Electric Railroad. The year is 1930, and Car 317 on the far right sits over the maintenance pit so workers may service the undercarriage.

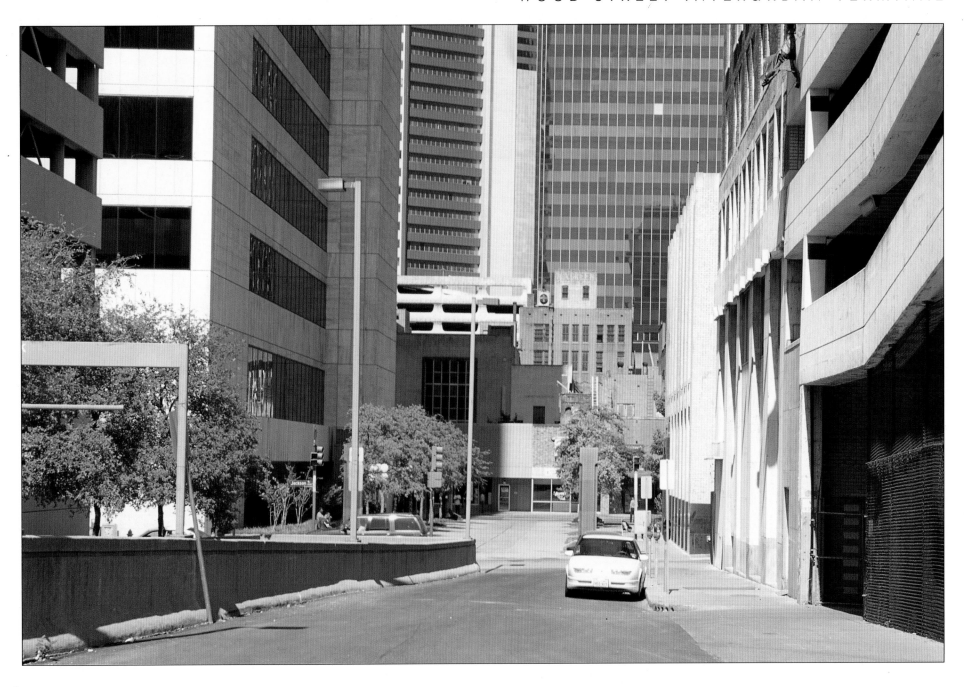

Texas Electric Railroad went into receivership in 1931 and was reborn as the Texas Electric Railway in 1936. At its height, it connected Waco and Corsicana to the south with Dallas and continued on to Sherman and Denison to the north. Although there is no trace of the railway's existence at this site today, an Interurban trip was certainly a bargain at three dollars for a round trip between Waco and Dallas.

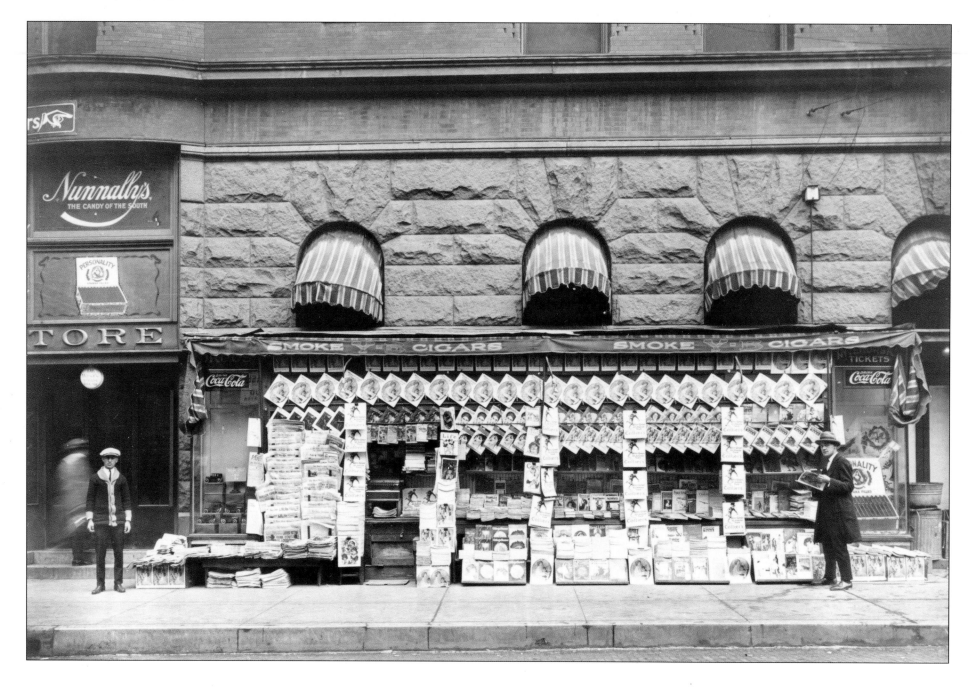

In 1922 on the Akard Street side of the Oriental Hotel between Commerce and Jackson, this newsboy hopes his sole customer will be a buyer and not just a browser. His stand is well stocked with newspapers, magazines, and dime novels for customers of the hotel, Nunnally's candy store next-door, as well as passersby.

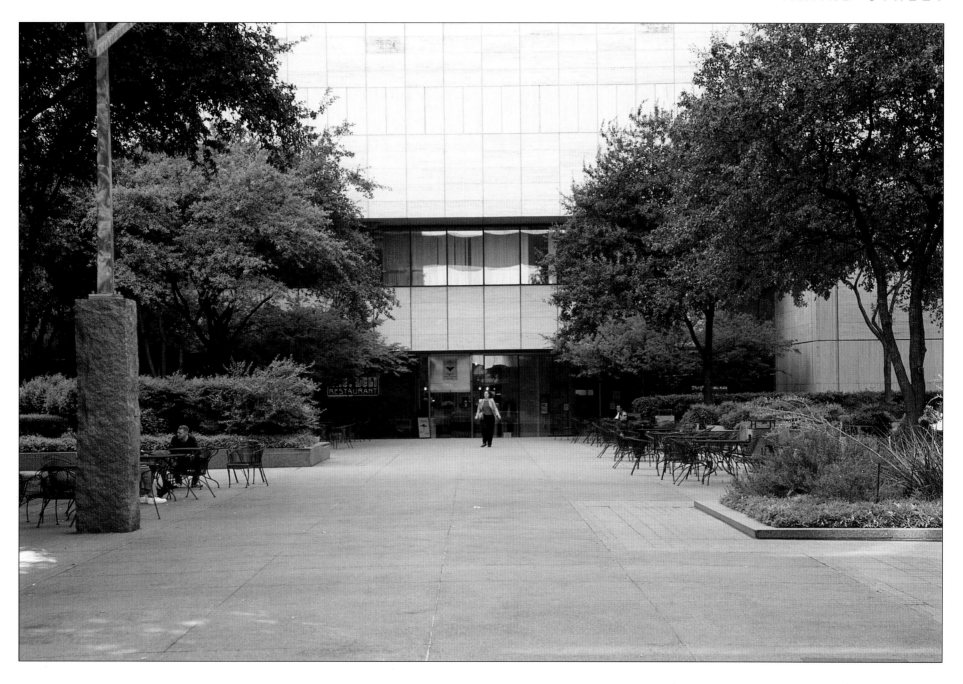

This same block of Akard has now been closed to traffic, creating a bucolic pedestrians' garden between One and Two Bell Plaza. The Oriental Hotel closed in 1924, but when local real-estate magnate Thomas W. Field opened it in 1893, it was the most opulent hotel in the city. In spite of hosting the rich and famous, it was called "Field's Folly" because of the half-million dollars spent on its construction.

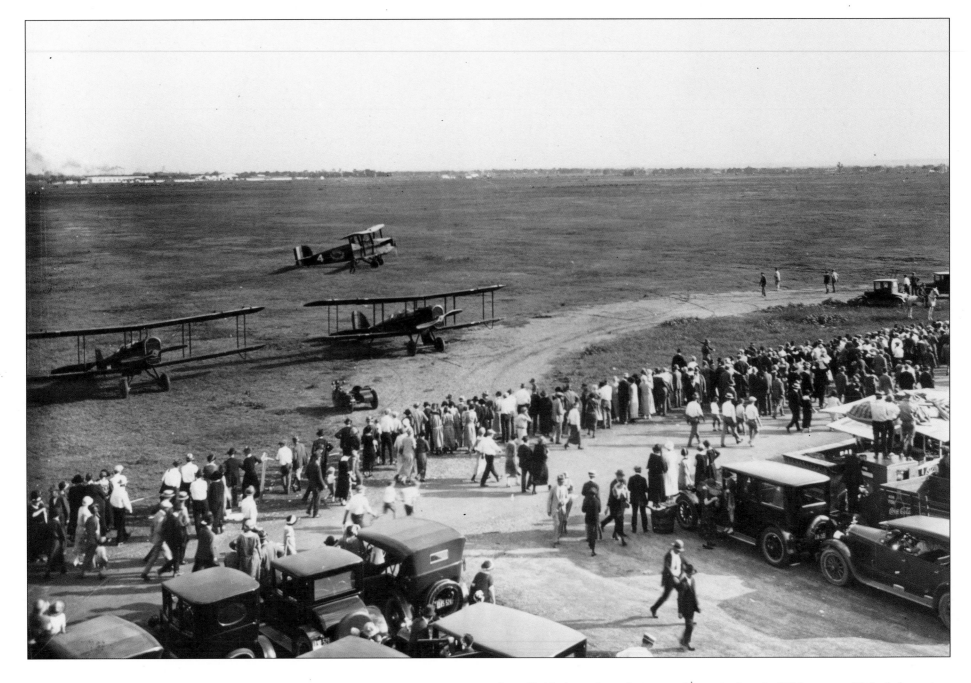

Love Field, shown here during a military air show in 1924, was established about six miles north of downtown in 1917 as a United States Army air training base for World War I. It was named in memory of Lieutenant Moss Lee Love, a military pilot killed in an airplane crash in California in 1913. Dallas gained its first municipal airport when it purchased two hundred acres of Love Field in 1927, and air passenger service began the next year.

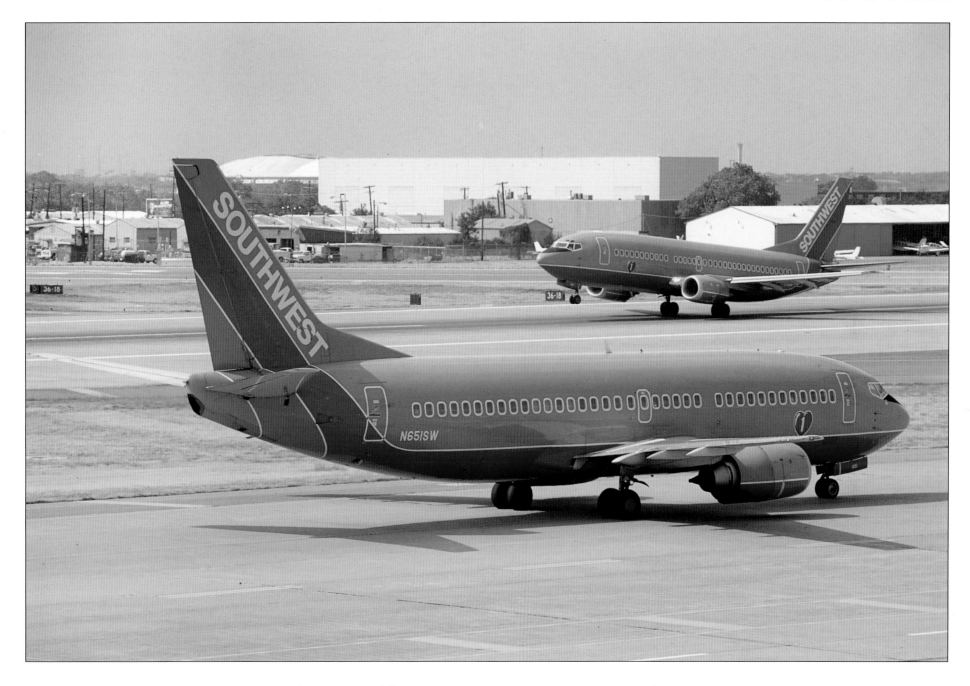

Love Field has since expanded to cover 1,300 acres but is prevented from growing any larger for now by the surrounding neighborhoods. Approximately seven million passengers a year use the services of American, Atlantic Southeast, Continental, and Southwest airlines. Southwest is headquartered here and grew from three planes serving three Texas cities in 1971 to become the fourth largest domestic carrier in the U.S. with over 300 planes serving fifty-five cities across the nation today.

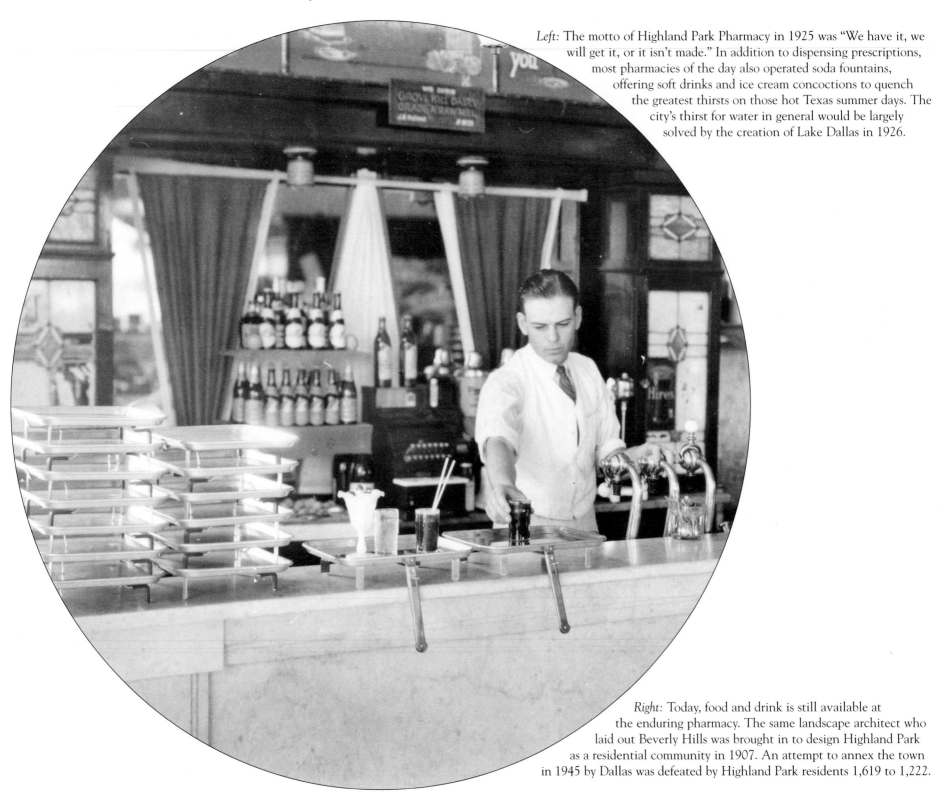

Left: The motto of Highland Park Pharmacy in 1925 was "We have it, we will get it, or it isn't made." In addition to dispensing prescriptions, most pharmacies of the day also operated soda fountains, offering soft drinks and ice cream concoctions to quench the greatest thirsts on those hot Texas summer days. The city's thirst for water in general would be largely solved by the creation of Lake Dallas in 1926.

Right: Today, food and drink is still available at the enduring pharmacy. The same landscape architect who laid out Beverly Hills was brought in to design Highland Park as a residential community in 1907. An attempt to annex the town in 1945 by Dallas was defeated by Highland Park residents 1,619 to 1,222.

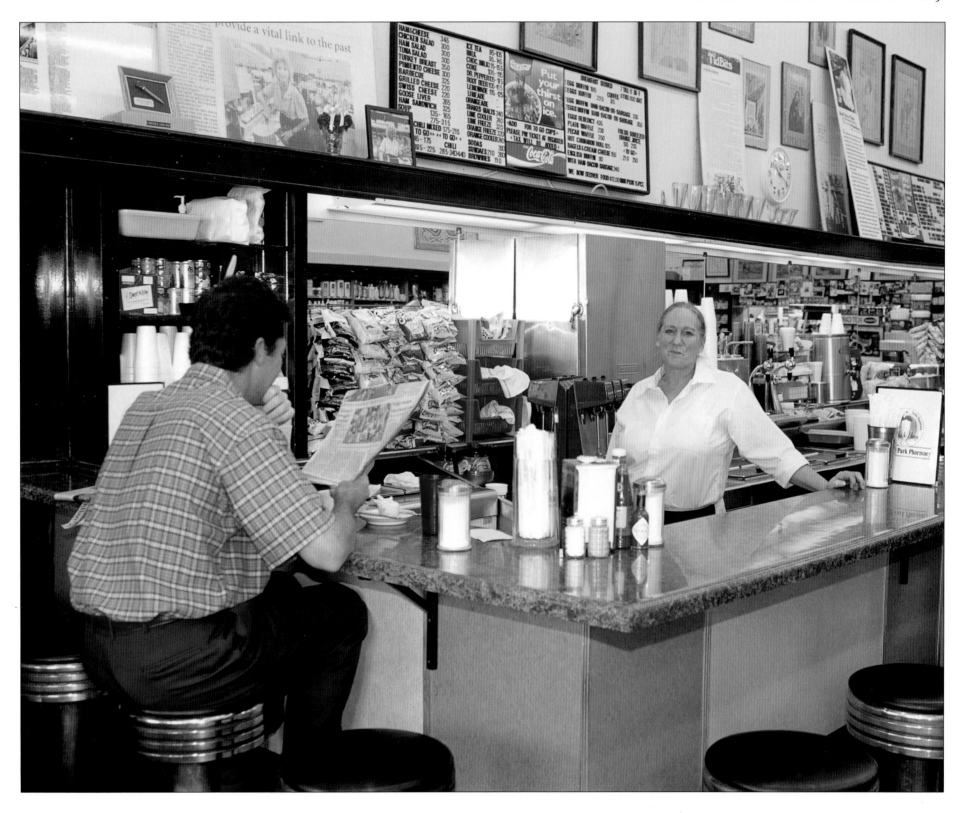

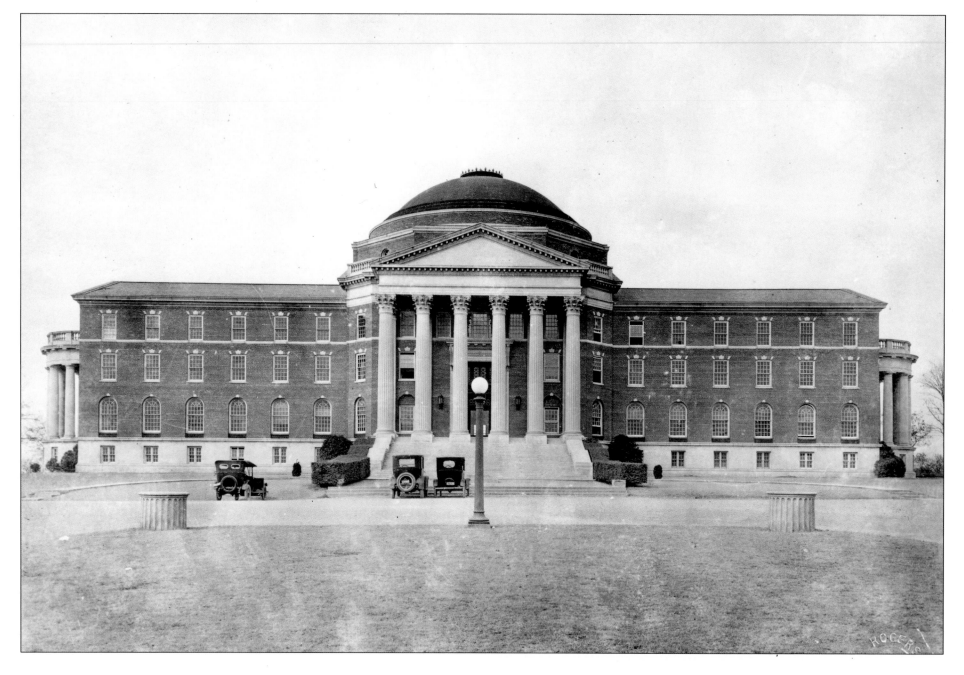

When rival Fort Worth welcomed Texas Christian University in 1910, Dallas also wished to acquire a college. The city's offer of $300,000 and nearly 700 acres of land near Highland Park brought about the opening of Southern Methodist University, intended to serve all Methodists west of the Mississippi. The school opened in 1915, the same year this picture was taken of Dallas Hall, the first building on campus.

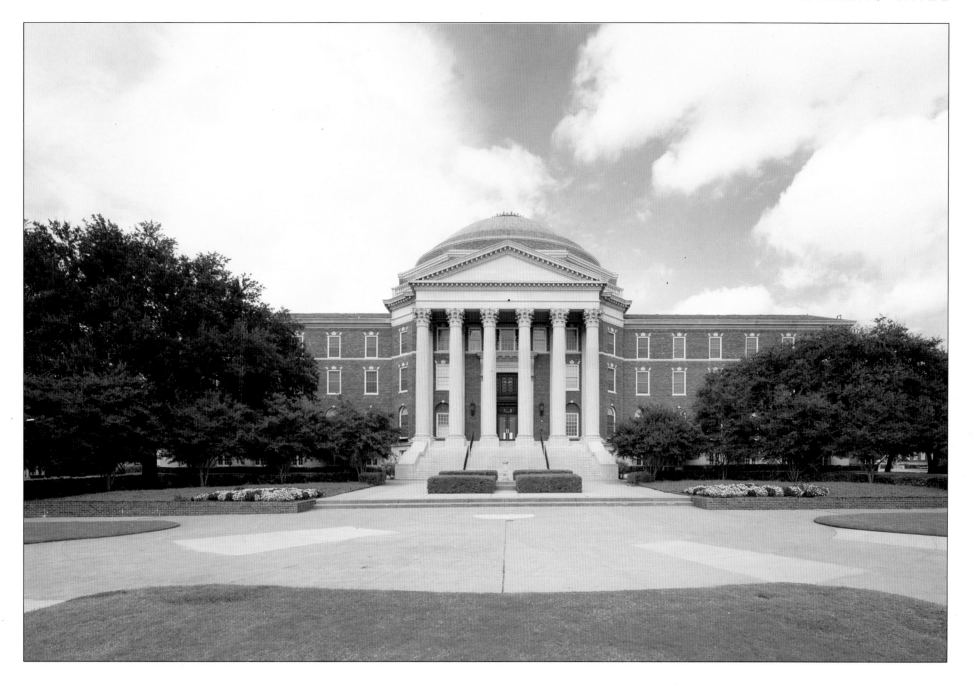

Dallas Hall still stands proudly at the north end of the quadrangle, little changed since 1915. S.M.U. is still a private school with more than 10,000 students enrolled from all fifty states and one hundred foreign countries. It offers degree programs in the arts, business, communications, engineering, humanities, law, sciences, and theology. Dallas Hall now houses the Dedman College of Liberal Arts, embracing the humanities and the social, natural, and mathematical sciences.

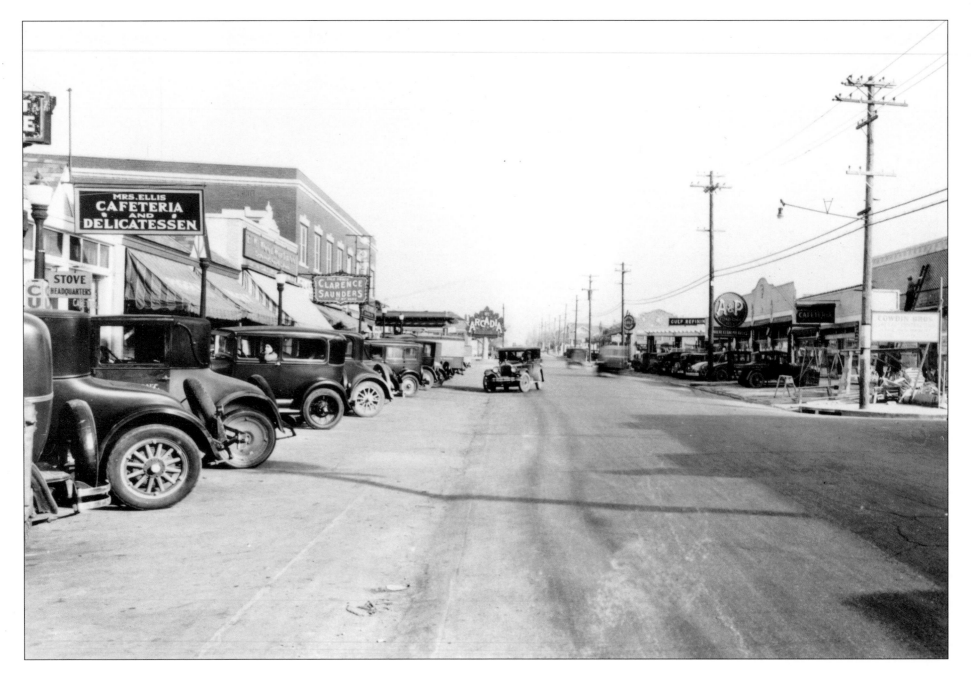

Greenville Avenue was first major road between Dallas and Greenville, approximately thirty miles to the northeast. The many parked cars indicate the number of people patronizing the small businesses that line the 1900 block in 1930. The population of Dallas exceeded 260,000 at this time, and the Cotton Bowl Stadium just completed at Fair Park could hold over 46,000 of them at a single event.

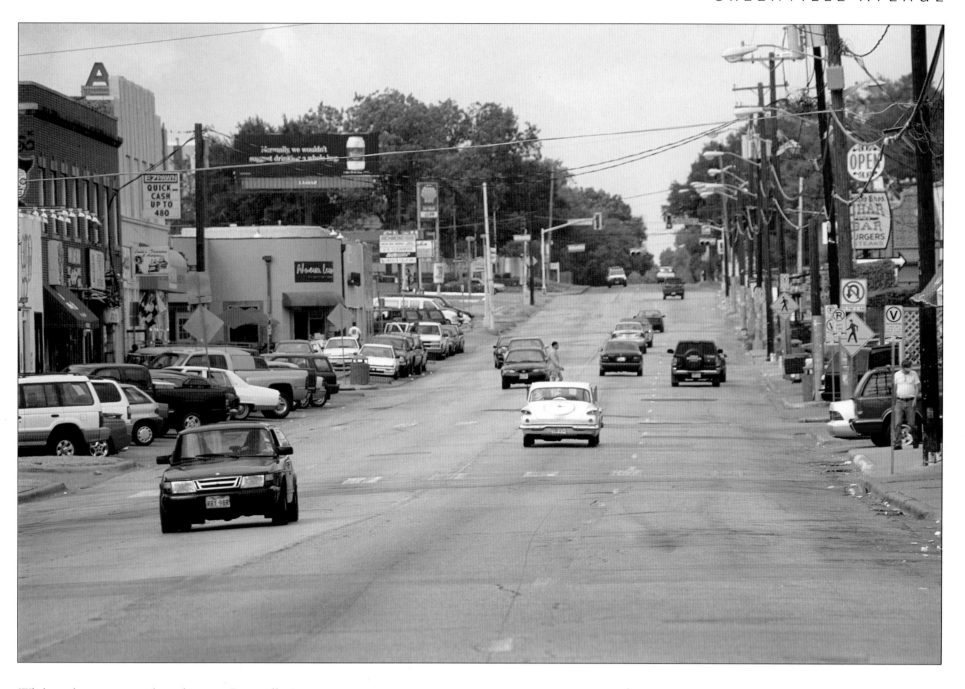

While no longer a main through route, Greenville Avenue is now just minutes away from downtown by DART light rail. The street has taken on a personality all its own, hosting a variety of the arts, as well as shopping, dining, and clubs. Upper Greenville offers a modern nightlife, while Lower Greenville shows off its old houses and is known for casual dining and boutiques. Lowest Greenville boasts cultural restaurants, pubs, and antique shops.

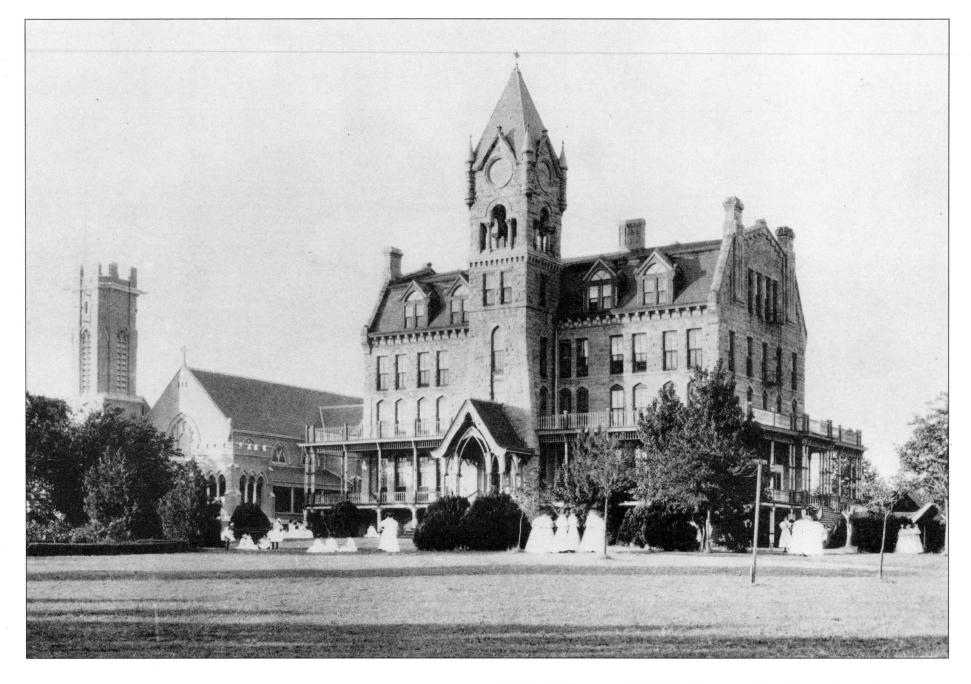

St. Mary's College opened in 1889 with seventy-six students at the southeast corner of Garrett and Ross. A school for girls, it was founded by the bishop of the Protestant Episcopal Church, Alexander C. Garrett, who often lectured there on astronomy, psychology, and logic. Viewed here in 1908, surrounded by carefully manicured grounds is the chapel with Graff Hall in the foreground. Many of the faculty members were educated in Europe.

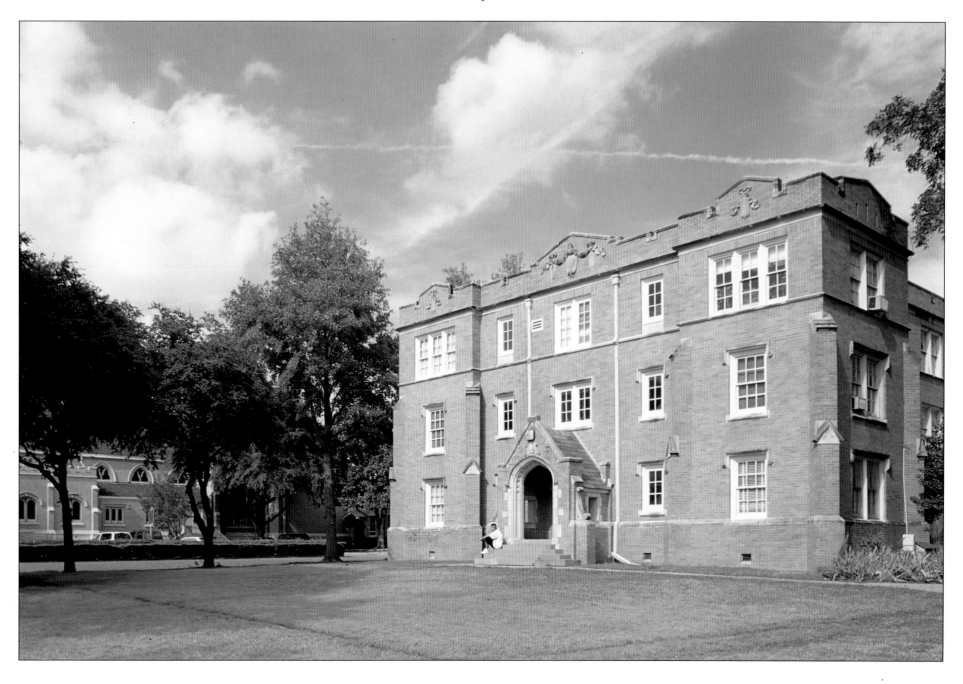

Good credentials not withstanding, St. Mary's always suffered from financial problems. It became a junior college in the 1920s and finally closed in 1930 when its assets were transferred to St. Matthew's parish. The still-beautiful grounds now hold the same chapel remodeled as St. Matthew's Episcopal Cathedral. Garrett Memorial Hall on the right, built in 1917 as a dormitory, now boards church offices instead of students.

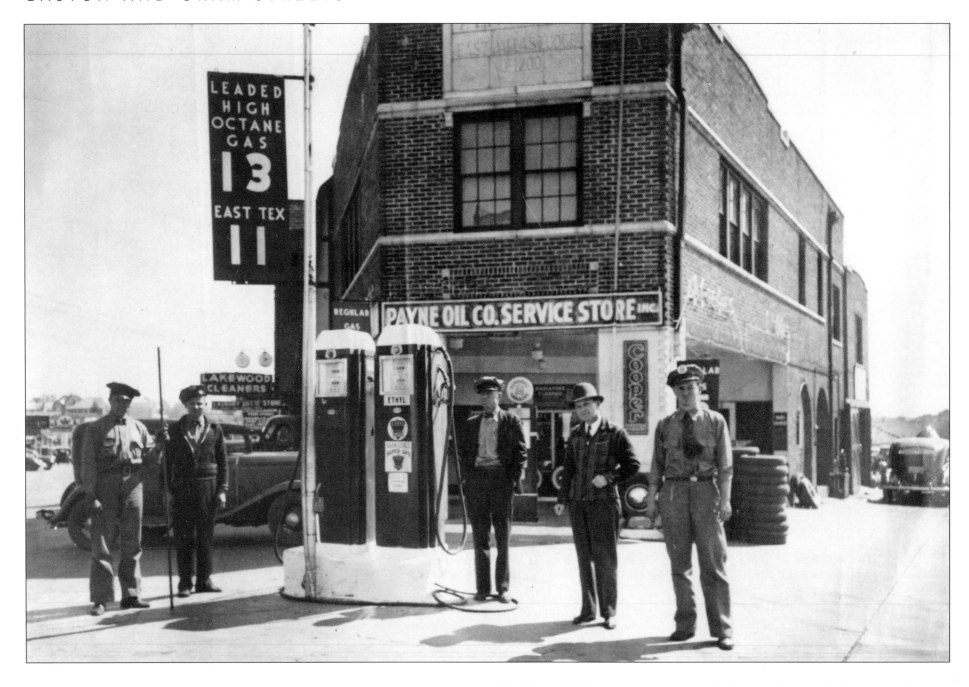

This Payne Oil Company service station had a prime location for business in the Lakewood Shopping Center at the "Y" intersection of Gaston on the left and Oram on the right. Care of the environment was not an issue back then, so automobile engines of the time were designed to burn leaded gas, sold here for thirteen cents per gallon in 1930.

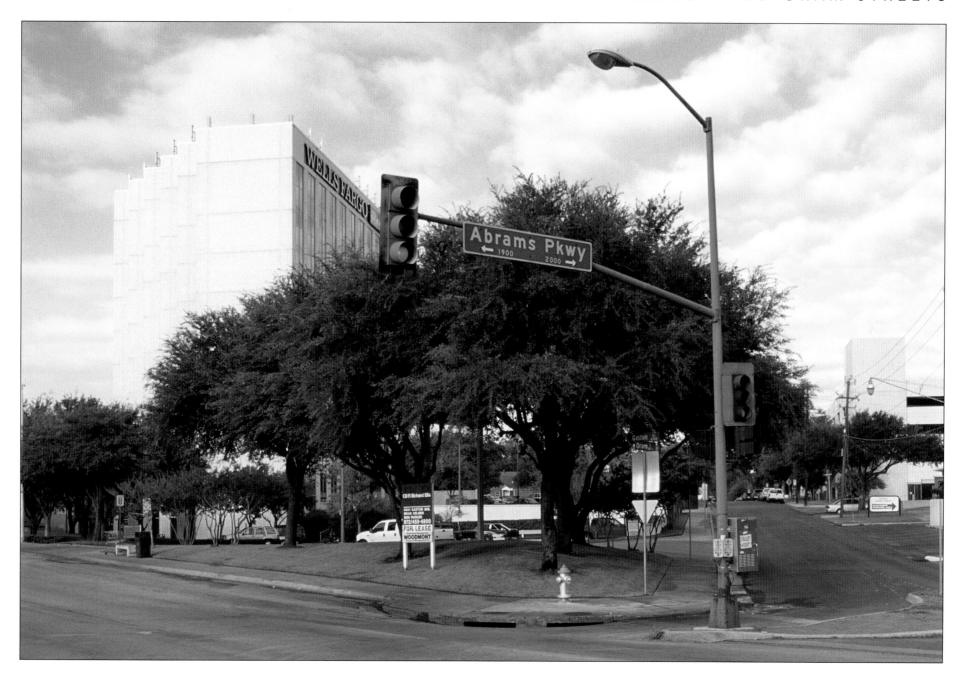

Today at this intersection, the only service providers are these live oak trees giving shade to anyone who pauses on the grassy island in a sea of pavement. Abrams Parkway gained its name from early businessman and violinist Harold J. Abrams. Wells Fargo Bank in the background derived its name from the famous stagecoach company, whose service connected the American West beginning in 1852.

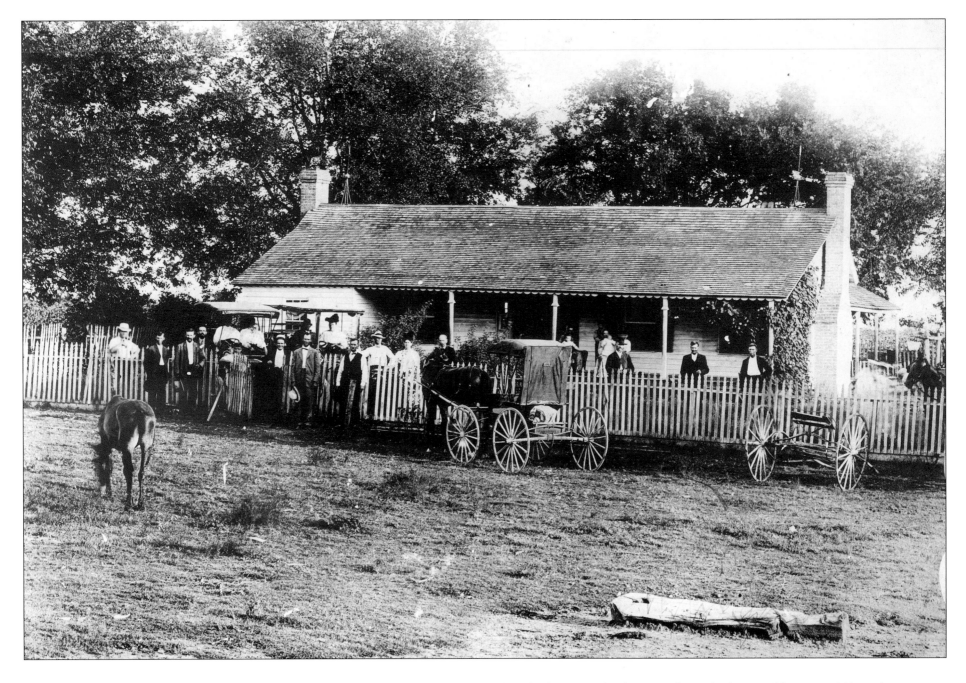

The Abraham Hart family pictured outside their rural home in 1880 at what is now roughly the 5700 block of Gaston Avenue. The population of Dallas had reached just over 10,000, but it would still take a ride of over two miles in the buggy tied up out front to get there. This distance gradually decreased year by year, as the expanding city filled the surrounding countryside.

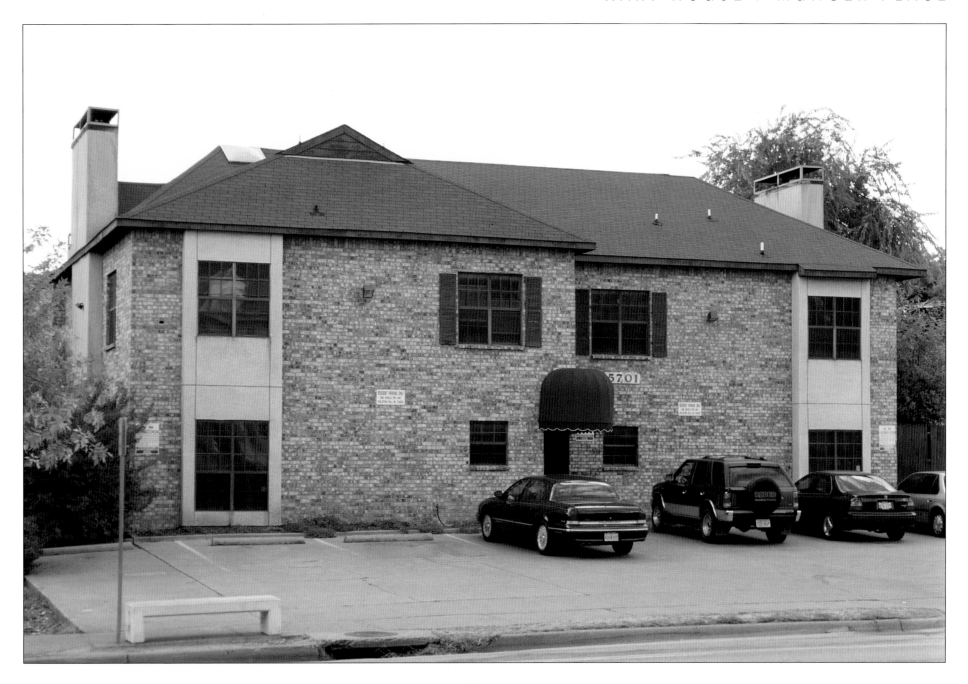

Where a single family lived before, a block of town homes now shelters at least four families in this primarily residential area. Robert Sylvester Munger was a pioneering inventor of improved cotton gin machinery in the late 1800s. In 1902, he sold his companies and devoted his time to real-estate development, starting with the Dallas neighborhood shown here, which bears the name Munger Place.

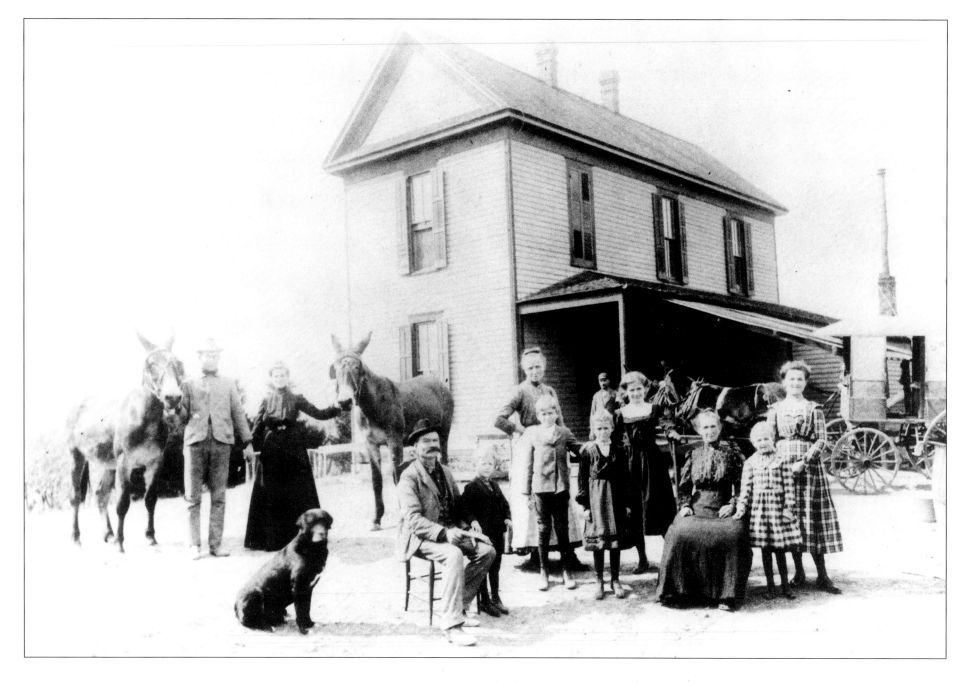

With the delivery wagon idle at the far right, Jacob Buhrer and family are gathered in front of their home in 1900, taking a few minutes from the operation of their Swiss Dairy Farm. The operation of a dairy meant long hours of hard work, and the Buhrer family kept at it until 1911 when their land was used for the construction of White Rock Lake. The house survived the building of the lake, only to be torn down in the early 1960s.

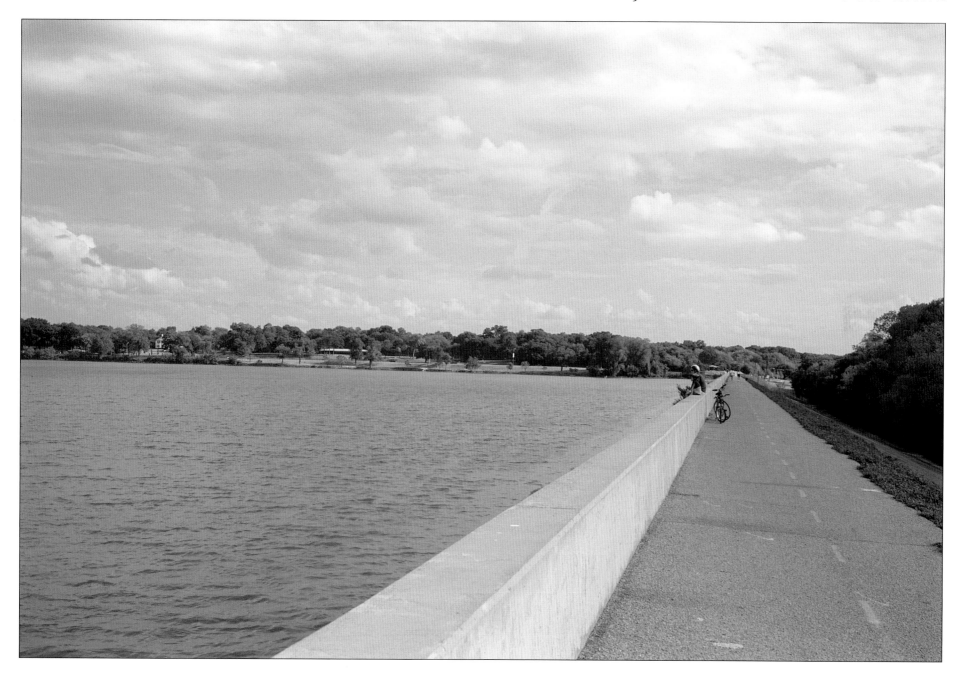

White Rock Lake was built on White Rock Creek for the purpose of alleviating the chronic water shortages in Dallas. As the areas surrounding the over 1,200 acres of water were developed for residential use in the 1930s, the Dallas Park Board and Civilian Conservation Corps turned the entire shoreline into a municipal park. In 1943 German prisoners of war from Rommel's Afrika Corps were incarcerated in the barracks at Winfrey Point at White Rock Lake.

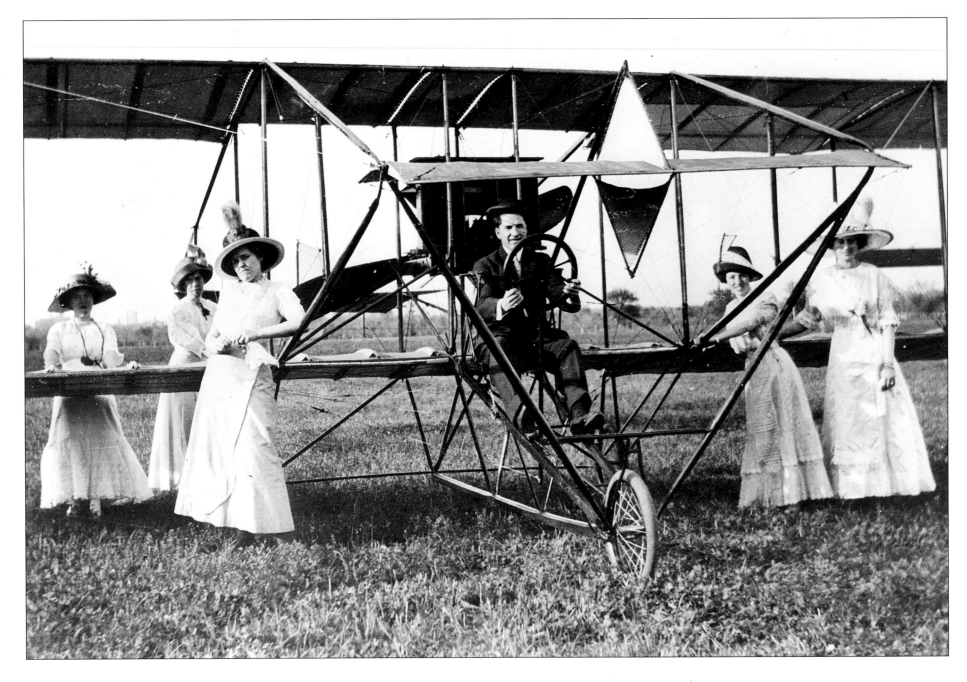

It appears to be a beautiful day in 1914 as these ladies pose in their best dresses around the brave aviator and his heavier-than-air flying machine at Caruth Field in the Trinity River bottoms. Hot air balloons had been seen in Dallas as early as 1861, but it was not until the Chamber of Commerce sponsored an air show in 1910 that a Curtis biplane soared above the crowds.

Caruth Field did not survive because the Trinity River bottoms were prone to flooding, preventing any permanent construction. City planner George Kessler proposed a solution in 1912, but it was not until 1933 that the $18 million was spent to build levees that controlled the waters. More than 10,000 acres of land between this viewpoint and downtown in the distance was reclaimed for lasting industrial development.

The exact year is not known, but as these two travelers pause in front of the Music Hall on the State Fair grounds, there is little doubt their journey here has been an arduous one, as indicated by the missing rear tire. Ford opened a factory in Dallas in 1914, but there were more than 5,000 individual automobile makers in the country over the years, and this vehicle is possibly an Empire, or a Maxwell.

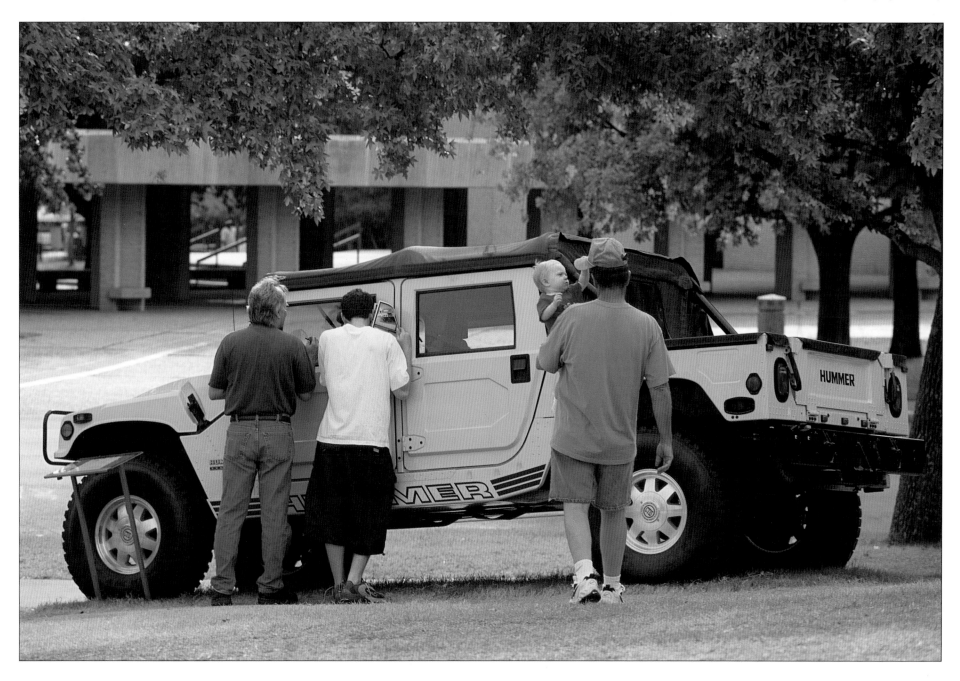

The present State Fair of Texas has been held annually at the Fair Park location since 1887, and here on display in 2000 in front of the Music Hall is a vehicle as rugged as its predecessor. The U.S. military needed a High Mobility Multipurpose Wheeled Vehicle, and so the "Humvee" was born in 1985. The civilian model admired here can climb a 60-degree slope and ford 30 inches of water, snow, or mud.

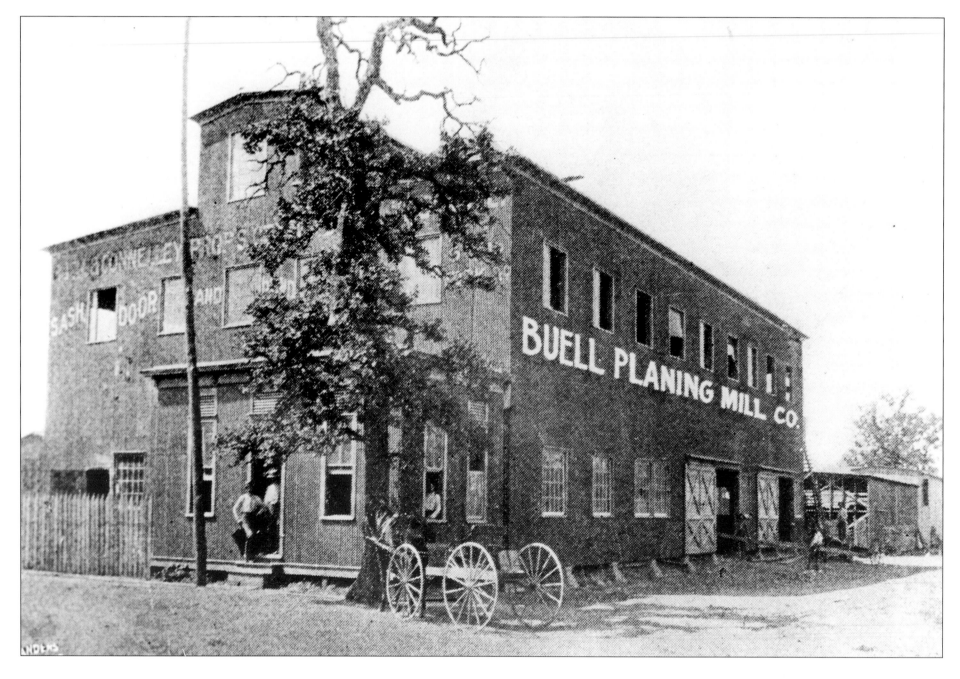

Two gentlemen in 1900 chat idly in front of the Buell Planing Mill, located at what was at the time the corner of Hawkins Street and Central Railroad. Perhaps one has just arrived in the wagon to pick up a door or a window sash for a new home. Settlers found the immediate area plentiful with oak, cedar, walnut, ash, elm, and bois d'arc for building their cabins.

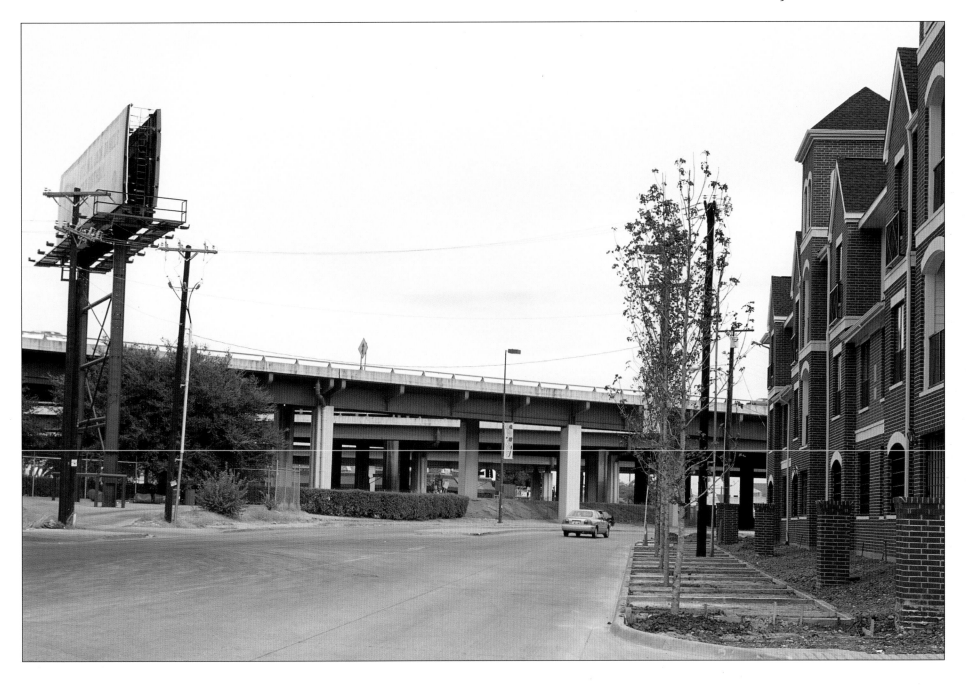

Today there is not a sign of anything made of wood along Young Street. The steel
and concrete lanes of the Good-Latimer Expressway carry traffic around the outskirts
of downtown. To the right is the brick edifice of the Canton Luxury Lofts, where, for
$196,000 and up, a condominium within easy walking distance of the business
district or farmers' market can be bought.

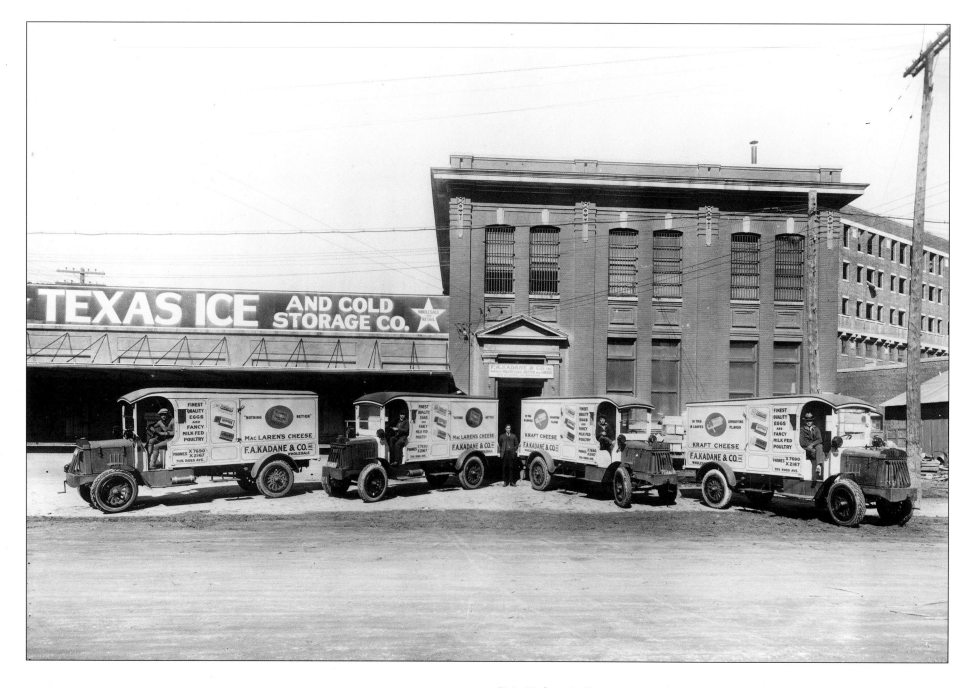

F. A. Kadane & Company, seen here in 1922, was located in the old city jail at the corner of Ross and Market streets. The Southwest General Electric Building on the right had three more stories added in 1922. Delivery vans stand ready to deliver their cargoes of ice around town, but their days were numbered by the advent of home refrigerators and the electricity to power them in rural areas.

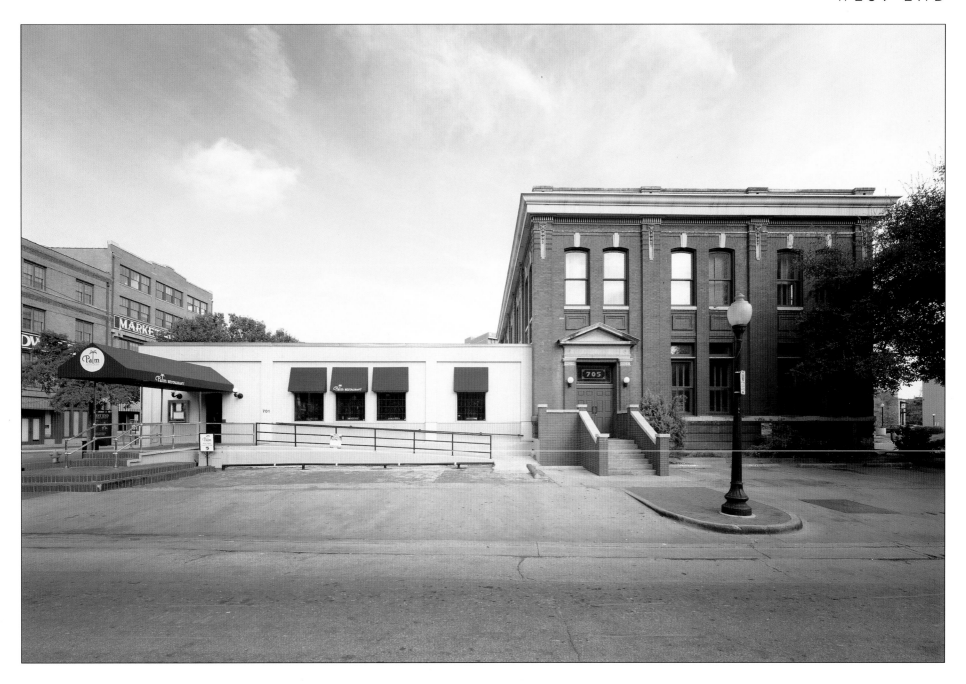

The whole complex was restored in 1980 and is now known as the Landmark Center. It is part of the entertainment district known as the "West End," which is a key element in Dallas's efforts to attract area residents and tourists to the city, thereby boosting the local economy. Filled with nightclubs, restaurants, and shops, the red brick buildings of the old manufacturing and warehouse district host an array of parades and events every year.

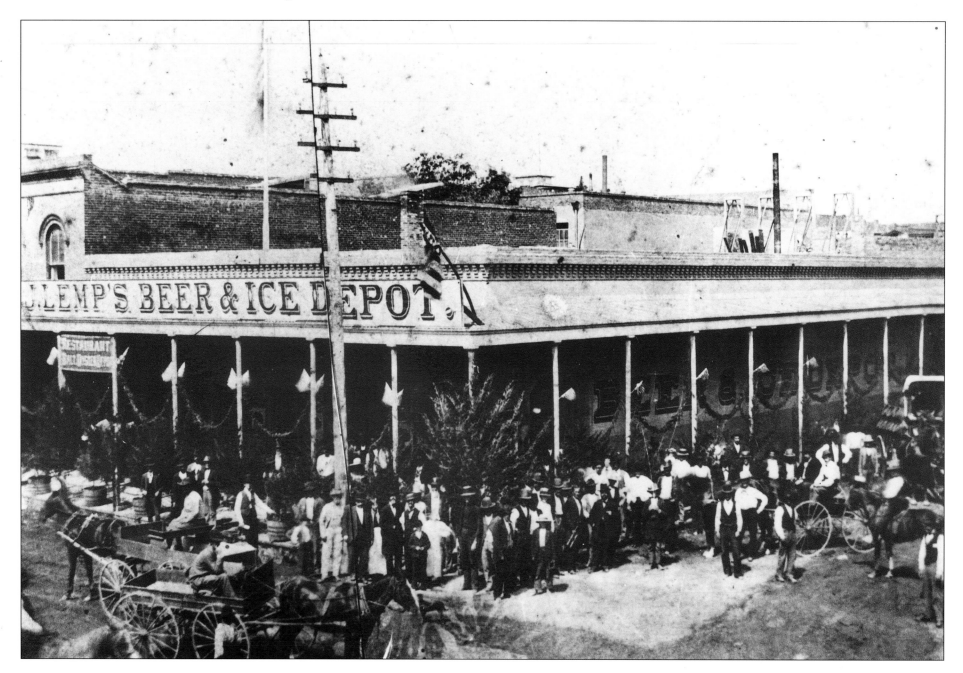

W. J. Lemp's Beer & Ice Depot was obviously a very popular spot in 1890. In pioneer days, the majority of the beers made in the U.S. were ales from British recipes that required no aging—an important factor since mechanical refrigeration did not reach Texas until the 1860s. After roughly 1840, German immigrants brought lager recipes that required the beer to be aged for up to nine months, limiting Texas brewing to cellars in the cool months.

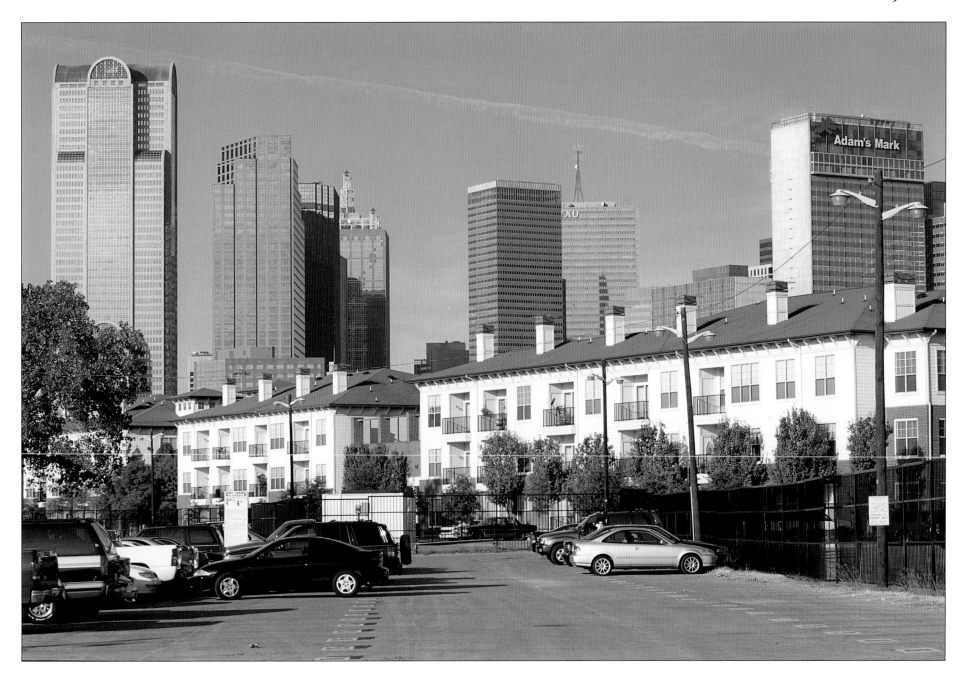

At present the Gaston Yard Apartments, named after an early Texas & Pacific rail yard located nearby, stand within a stone's throw of the business district. Many such developments are beginning to sweep aside older neighborhoods and industrial areas in an effort to reverse the trend of people moving to the suburbs. Facing long commuting times between bedroom communities and their downtown jobs, many today opt to live in the city as early settlers did.

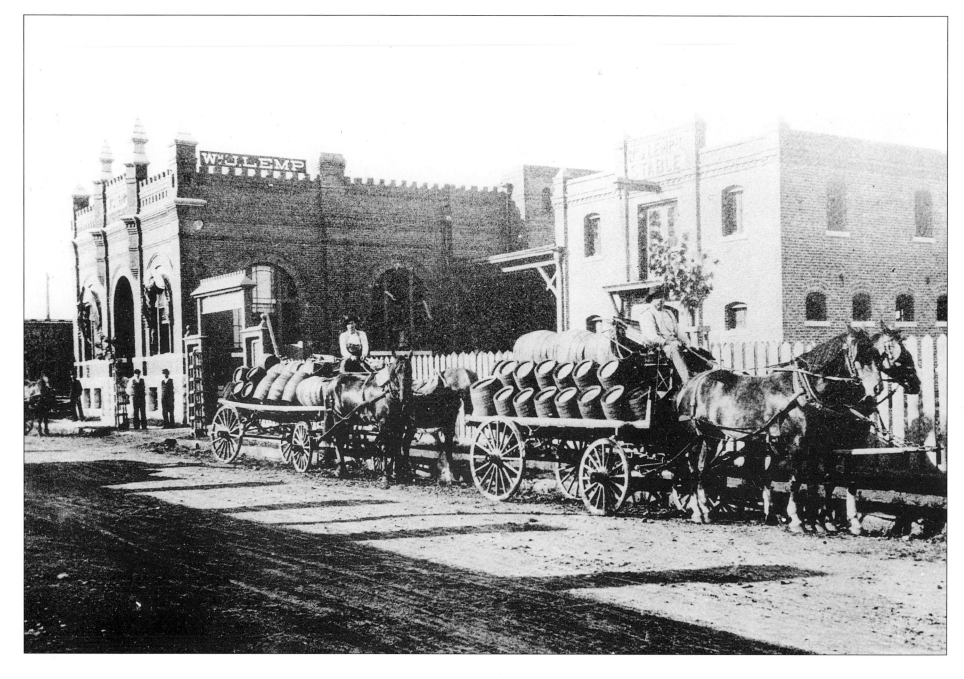

Here we see Lemp's again in 1895, still at the southeast corner of Crowdus and the Texas & Pacific tracks. Thirsty patrons of the various drinking establishments around town eagerly awaited the arrival of delivery wagons with their stacked kegs. Dallas citizens voted themselves "dry" in 1917, closing all the local saloons in October of that year. The entire state went dry in 1919, and Lemp's closed its doors forever.

"Deep Ellum" is now filled with a mix of trendy retail and entertainment businesses, the latter serving alcoholic beverages since the repeal of prohibition nationally in 1933, followed by the repeal of Texas state dry laws in 1935. The great national experiment to legislate morality had failed, only succeeding in creating an industry in making and selling illegal alcohol.

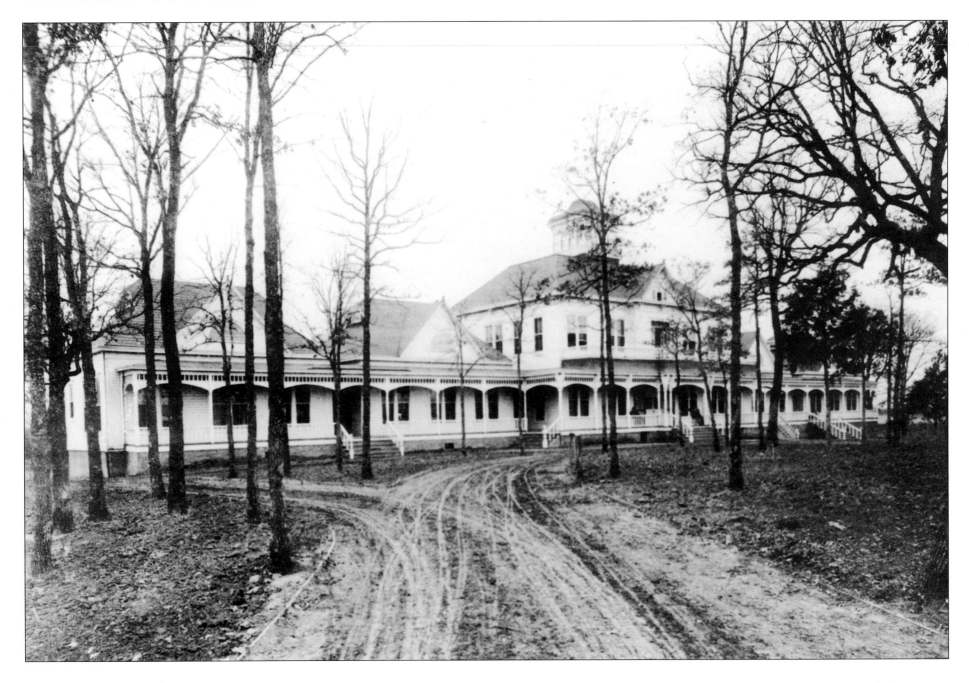

Parkland Hospital is one year old in this 1895 view, which shows it nestled on a wooded seventeen-acre tract at the northwest corner of Maple and Oak Lawn. Owned and operated by the city and county of Dallas, it was created out of a need for more sanitary conditions and better-trained doctors and nurses, as reported by the *Dallas Morning News* in 1890.

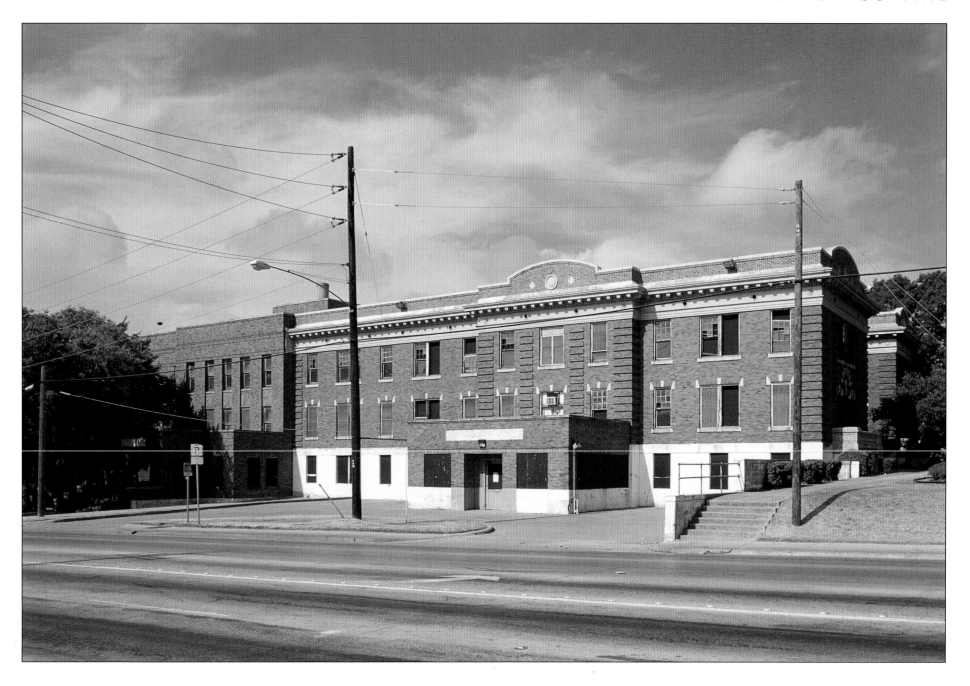

While the current Parkland Hospital was constructed on Harry Hines Boulevard a mile to the west, the abandoned shell of the second Parkland stands at the original location. Brick structures began replacing the original wooden hospital in 1913, growing to a capacity of 400 beds by 1940. After Parkland was moved, these county-owned buildings were used for the Woodlawn Hospital and then as Woodlawn Correctional Facility before falling into disuse.

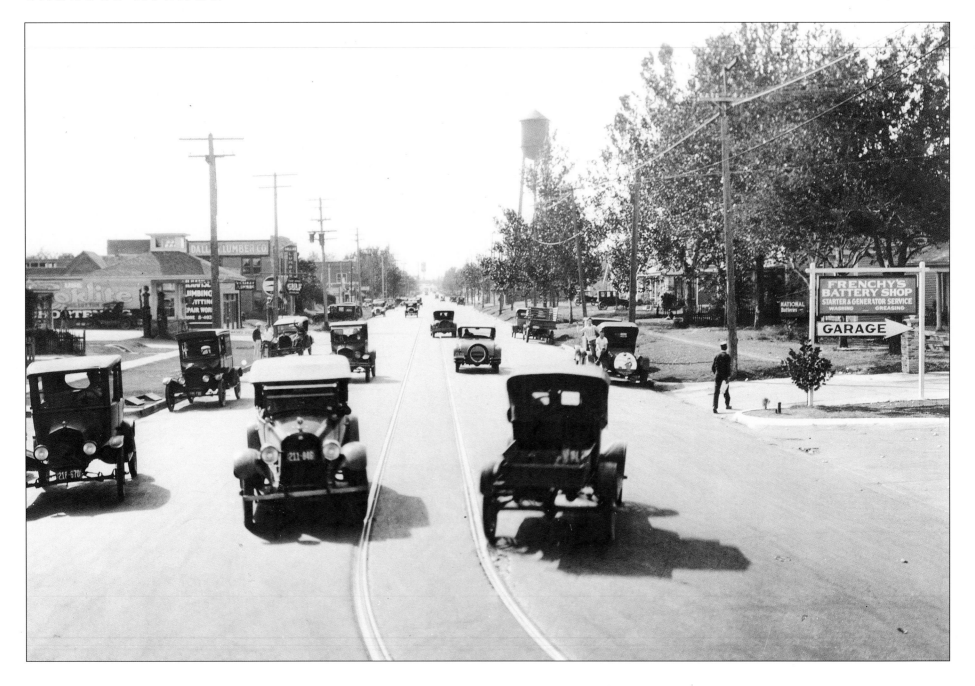

This 1924 photograph shows traffic moving along Carroll Avenue, named for Dr. Carroll Peak. Frenchy's Battery Shop & Garage offered a vital service to these motorcars, just as the stable and liveries did for the horses that preceded them. Automobile accidents took a total of forty-one lives this year, leading to the immediate introduction of traffic lights and boulevard stop signs in 1926.

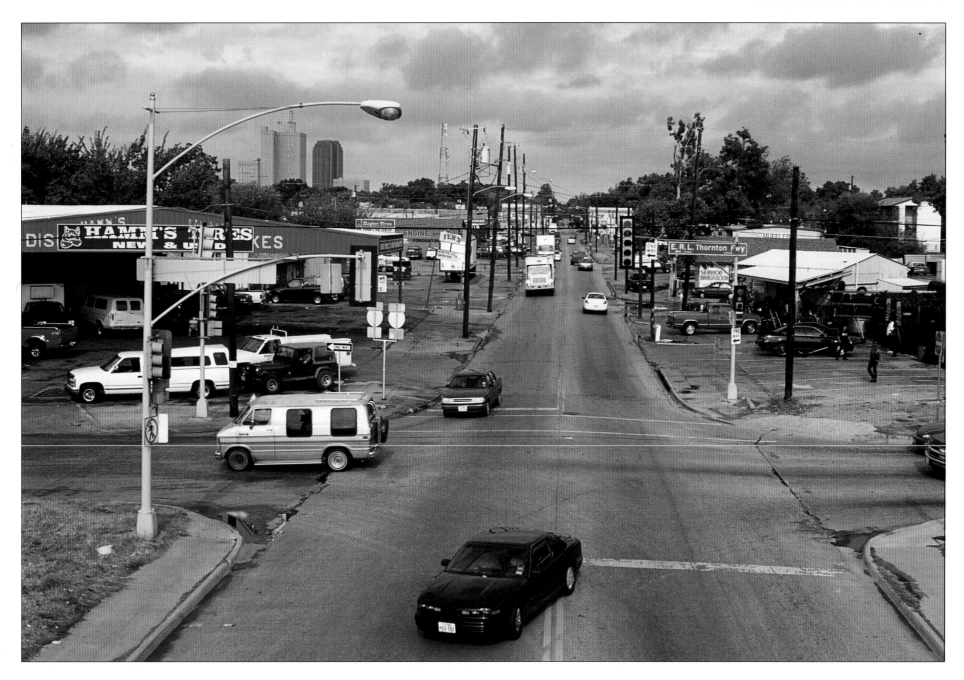

Looking down from the shoulder of E. R. L. Thornton Freeway, named for one of the city's influential early bankers and civic leaders, it can be seen that Hamm's Tires is now serving motorists at this location. The skyscrapers of downtown, a mile to the northeast, have grown tall enough to be visible from street level here.

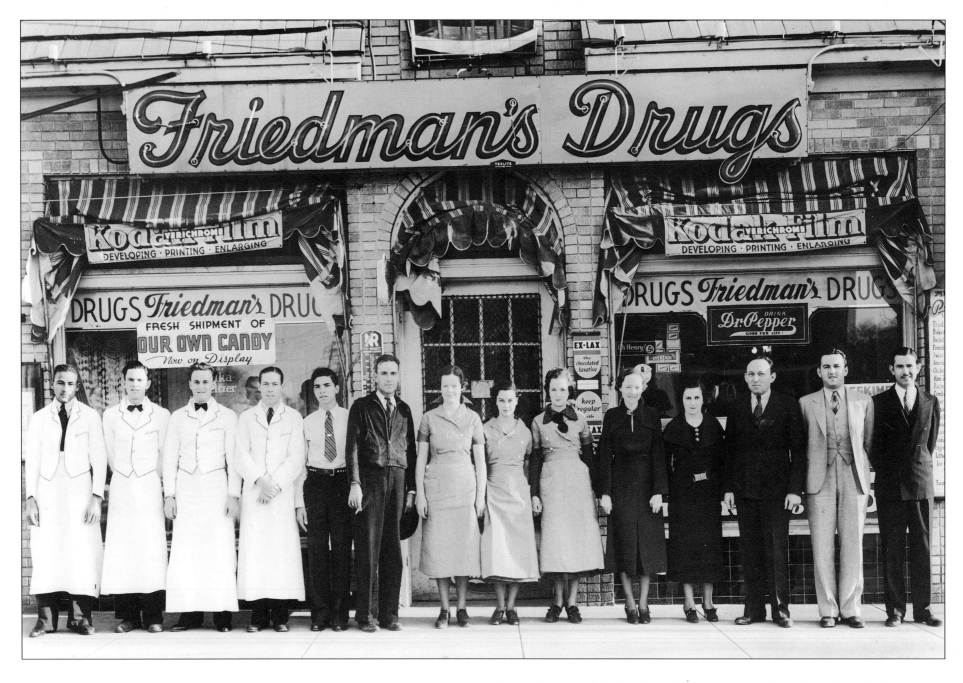

The employees and family of Friedman's Drugs stand proudly in front of their establishment at 1920 Grand Avenue in 1939. One can tell from the neatly detailed clothing and the general appearance of the store that it is dedicated to serving the neighborhood surrounding it.

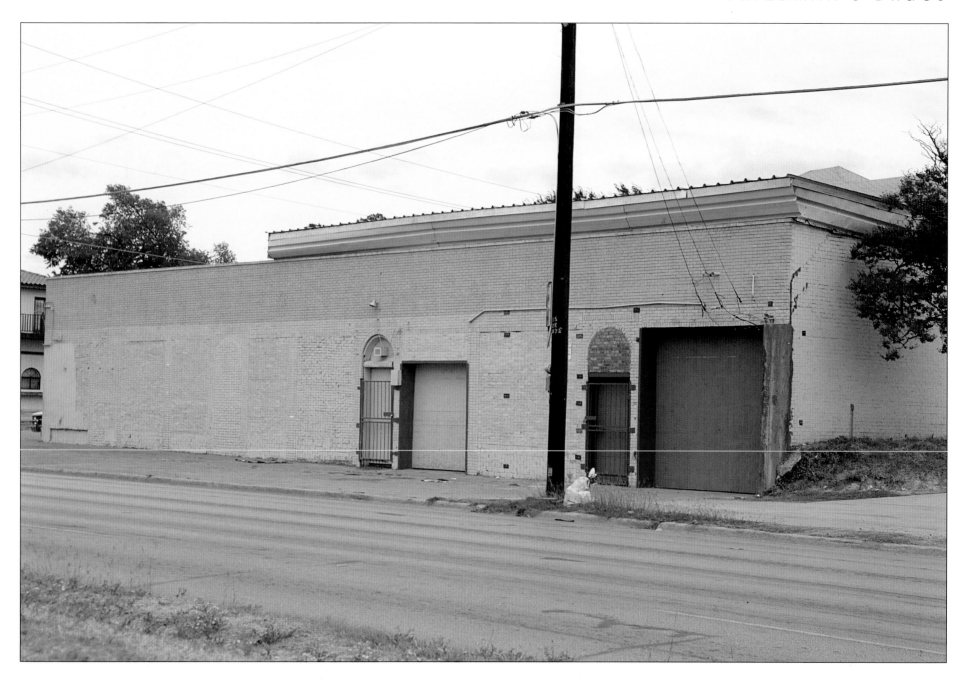

The building may still stand today, but the spirit of many small, family-operated businesses has moved on. The neighborhood has also changed, as evidenced by the barred doors guarding what little may be left inside. Friedman's Drugs moved several blocks east to Martin Luther King Drive in later years, but now all that is left, even there, is a broken sign.

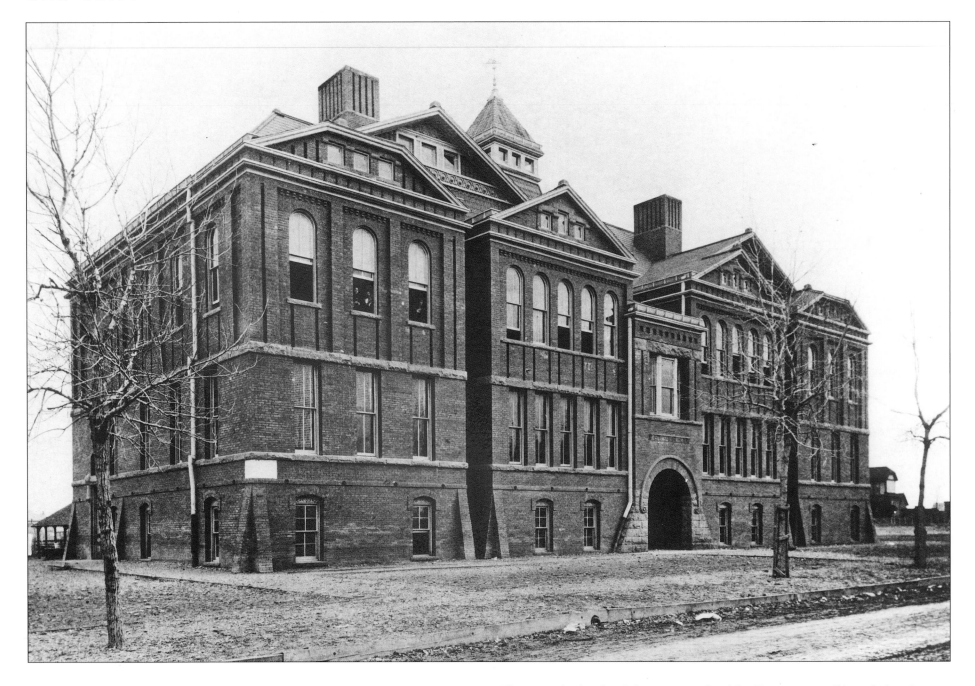

The post oaks that lined the western side of the Trinity may well have led to the area being called "Oak Cliff." Originally a residential neighborhood of Dallas, Oak Cliff became a town in its own right in 1891, only to be annexed by Dallas in 1904. Completion of the all-weather Oak Cliff viaduct in 1912 allowed the population to soar to over 100,000. Here we see the solid brick edifice of the Oak Cliff Central School in 1895.

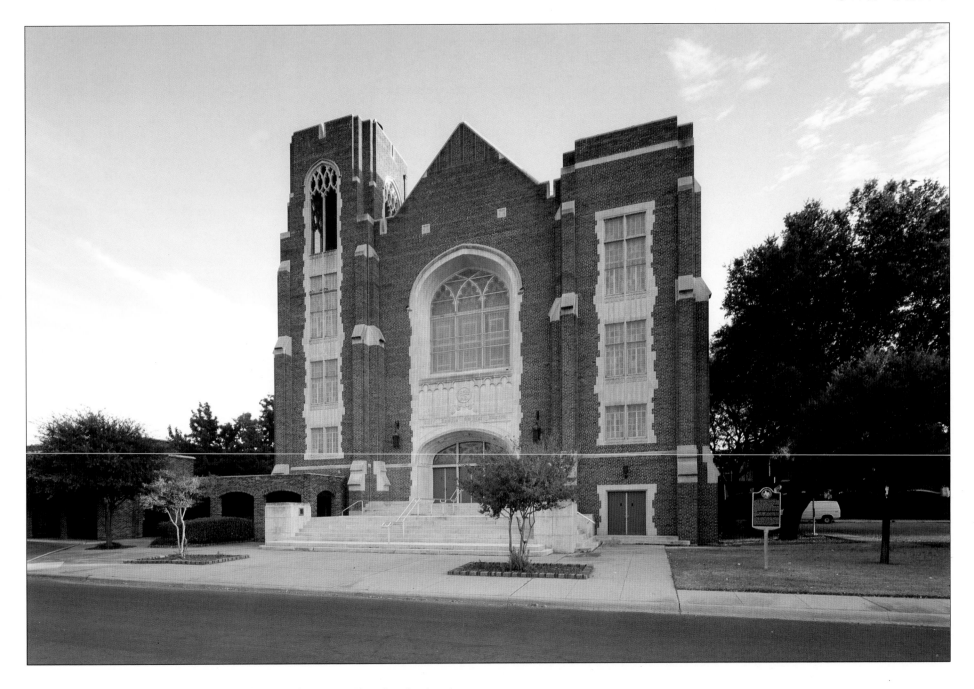

At 150 East 10th Street now stands the Cliff Temple Baptist Church, a landmark designated by the Texas Historical Commission. Twenty-six members of the First Baptist Church of Oak Cliff founded it as the Oak Cliff Baptist Church in 1898 in order to remain with the Baptist General Convention of Texas. Dr. Wallace Bassett, pastor for forty-eight years, prompted the change to its present name.

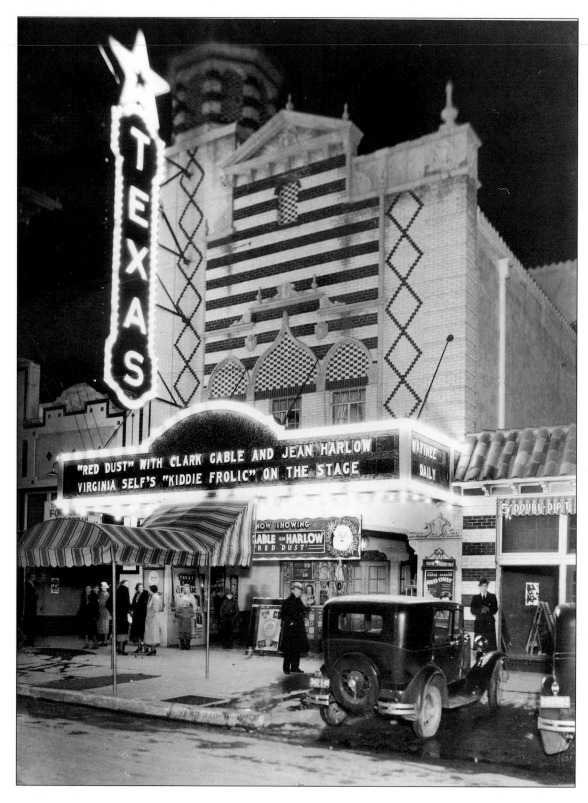

Television was still in its infancy in 1932, so neighborhood theaters like the Texas shown here on Jefferson Street in Oak Cliff, were commonplace. A nickel would buy an afternoon or an evening's entertainment in a comfortable, air-conditioned environment. *Red Dust* marked the first pairing of Clark Gable, playing a rubber plantation owner, and Jean Harlow, playing a prostitute fleeing from Indo-Chinese authorities.

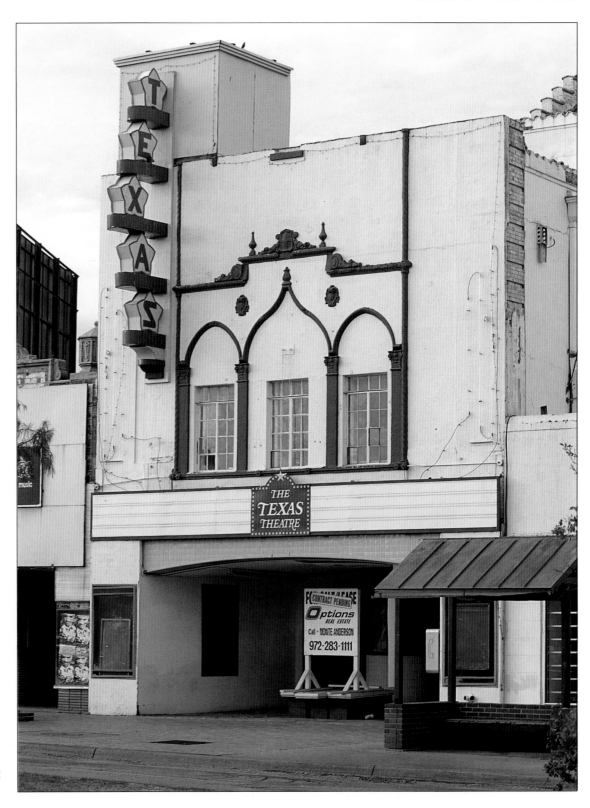

One could not guess its role in history by looking at today's dormant Texas Theater. After shooting President Kennedy, Lee Harvey Oswald took a bus and then a taxi to his room in Oak Cliff, where he picked up a jacket and a pistol before walking down Jefferson Street. For reasons unknown, he shot and killed officer J. D. Tippit before slipping into the Texas Theater without paying, where he was subsequently arrested after a struggle.

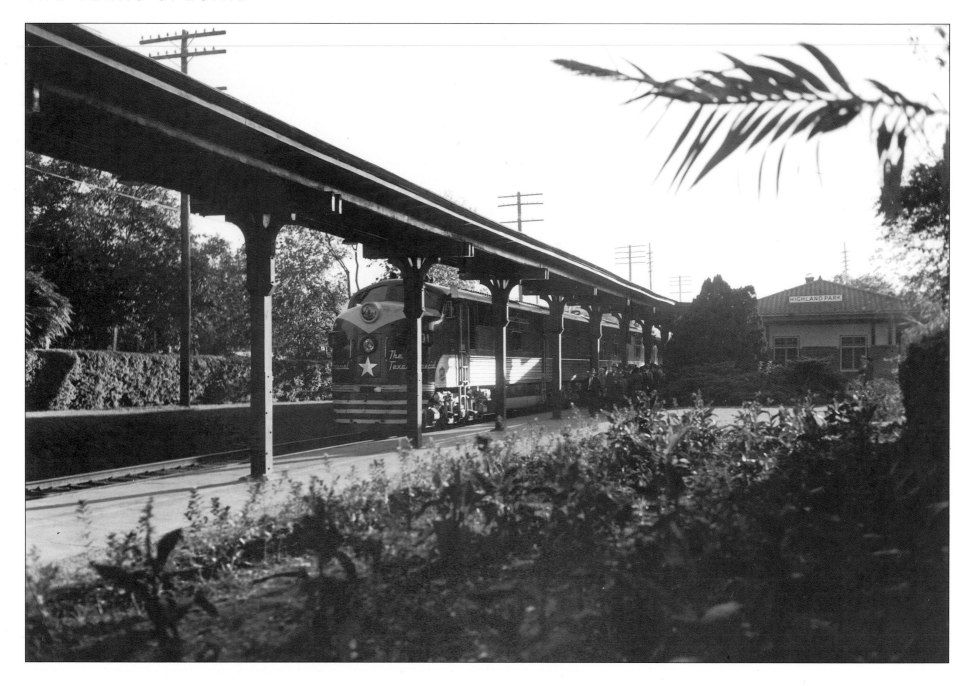

In the late 1940s the Texas Special, shown here arriving northbound at Highland Park, was operated between San Antonio and St. Louis as a joint venture by the Missouri-Kansas-Texas (Katy) and the St. Louis-San Francisco (Frisco) railroads. Roughly half the trip was made over the tracks of each railroad, each providing locomotives and cars painted in a distinctive red, yellow, and silver livery.

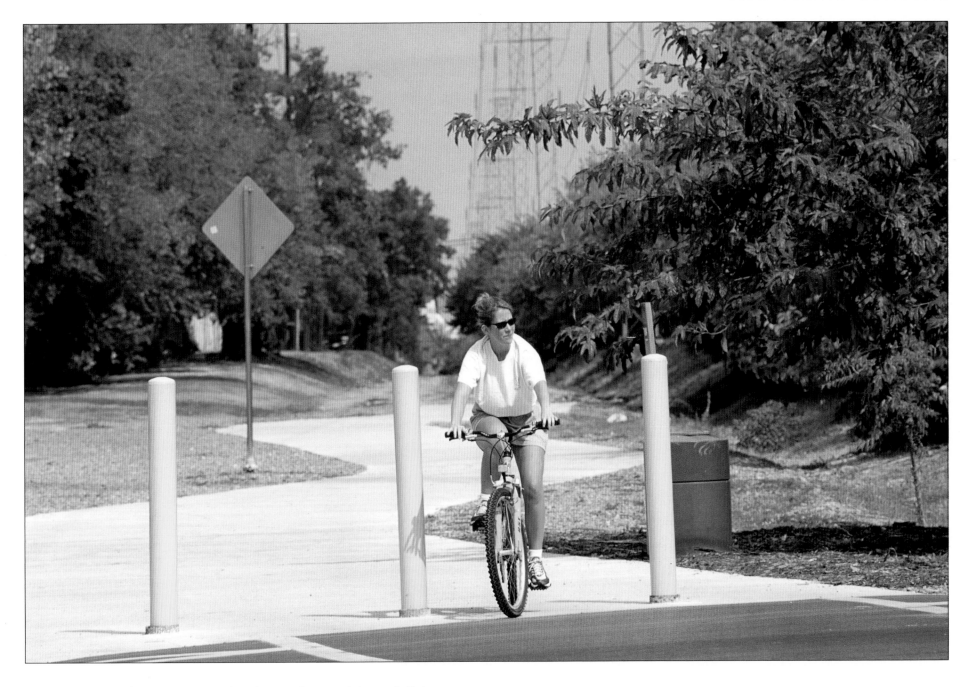

The U.S. has since become a nation of airplanes and automobiles, and all the great passenger trains have been either discontinued or turned over to Amtrak to operate. The Texas Special vanished in 1965, and the beautiful old Katy Highland Park depot just off of Abbot Boulevard was demolished in 1968. The tracks were removed in the mid-1990s, and today many people enjoy bicycling and jogging on the heritage trail that replaced the tracks.

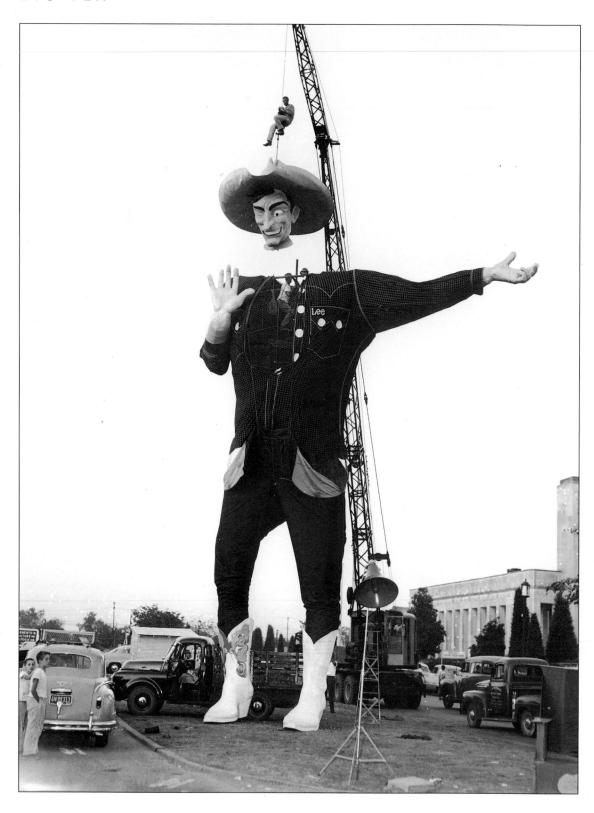

Following the popular belief that everything in Texas is larger than real life, the State Fair of Texas adopted "Big Tex" as its official ambassador and greeter in 1952. Shown here being assembled for the first time, Big Tex is fifty-two feet tall and wears a size 100 red, white, and blue shirt; 284W by 185L western-cut jeans; and size 70 boots. His clothing is made by Williamson-Dickie, while Dan Post crafts the boots and belt buckle.

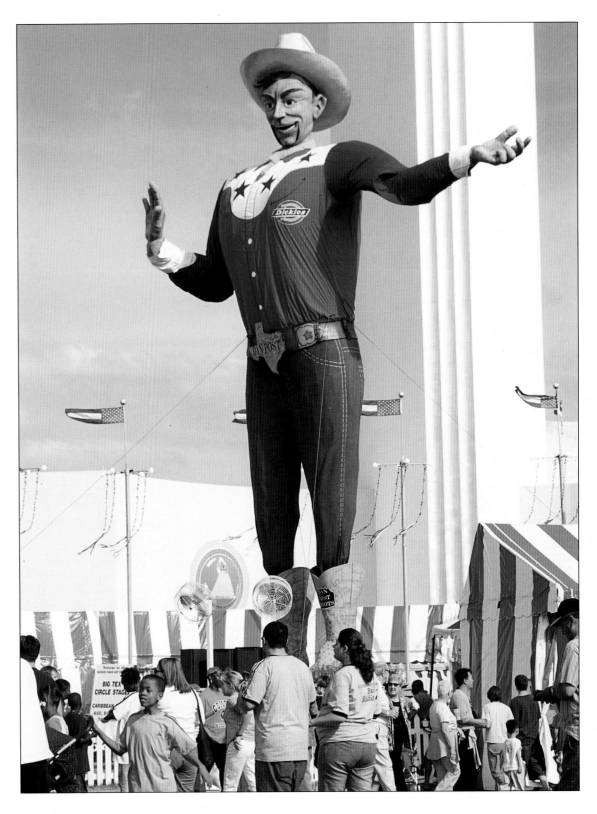

Held at Fair Park, the first State Fair of Texas was attended by 14,000 people in 1886 and has been held over three weeks every fall since then. Over three million people were in attendance in 2000. Always at the center of the fair, Big Tex began speaking to the crowds in 1953 and added a wave in 1997. If the spirit and determination of the people of Dallas in upholding Texas tradition is any indication, Big Tex's job will be safe for many, many years to come.

INDEX